CALLIGRAPHY STUDIO

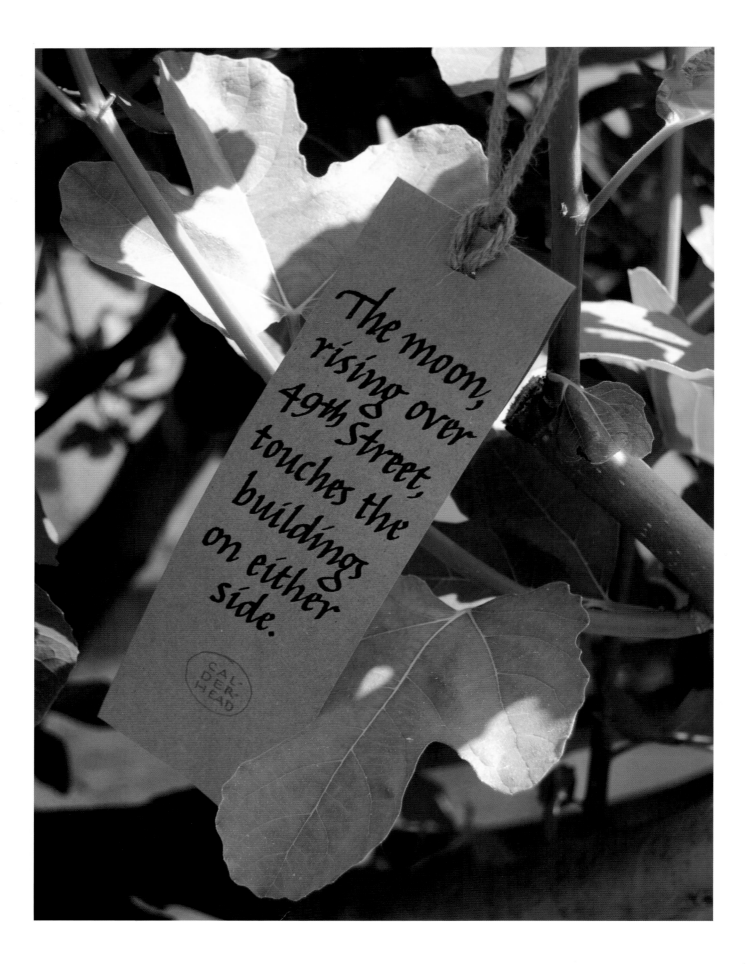

CALLIGRAPHY STUDIO

The Ultimate Introduction to the Art of Hand Lettering

Christopher Calderhead

STERLING
New York

STERLING
New York

An Imprint of Sterling Publishing
387 Park Avenue South
New York, NY 10016

© 2012 by Christopher Calderhead

ISBN 978-1-4027-3369-7 (PB-Trade Paperback)

Library of Congress Cataloging-in-Publication Data
Calderhead, Christopher.
 Calligraphy studio : the ultimate introduction to the art of hand lettering /
Christopher Calderhead.
 p. cm.
 Includes index.
 ISBN 978-1-4027-3369-7
 1. Calligraphy. 2. Lettering. I. Title.
 Z43.C15 2011
 745.6'1--dc22
 2010039016

Distributed in Canada by Sterling Publishing
c/o Canadian Manda Group, 165 Dufferin Street
Toronto, Ontario, Canada M6K 3H6
Distributed in the United Kingdom by GMC Distribution Services
Castle Place, 166 High Street, Lewes, East Sussex, England BN7 1XU
Distributed in Australia by Capricorn Link (Australia) Pty. Ltd.
P.O. Box 704, Windsor, NSW 2756, Australia

Book design and layout: Edwin Kuo

For information about custom editions, special sales, and premium and
corporate purchases, please contact Sterling Special Sales at 800-805-5489 or
specialsales@sterlingpublishing.com.

Printed in China

2 4 6 8 10 9 7 5 3 1

www.sterlingpublishing.com

Frontispiece: A weathergram made by the author.

Contents

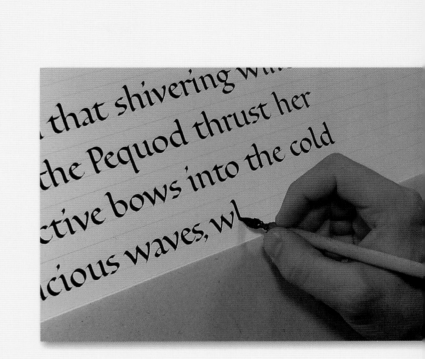

Introduction 1

1 Getting Started 13

2 The Foundational Hand 29

3 Roman Capitals 51

4 The Italic Hand 69

5 A Repertoire of Scripts 79

6 Working with Color 87

7 The Broadside 97

8 The Manuscript Book 111

9 Mapmaking 137

10 Calligraphy and Cut Paper 151

11 Ephemera 165

12 The Maker's Eye 177

Afterword 187

Acknowledgments 189

Glossary 191

Metric Equivalency Chart 195

Index 197

Picture Credits 202

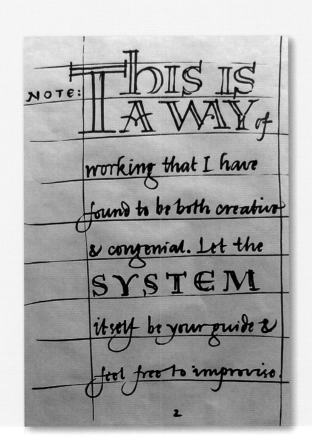

The practice of calligraphy begins with a human hand moving across the blank page.

Introduction

CALLIGRAPHY IS AN ART OF THE HAND AND THE EYE. YOU PICK UP a pen, dip it in ink, and make a mark on the page. Stroke by stroke you build letters, words, lines, and whole paragraphs of text. When you first begin, the tools and materials may seem awkward—ink gets on your fingers, the pen doesn't flow properly, or you grip the pen too tightly. With time, it becomes easier. Your calligraphy begins to flow more naturally and your hand starts to dance across the page.

To reach that level of ease, you need to set aside some time in your schedule to simply write. Hour by hour, day by day, you train your hand so the motions become second nature. You build up muscle memory; you internalize the rhythm of writing. Calligraphy is like any physical skill: The dancer learns her craft by dancing, the pianist by playing scales, the soccer player by working out on the field with the ball. The calligrapher learns by spending time at the writing board.

While you work on training your hand, you will also need to train your eye. By looking at good examples of calligraphy—both the works of contemporary masters and the best historical manuscripts—you begin to see what makes fine writing work. Our alphabet has a logical structure; the letters are not a random assortment of shapes, but relate to one another in certain simple ways. The more you look, the more you learn. And by training the hand and the eye at the same time, you bring your own work into a rich dialogue with the work of others. As you become more adept with the pen, you begin to understand how the historical scripts were constructed. As you understand historical scripts better, you recognize how to adjust and improve your own writing.

This is a beginners' book, meant to introduce you to the fundamentals of calligraphy practice. As such, it aims to do one simple thing: take you through the basic strokes of a few of the most important hands (sometimes referred to as "scripts" or "styles"). By working your way through this book, I hope you will find that you are both training your hand and learning to look at calligraphy more critically and with greater appreciation.

THE LEGACY OF EDWARD JOHNSTON

There are many ways to approach the study of calligraphy. This book is based on my own experiences as a teacher and as a working calligrapher. The method I introduce in this book grows out of the particular tradition in which I was trained. Although I know this is not the only way to begin, I believe it is a good starting point, having used it with students for almost twenty years.

My own training began in high school in the late 1970s. I began by using any calligraphy books I could find (and there weren't that many back then). I spent years copying examples I found in books, experimenting with pens, and trying out different historical styles. After college, I went to London, where I

1. With time, your calligraphy will flow from your pen and your hand will dance across the page.

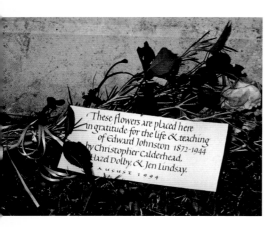

studied under Ann Camp at the Roehampton Institute. There I was introduced to a logical and coherent system of calligraphy study that grew out of the tradition of Edward Johnston.

Edward Johnston (1872–1944) was the calligrapher who set the twentieth-century English calligraphy revival in motion. His book, *Writing & Illuminating & Lettering* (1906), is a classic in the field and remains in print to this day. He embarked on a systematic study of the methods of earlier calligraphers, especially those of the Middle Ages and the Renaissance. Johnston's most important insight was that the forms of our letters grow naturally from the use of the edged pen—in other words, the tool determines, to a large extent, the way the writing will look. While many of his contemporaries copied the shapes of older writing, he revived the techniques of the ancient masters.

Johnston understood that calligraphy was *writing*, of which I will say more in a moment. By studying old manuscripts, he was able to unlock many of their secrets. Crucially, he saw what he was doing as a foundation for the contemporary practice of calligraphy, not a romantic revival. He wanted his students to learn from the past in order to create a fresh kind of calligraphy for their own time.

Johnston managed to balance several contradictory impulses. On one hand, he was highly analytical and was self-critical to a fault. He could be incredibly scrupulous in assessing his own writing and the writing of his students. This analytical approach helped him understand the structure of the written alphabet.

When he wrote, however, he retained a dazzling spontaneity. In this, he was able to capture the freedom of direct writing. His penstrokes were clean, confident, and not touched up. He left the imperfections of the hand for all to see. Johnston's students and followers have tended to domesticate his work, neatening his rough edges, applying his principles with a doctrinaire approach that makes their compositions rather cold or mechanical compared to his. Johnston's writing, by contrast, evokes the freshness of the best medieval work.

Because Johnston's legacy has been so crucial to my own development as a calligrapher, I mention him often in the pages that follow. The Foundational Hand, introduced in chapter 2, is his creation and the script he used as a basic introduction to the craft.

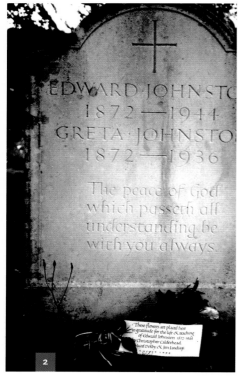

2. In 1988, I made a pilgrimage with two friends to Johnston's grave in the village churchyard of Ditchling in southern England.

WRITING AND DRAWING

As any calligraphy book will tell you, the word *calligraphy* is derived from two Greek words: *kallos*, meaning "beautiful," and *graphein*, meaning "to write."

Many calligraphers like to refer to calligraphy as "formal writing." The word *formal* here does not imply fanciness or even elegance, although calligraphy is often both fancy and elegant. *Formal*, in this context, means writing in which the form—the shape of the letters—matters.

When doing calligraphy, the scribe can feel the pen moving at a particular pace. It is faster than ordinary handwriting, but it is not as slow and heavily reworked as a text that is drawn and retouched.

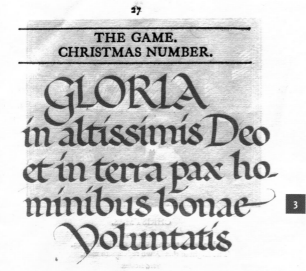

3. In this printed magazine, *The Game*, published in 1916 by St. Dominic's Press, Johnston added a text by hand to every copy. This text is written in his Foundational Hand. Note the freedom and grace of his writing—and that he writes without guidelines!

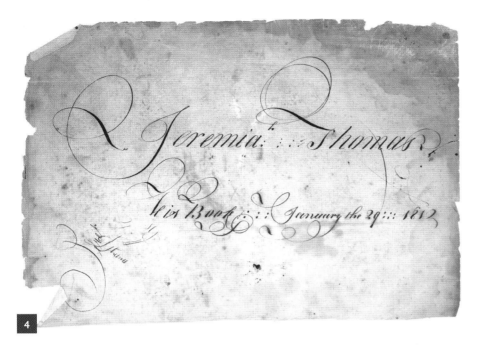

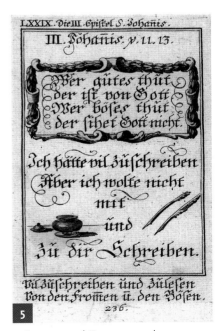

4. In the not-so-distant past, handwriting was a highly developed skill taught in every grade school. Few of us today have as elegant (and nearly calligraphic) a hand as Jeremiah Thomas, who inscribed the endpaper of his family Bible in 1812.

5. An engraved German word game, eighteenth century. The letterforms here are based on pen-written calligraphic scripts, but the letters themselves have been painstakingly drawn with an engraver's tool. The texts, from the Bible, include this little rebus: "I have much to write to you, but I would rather not write to you with [inkpot] and [pen]."

In ordinary handwriting, legibility is the most important goal. Handwriting is quick and fairly casual. If your day-to-day writing is even, well-formed, and attractive to look at, that is a bonus. But the most important thing is to write with speed and clarity. Whole words are written in a single continuous line without lifting the pen from the page. The rhythm of ordinary handwriting is like a sprint, which is why it's often referred to as *cursive* (which means "running" in Latin) writing. If you were trained in penmanship in school, you will recognize the feeling of rapid, fluid writing, the confident dance of the pen across the page.

These days, since schools generally no longer teach handwriting, many people are using their own personally devised writing. Very often, people don't write by hand at all, except to make brief notes. We live in a culture where people now seem to prefer the keypad on a phone or the keyboard of a computer. If you have little experience with handwriting, you may find that calligraphy introduces you to writing in a new way. The forms of your letters will be more logical, and you will begin to develop the muscle memory that makes for smooth, flowing writing.

Calligraphy is written more slowly than ordinary handwriting; it is more carefully constructed. In most scripts, each letter is made of a series of separate strokes—the pen is lifted and put down several times within each letter. The pace of writing is more deliberate than the pace of handwriting. Yet, despite the slower speed, the movement still feels more like the act of writing than like the act of drawing. Each stroke is made directly on the page, without being retouched or refined afterwards. The beauty and freshness of calligraphy grows out of this directness. Each stroke has the grace and fluidity of a straightforward, handmade mark.

By contrast, drawn letters, such as typographic fonts, are built up, refined, and retouched. This approach—appropriate for designing typefaces, painting large signs, or creating logos for reproduction—is not direct in any sense of the word. While such designs may imitate the fluidity of calligraphy, the deliberate, slow process needed to make them is completely different from the act of writing.

BRICK

6. This design for a sign was sketched with a pencil, scanned and traced on the computer, and eventually printed mechanically before being attached above the entrance to a restaurant.

Calligraphy, then, has its own stately rhythm. It is slower than handwriting, but much more direct than drawing. You will find that rhythm as you begin to practice. Write too quickly, and your lettering will become slapdash and overly casual; write too slowly, and you will find your letters becoming stodgy and awkward, without grace or fluidity. A calligrapher who has mastered the rhythm is able to make letters of lasting beauty.

OUR ALPHABET(S)

We inherited the alphabet we use today from ancient Rome. Of course, over the course of several thousand years, it has changed enormously. This is the result of new methods of making written forms—the use of the edged pen or the invention of printing—and because the Roman alphabet is used today to write languages Julius Caesar never heard of. A first-century Roman would be completely bemused by the letters sitting on this page, except for the occasional capitals that we use at the beginning of sentences and for proper nouns. He would find the letters **W**, **U**, or **J** as odd as we find the Cyrillic **Б** or **Ч**. He would never have seen small letters like **a** or **g**.

We use two very different forms of the Roman alphabet: capitals, or *majuscules*, and small letters, or *minuscules*. We also refer to them as *upper case* and *lower case*. These terms refer to the wooden boxes, or cases, in which movable type was once stored. The upper case held the capital letters, while the lower case held the small letters. While the terms are useful for describing typesetting on a computer, they are foreign to the handwritten tradition and, because they stem from typography, most calligraphers do not use those words to describe their writing, preferring to use the terms *majuscule* and *minuscule*.

Our majuscules and minuscules originated in different times and places. The majuscules are direct descendants of the type of letters the ancient Romans carved onto their public monuments; the minuscules developed during the Middle Ages as products of pen writing.

If we look at the majuscules, we see that they are written on a two-line system. They sit on a *baseline*, and they are all equally tall, hitting a *cap-height* line. In general, the letters never extend above or below these two guidelines (the **Q** being the one exception to this rule).

The minuscules are written on a four-line system. The letters sit on a baseline, like the capitals. The *x-height line* determines the height of the shortest letters, like **x**, **a**, **m**, or **o**. Certain letters, like **l** or **h**, have component parts, called *ascenders*, that go up all the way to the *ascender line*, while others, like **p** or **q**, have *descenders* that go down to the *descender line*. In general, all your ascenders should be equally tall and all your descenders should be equally deep.

When combining majuscules and minuscules, we lay these two systems on top of one another, creating a five-line system. The same baseline is used for the caps and the small letters, but the cap-height line is lower than the ascender line.

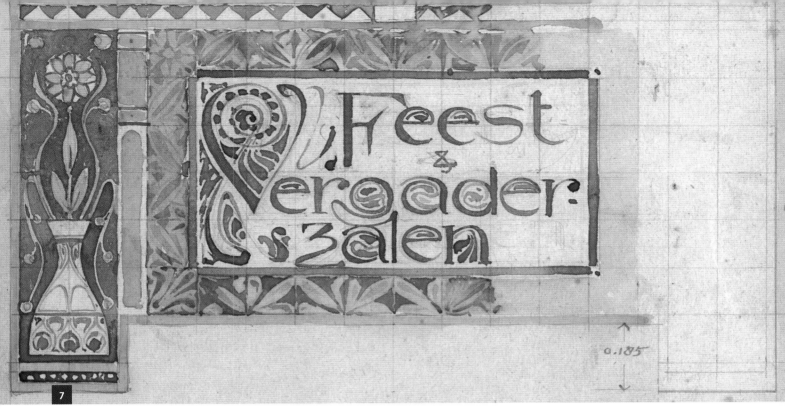

7. An early twentieth-century design for tiles is worked out in pencil and water-color as a pattern for the tile maker.

When beginning to learn a calligraphic script, you can draw all these lines in pencil to serve as guidelines. Expert scribes, however, usually only draw baselines. Through years of practice, professional calligraphers have internalized the shapes of the letters, and they can judge x-height and the length of ascenders and descenders by eye. In this book, I have set out a pattern of ruled lines that gives you a fixed baseline and x-height; however, I encourage you to begin judging the height and depth of your ascenders and descenders like a professional, by using your eyes.

Each calligraphic script has its own particular character, and often includes some variants of the standard letterforms we are familiar with in printed

8. Majuscules on a two-line system.

ALPHABET

9. Minuscules on a two-line system.

alphabet

10. Majuscules and minuscules combined on a five-line system.

Alphabet

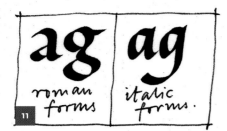

11. Examples of Roman and Italic script.

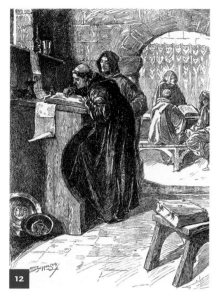

12. A highly romanticized nineteenth-century engraving shows monks at work in a medieval scriptorium. Scribes in many traditions have used such tall tables with fixed, tilted tops. The posture of the writer, however, is less than ideal: Stooping over your work causes back pain.

alphabets. In the two minuscule scripts shown in this book—the Foundational and Italic Hands—most of the letters are based on similar essential forms. Two letters, however, are quite distinct. The Foundational **a** and **g** are quite different in structure from the Italic **a** and **g**. This distinction, found in Renaissance manuscripts, survives in our contemporary typography.

SOME NOTES ON TERMINOLOGY

The styles calligraphers write—Uncial, Foundational, Italic, Gothic, and so on—are usually referred to as *scripts* or *hands*. In fact, many of us shy away from using the word *style* to describe any of these hands. For those of us in the Johnstonian tradition, this is probably due to Johnston's own mistrust of the idea of style—he was more interested in analyzing the methods used by the early scribes. Style, for Johnston, carried the connotation of a superficial, fashionable appearance. He was more interested in the root practices that made a script hold together, both in terms of its aesthetics and in terms of how the hand moves.

With the advent of the computer, which has democratized and popularized typography and its terminology, people tend to ask calligraphers what *font* they are writing. That's a complete misnomer. We don't write fonts. We also don't *calligraph* anything. The appropriate term is that we *write* our texts. I know this is confusing at times, because people usually use the term *writing* to refer to an author composing a text. But the word stands: Calligraphy is writing.

A BIT OF HISTORY

The two scripts taught in this book could be the basis for a lifetime of calligraphic practice. Many, if not most, scribes eventually specialize in just one or two hands. But as you explore the art of calligraphy, you will want to know more about the incredible variety of scripts available.

The techniques we use to analyze the Foundational and Italic Hands can be applied to the study of many historical and contemporary scripts. Once you have mastered a few basic concepts—using a consistent pen angle, measuring scripts by nib-width, or defining stroke order and direction, for example—you can use these concepts to analyze almost any script you encounter.

We can learn about the best writing practices and understand the roots of our own letterforms by looking at medieval and Renaissance manuscripts. This can be done in museums, by looking at actual surviving manuscripts, or it can be done by looking at high-quality reproductions. When you examine a historical script, you are looking at the work of a scribe who wrote day in, day out within a vibrant calligraphic tradition. These people knew how to write— they cared about what they were doing, and they put in long hours at their desks. Their writing is the product of an approach imbued with the culture of the scriptorium.

The edged pen came into use during the waning days of the Roman Empire. Before the fourth century or so, most manuscripts of the Western tradition were written with a pointed reed. Later on, calligraphers began to use a quill cut to a chisel edge. That chisel edge is the key to the task; it naturally produces a sequence of thick and thin strokes.

The new tool immediately began to affect the shape of the Roman letters. In a gradual process, new scripts developed. The Roman alphabet took on new forms. Different regions produced their own variant scripts, which changed and developed over time.

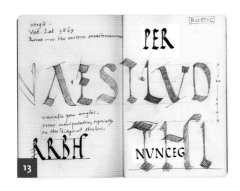

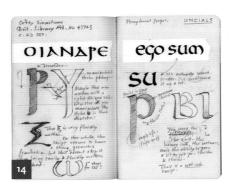

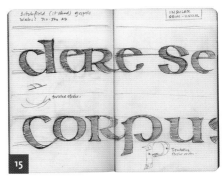

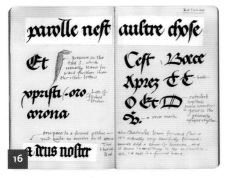

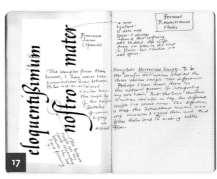

The conventional names we use for these scripts—Rustic, Uncial, Half-Uncial, and so on—are generally not the names the scribes themselves would have used to describe their own writing. We don't know much about how medieval scribes talked about their writing. It was only in the Renaissance that writing manuals began to appear and we can read detailed accounts of then-current scribal practice. Most of the names of the historical scripts were devised by later paleographers and historians to describe particular groups of manuscripts. So when we speak of Uncials, for instance, we're describing a family of scripts with certain characteristics. It's a common misconception that there are rules for each script, or a perfect pattern for each one. In fact, each of these names describes a family of scripts with broadly similar structure. There are many varieties of the Uncial, just as there are many varieties of the Gothic or Italic. The modern interpretations of these scripts are just that—interpretations. The Foundational Hand in chapter 2, the Roman Capitals in chapter 3, and the Italic Hand in chapter 4 are my own versions of these important scripts; others will make them slightly differently.

In chapter 12, I discuss a late medieval manuscript in some detail, demonstrating a way of learning from a historical sample of writing. Figures 13 to 18 are some pages from my study notebooks. My sources were mostly photographic reproductions from books. I used both pencils and edged pens to write or draw the letters, and added notes about the characteristics of each script. The samples I show here are not a comprehensive overview of the history of formal writing, but they do give a glimpse of the enormous variety of scripts we can find in medieval and Renaissance manuscripts. Note that I consistently jot down the name and date of each manuscript so that I know which particular Uncial or Rustic or Gothic manuscript I am studying.

Studying the great masters of the past is both challenging and rewarding. Trying to copy a historical manuscript is great practice, as it trains your eye and challenges your hand. If you explore the riches of the manuscript tradition,

13. Sketches of Rustic Capitals from two manuscripts in the Vatican Library. The pencil drawings are from a sixth-century manuscript of Virgil; the pen-made sketches that have been pasted in are from another Virgil manuscript of about the same date, the Codex Palatinus. The Rustic Capitals have very pronounced, thin, upright strokes and thick diamond-shaped bases.

14. These two samples of Uncial show how variable that script can be. On the left is a Greek Uncial with a very flat pen angle, dating to the fourth century. On the right is an English manuscript from the late seventh century.

15. Insular Semi-Uncials were used in manuscripts from Ireland and northern England in the seventh and eighth centuries. The Book of Kells, a famous manuscript of the Gospels, was written in this script. You can see here the emergence of distinct ascenders and descenders. The script is incredibly subtle, involving a good deal of pen manipulation, or twisting of the pen, to make the strokes.

16. A Gothic Cursive, also referred to as a Bâtarde script, from about 1450. This Northern European script takes the formal upright Gothic and makes it into a rapidly written, lush running script. The capitals are delightfully free and playful. There are quite a few flicked strokes, which are rapid lifts of the pen with a little twist at the end.

17. Sketches of Renaissance Italics from Italy and Spain.

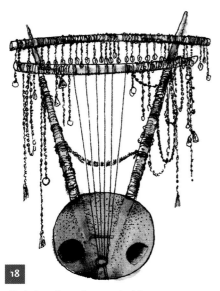

18. A drawing of a musical instrument, after a postcard from an exhibition.

19. Once you begin writing the scripts in chapters 2 to 4, come back and look at this manuscript. Notice that the ruled lines (which have been made with a pen and ink) don't line up with the baselines of the writing. Instead, the scribe has written in between the lines, letting the writing float freely in the space. The scribe is judging all the intervals by eye—the baselines, x-heights, and ascender and descender lengths. That's a very advanced technique.

you will find that some scripts are fairly easy to replicate; others will defeat you again and again. The Insular Semi-Uncials I drew in my sketchbook are made with a pencil because I have never been able to master making them with a pen. The Gothic Cursive I took to like a duck to water. You learn as much about yourself as you do about the historical styles when you go pen-to-pen with the masters.

THE PLEASURES OF IMPERFECTION

Everywhere we look in daily life, we are surrounded by machine-made, cookie-cutter-perfect objects. Calligraphy is the work of the hand. As such, it never has that cold, mechanical perfection. The rhythm we achieve in our writing is an organic repetition.

When you look at a piece of skilled writing, you see this principle in action. A page from a Book of Hours—a type of medieval illuminated manuscript, rapidly written by an expert scribe using a quill on vellum—has just this quality. The letters are not perfect, but the overall effect is one of tremendous consistency.

Our word *text* comes from the Latin word *texere*, meaning "to weave." Once a scribe has mastered the basic construction of letters and begun to write lines of text, the act of writing does begin to feel like weaving. Patiently working your way across the page, you find that your letters begin to create a texture (that word again), evenly balancing black strokes with the white spaces in between. Each line will have a similar balance of dark and light, a repeating pattern of curved and straight strokes. Like a kilim rug or a hand-knit sweater, the writing will have its small imperfections, but the overall texture will be even and satisfying.

Eric Gill, one of Johnston's students and a noted lettering artist in his own right, liked to say, "Look after goodness and truth, and beauty will look after herself." The first task of the calligrapher is to concentrate on issues of craft: Are my letters neatly and consistently written? Is my spacing even, creating lines of writing with the same balance of dark and light? Are my ascenders and descenders consistent in height? Is my ink flow under control? Are my lines properly spaced?

By concentrating on the craft of fine writing, you create work with integrity. A piece of fine writing, carefully executed, is all you need to achieve. In a sense, you never need to "design" a piece or add ornament to your writing. You simply let the system carry you. It *will* be beautiful if you mind your craftsmanship.

I have a postcard over my desk of a nineteenth-century musical instrument from the Sudan. Made by a village craftsman, it is constructed of the simplest materials: a gourd, some poles, animal skin, and gut strings. The most extraordinary thing about the instrument, however, is the pattern of beadwork that is wrapped around the poles. Strings of beads—green, yellow, white, and red—have been carefully looped around the poles, around the side, and at the top. The dangling ends are weighted with cowrie shells and small metal ornaments. The system couldn't be simpler: Take a string of beads and wrap it around the next available space. The pattern is irregular—green-red-green-green-red-white-red, and so on. I suspect the wrapping took some time, and probably was not made in a single session; perhaps the musician added a string of beads after each performance.

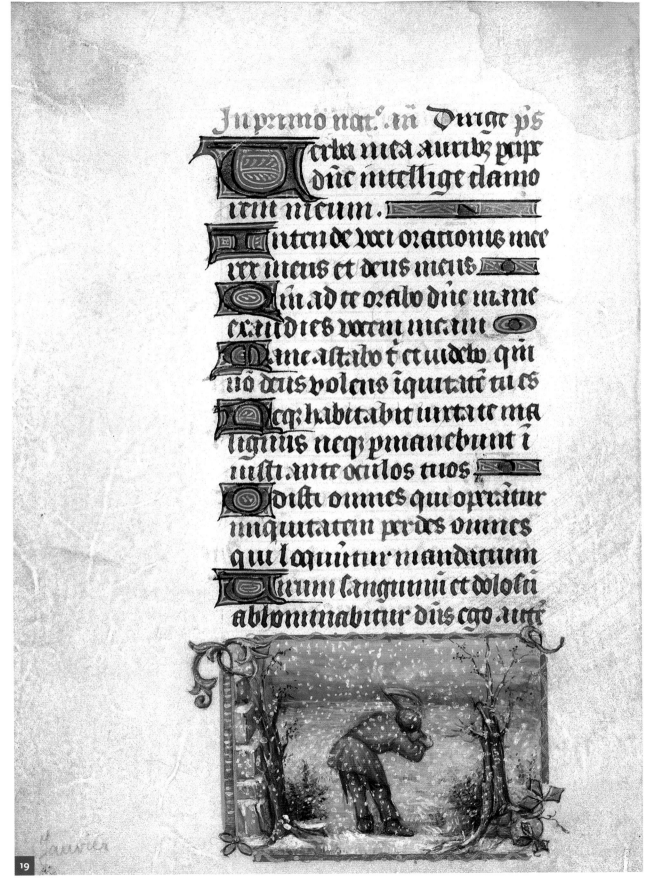

20. Practice the motto in this caption when creating calligraphy.

It is preferable to study a piece of "live writing" than to pore over an exemplar, however fine it may be.

This little postcard is over my desk to remind me that a calligrapher does a similar thing: adding bit by bit to a paragraph of text, letting a simple system carry the work along. Our work is not "perfect" in a machine-made way, but when it is carefully made, it can be as splendid as that lovely lyre.

ABOUT THIS BOOK

Many calligraphy books are written as if no one ever blotted a line or made a crooked ascender. The printed exemplars that are shown are perfect, literally so: They have been selected, retouched, and, in some sense, denatured. You cannot see the ruling up (the pencil lines that guided the original writing); this has been erased or retouched. Nor do you see the process through which the best letters were selected for the exemplar and the touching up that has gone into making the sample. That kind of perfectionism has its place, for sure, and I am very grateful for the beautifully constructed, ultrafinished exemplars I have found in many calligraphy manuals.

However, it seems to me that the process of writing is deeply organic. Johnston might side with me on this one. One of his practices was to hand out sheets on which he would do a sample of actual writing for his students. Many of these samples were not master alphabets. Instead, he would write a short passage of text in a script the student was studying. His samples were living writing, not simplified for the beginner, but showing all the quirks and variations that come with real writing.

I like that approach. For one thing, I don't think it's good for students to be given overly simplified samples to work from; it becomes difficult to separate what is a hard-and-fast rule from what is a simple rule of thumb. Most importantly, it gives students a little room to work things out for themselves. There is nothing quite so challenging as figuring out how to do a particular letter—a **y**,

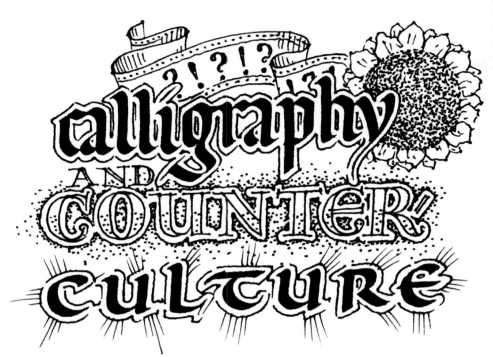

21. There is something decidedly counter-cultural about the practice of calligraphy. In an era when everything is fast, from instant messages to fast food, calligraphy asks us to slow down and take our time. This heading was made for *Alphabet*, the journal of the Friends of Calligraphy.

for example—when the sample in front of you doesn't contain that letter. It means having to use your wits and trying to work out for yourself, within the logic of a particular hand, how the missing letters might be made. When you have to figure out some of the details on your own, it helps you really analyze what's going on in a script, and you understand the basic structure much better. You're not just copying a sample you have in front of you.

In this book, I have chosen to reproduce my writing with the line rulings showing. Most of the samples are reproduced at actual size (unless otherwise indicated) and I have not retouched the letters. Sometimes, when I have made a selection of letters or replaced poorly written words, I have taped or pasted them in place and you can see the cut-marks. You can also see my bad habits (I lean slightly backwards or forwards sometimes, and sometimes my strokes miss their mark). There is a method in this: I want you to see what living writing looks like, with all its imperfections. I want you to see the rough edges, the tooth—or texture—of the paper, and the little marks that I use to guide my writing.

Calligraphy is a deeply rewarding, methodical practice. It is the opposite of so much of our fast-paced, quickly bored, throwaway society. It asks you to take your time, to concentrate on what you are doing, and to enjoy the feel of wet ink on a piece of good paper. Remember that this book is just a beginning. If you learn the basic principles from the chapters that follow, you will be well prepared to further explore the riches of formal writing.

22. A friend of mine once mentioned something one of his teachers had told him: "Calligraphy is like the leaves of a tree." Every letter has the same basic shape and size, but each one is unique.

Getting Started

The ideal working space for a professional calligrapher is a fully furnished art studio that has a drafting table with an adjustable tilting top, a flat table for ruling and cutting, flat files (special filing cabinets for storing art) with large drawers for paper storage, and places to keep inks, paints, and pens. A beginner, however, can set up a work area at relatively little expense. The basic needs of the craft are fairly straightforward, and even many professionals work in simply furnished studios.

There are many ways to set up a writing space. The instructions I give here work; I have used them myself. But if you can improvise other solutions, feel free to do so.

The first thing to consider is the table you will use for writing. You will need a tilted surface on which to write. While it's possible to work on a flat surface, it's rather awkward. I've done it, and found that not only did I have to lean uncomfortably over my table to see what I was doing, but I bruised my ribs from jamming my body against the table edge. A tilted tabletop presents your work to you at a comfortable angle and lets you sit upright while you work.

A small tabletop easel can be placed on an ordinary dining table or desk. While any tabletop easel could be used, I recommend ones specifically made for calligraphers. They are available from John Neal Bookseller, online, or by mail order. These easels are inexpensive, lightweight, and portable. Some even come with a carrying case, so they can easily be taken to classes and workshops. Made of two wooden frames connected at one end, they can adjust to several angles of tilt.

A drawing board is placed on the easel. The best drawing boards are made of wood; the edges of the board should have metal reinforcements on the two sides to provide a true straightedge for ruling up. An 18 x 24–inch board fits most easels comfortably. In a pinch, you can use a sheet of Masonite or even plywood cut to fit your easel.

23. The pen is a very important part of calligraphy. Make sure you find one that you're comfortable with.

24. The ideal set-up for your calligraphy writing desk.

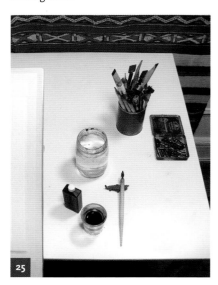

25. Tools positioned for a right-handed writer. The inkpot is close to the writing board, so it can be easily reached. The pen lies on a small pen rest. A bottle of ink is at the ready for replenishing the inkpot, and a jar of water, known as the waterpot, stands nearby for rinsing the pen. Extra pens, pencils, and nibs are also within easy reach.

26. Having good lighting, a relaxed body position, and all the correct tools at hand allow you to work to the best of your ability.

It is unpleasant to write on a completely hard surface, so you need to pad one side of the board with several (three to five) layers of paper. These can be kept in place using masking tape. The surface should be absolutely flat, without wrinkles or bumps. It's best not to wrap these sheets around the edges of your board for two reasons: First, wrapping the sides creates an uneven surface on the backside, so the board no longer sits flat against the easel; second, you don't want to cover the metal edges that are used for ruling. The padding should stop an inch or two from the edges. With your writing pad in place, your board has two distinct sides—one for writing, the other for ruling up.

Good lighting is important. A right-handed person will want light to come from the left side so the hand does not cast a shadow over the work. A left-handed person will want light from the right side. Your lamp should cast even, clear light over the writing surface; just as you shouldn't read in bad light, you shouldn't write in bad light. It's good to have a lamp that casts light directly on the drawing board, rather than using the ambient lighting in the room. Natural light is a luxury and a pleasure to work in, even if it is only available at certain times of day. If you work in natural light, make sure it falls on the desk from the appropriate side. Don't work in direct sunlight, which is too bright.

Your ink and pens should be on the flat surface of the table next to your dominant hand (to your right if you are right-handed; to your left if you are left-handed). You shouldn't have to stretch, turn, reach, or lean over when dipping your pen in the ink. Make sure these things are positioned so that your movements are smooth and don't interrupt your writing. Some people

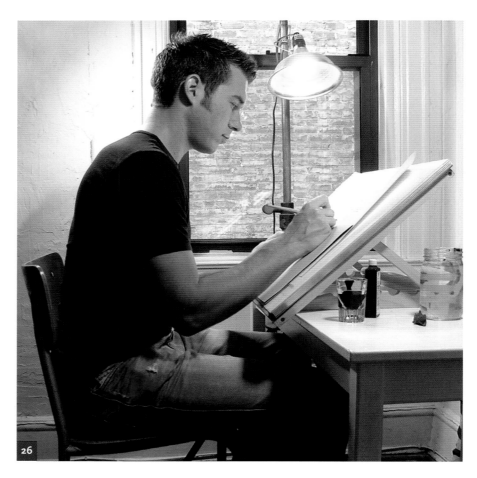

like to keep their tools on a small table next to their chair.

Your chair should be a comfortable desk chair. Many people use padded office chairs with adjustable height, although I prefer a hard, dining room–style chair.

Like any sustained activity, calligraphy will take a toll on your body if you are sitting poorly. You should sit with your shoulders parallel to the edges of the table. Your body should not be twisted or turned. When writing, you should not be hunched over your work; you should only need to lean forward slightly. Keep your feet flat on the floor. Some people like to use a little footrest. Try not to tilt your head to the side, and remember to relax your neck and shoulders. This can be hard at the beginning—when I was first starting, I found I was continually holding my breath! It took some time for me to find the most comfortable, natural posture. A relaxed body position makes the act of writing much easier.

You should always keep a guard-sheet between your hand and the paper you are writing on. No matter how clean your hands are, the natural oils in your skin will transfer to your page if you don't protect it, so it's a good practice always to have a sheet under your writing hand. This can be a sheet of ordinary paper; it should be large enough to cover the entire surface below your writing line. Some people like to fix their guard sheet in position with tacks or masking tape. I prefer to let it lie under my writing hand; the weight of my hand holds the sheet in position, and I like the flexibility of not having it tacked down.

The pen is held with the thumb, index finger, and middle finger. The last two fingers are tucked in underneath. There are many small variations of this basic pen grip, but the fundamental principle remains the same—those three fingers guide the pen. If you tend to grasp your pen in a different way, you need to get used to this new way of holding the pen.

If you are right-handed, the paper you are writing on should be positioned parallel to the edges of the board. Tilting the page, which many of us were taught to do in school, is useful for informal handwriting, but not ideal for calligraphy. A page positioned straight-on allows you to see the pen angles most clearly, and judge whether all your upright strokes are parallel.

Left-handed calligraphers should tilt their paper as shown in the image at right. If you are used to doing the "hook"—writing with the hand above the writing line—you should try the "underhand" position. This will be uncomfortable at first, but it will eventually make the process of writing easier.

The truth is, calligraphy, like many other things in this world, was designed with right-handed people in mind. In the beginning, left-handers will find calligraphy to be a bit more difficult; it will feel awkward and unnatural. But a little perseverance will pay off. There are left-handed professional calligraphers, so left-handedness is no bar to becoming proficient and enjoying the act of writing. Although I am right-handed, I always demonstrate for left-handed students in my classes using both hands—once with my right hand to show how a letter should look, and then again with my left hand, to show how the movements are made.

TOOLS

Most of the tools and materials for calligraphy can be bought at art supply stores. You may find that, for certain items, such as nibs and penholders, a specialty online calligraphy store is a better source. The basic tools you will need to begin are listed on page 16.

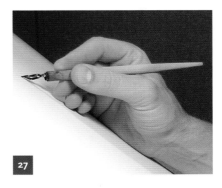

27. Note the position of the pen shaft relative to the writing surface.

28. Left-handed calligraphers should tilt their paper when writing. Note the position of the hand, which is under the line of writing.

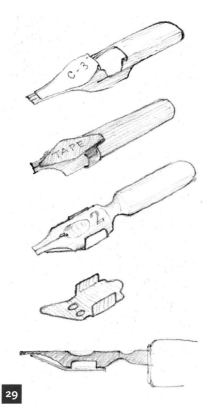

29. From top to bottom: Speedball, Tape, and Mitchell Round Hand nibs. Below the Mitchell nib, the reservoir is shown separately. The Speedball and Tape nibs have a built-in reservoir on top of the nib, while the Mitchell uses a separate reservoir, which slides on below. Make sure the reservoir is pushed back at least 1 millimeter from the end of the nib—it shouldn't interfere with the writing end. The side view of the Mitchell nib shows the position of the tongue. It should touch the bottom side of the nib.

30. From left to right: A square-cut nib, a right-oblique, and a left-oblique.

Tools for Writing
Metal nibs
- Reservoirs (if your nibs need them)
- Penholder
- Nonwaterproof black ink
- Inkpot
- Waterpot
- Rag
- Toothbrush
- Paper

Tools for Ruling
- 2H pencil
- Soft eraser
- Pencil sharpener
- Long metal ruler (24 inches is a good length)
- Masking tape
- Two large plastic triangles (30°-60°-90° and 45°-45°-90°)
- T-square
- A pair of dividers (recommended)

Tools for Cutting
- Self-healing cutting mat
- Sharp cutting knife

THE PEN
The word *pen* is derived from the Latin *penna*, meaning "feather." A quill from the flight wing of a goose or swan was the primary writing tool in the European tradition for almost two thousand years. The quill is a delight to write with. Good quills, however, are hard to find, require proper curing, and must be cut by hand.

Most calligraphers now use a metal pen with a nib dipped in ink (I will say a few words about fountain pens and felt tips in a moment). Using a dip pen gives you good control over your ink flow, and, later on, allows you to experiment with writing in color.

The nib needed for the scripts in this book will have a broad edge (sometimes called a chisel edge). It is this broad edge that creates the thick and thin strokes of the writing. There are many brands of broad-edged nibs. William Mitchell Round Hand, Brause, Tape, and the Speedball C-series nibs are popular. I find the first three best for regular writing; Speedballs, which give a less crisp, thin line, are best for very large, poster-sized work.

Pen nibs can either be square-cut or cut at an oblique angle. I prefer the square-cut William Mitchell Round Hand nibs, but many people find the right-oblique cuts of other brands useful (left-handers will want to buy left-oblique nibs). Once you have chosen a brand of nib, stick with it for a while; it's hard to switch back and forth between pens with differently cut edges.

The nib slides into the end of a penholder. These come in a great variety of shapes and sizes. I recommend a holder with a straight shaft that is round in section, meaning the penholder has a smooth, cylindrical shaft, and is not faceted (the shaft shown in the photograph is ideal). Penholders with a flange at the writing end or with faceted sides are not a good idea. The penholder may be plain wood, painted, lacquered, or plastic—it makes little difference. Some people find that the holders with a cork end are easier on the fingers.

The simplest penholders have a groove at one end; you just push your nib into the groove. Most penholders, however, have a barrel lined with a metal sheath. Inside, you will see a group of bent "teeth." The nib slides between the sheath and the teeth. Push it in as far as it will go; the teeth should hold the nib firmly in place against the sheath, without wobbling. If you find that the nib isn't going in, turn the shaft and try again in another

SOME NOTES *on the* TOOLS

METAL NIBS, RESERVOIRS, AND PEN-HOLDERS are discussed in detail in the next section.

NONWATERPROOF BLACK INK: Your ink must be *nonwaterproof*. Waterproof inks will quickly gum up your pen, and are (obviously) hard to wash off the nib when it becomes encrusted. Popular brands of fountain-pen ink are too thin, tend to bleed, and do not produce a solid black stroke. I primarily use bottled sumi ink from Japan, which goes down rich and black on the page. Sumi ink is now widely available in art supply stores. It may be a little thick; you can add a little water if it doesn't flow through the pen easily. Higgins Eternal is also a good ink for calligraphy.

INKPOT: If your ink comes in a small wide-mouthed container, you can do without the inkpot. But if your ink bottle has a small aperture, it is useful to have a pot to make dipping the pen easy. A shot glass works perfectly (bear in mind that once you have used a shot glass for ink, you should never thereafter use it as a drinking vessel). Whenever you leave your desk, it is a good idea to cover the inkpot to prevent evaporation. If, after a while, your ink is not flowing well, you may want to add a few drops of water; after a few days, ink in an inkpot will need to be replaced.

WATERPOT: Ink will begin to dry on your pen whenever you pause. It's helpful to have a small waterpot to rinse the pen. A clean jam jar is ideal. I rinse the pen whenever I get up from my desk. I also find that the pen begins to grow clogged with ink residue during a prolonged stint of writing; swishing the pen a few times in water and wiping it with a rag removes any buildup.

RAG: Keeping a rag or paper towel handy is a good idea. Not only can you wipe the pen from time to time, but you can mop up any inadvertent ink spills.

TOOTHBRUSH: When you get up from the writing table at the end of a writing session, you should wash off your pen under the tap. A toothbrush helps clean the pen properly.

PAPER: The best paper for calligraphy is fairly smooth and not too absorbent. A simple sign writer's bond paper, which is a smooth white paper available in pads at most art supply stores, is good for practice. For finished work, you will want to work on a fine art paper. Ingres papers are made by a number of manufacturers; these have a bit of texture and come in a wide variety of colors (if you're writing in black, it's best to stick with white or off-white papers). Hahnemühle, Nideggen, Frankfurt, Rives BFK, Arches Text Wove, and Canson Mi-Teintes are other good-quality papers popular with calligraphers. Before buying a large quantity of any paper, it is wise to try a sample first—not every paper that looks good works well, and individual preferences vary.

2H PENCIL: Art pencils (as opposed to the ordinary no. 2 pencils you find in stationery stores) come in varying degrees of hardness. A soft pencil will be labeled with a B and a number; the higher the number, the softer the pencil. Soft pencils give you a dark (and very easily smudged) line. Hard pencils are labeled with an H and a number; the higher the number, the harder the pencil. Hard pencils give you a light line, which doesn't smudge. 2H pencils are the most useful for ruling up.

SOFT ERASER: Kneaded rubber erasers are the best, in my mind. Like putty, they are malleable; when the eraser becomes smudged with pencil residue, just pull it, fold it over, and roll it back into a ball. Kneaded erasers can also be pinched at one end if you need to erase a small area.

The **PENCIL SHARPENER** is self-explanatory.

LONG METAL RULER: It is best to have one about 24 inches long.

MASKING TAPE is handy to tack your page in position while you work.

TWO LARGE PLASTIC TRIANGLES: Triangles help you judge pen angles and are also used for ruling upright lines. You should have a 30°-60°-90° triangle and a 45°-45°-90° triangle.

T-SQUARE: This is the most useful tool for ruling up. It should be about as wide as your drawing board, so a T-square 24 inches long is a good size. The metal ones are usually the best, although plastic ones work as well. The small, foot-long versions sold in stationery stores are cheap and useless; you need to buy a good T-square in an art supply store.

A pair of **DIVIDERS** is an optional extra. I find them invaluable for ruling up. Fixed-point dividers are best, although a drafts-man's compass with changeable points can also be used, providing it comes with two metal points. (A picture of the dividers appears in figure 46 on page 24.)

A SELF-HEALING CUTTING MAT is an excellent surface for trimming paper.

SHARP CUTTING KNIFE: An X-acto knife or scalpel is used to cut paper to size. These are dangerous, and should be used and stored carefully.

31. A wooden pen with a metal nib.

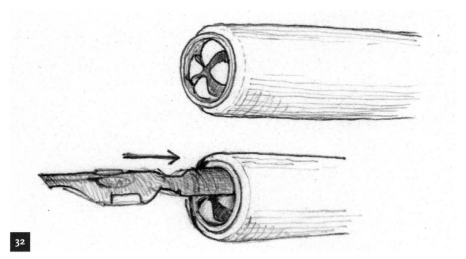

32. Inserting the nib.

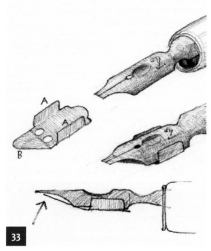

33. Attaching the reservoir.

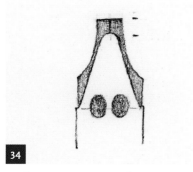

34. Proper positioning of reservoir and writing tip.

spot. Sometimes it takes a little fiddling to get the nib firmly in position. Look carefully at figure 32 to see how the nib is inserted. A common mistake is to insert the nib into the middle of the space, where it floats unsupported. The teeth are there to hold the nib against the metal sheath.

New nibs sometimes have a residue of oil on them; passing them through a flame for a moment will burn this away. (Be careful: The nib will be hot after you do this. You can plunge it into water to cool it down.)

The reservoir holds a little puddle of ink against the nib. This allows you to dip the pen less frequently and helps with ink flow. I recommend using reservoirs, although some people prefer not to. If you are using a reservoir, there are a few things to note. On Brause, Tape, and Speedball nibs, the reservoir comes already attached to the top of the nib. The reservoir can shift in position, so make sure this hasn't slid down and is not touching the writing edge of the tool. If it has, gently push it back. It should be a millimeter or two away from the writing edge.

William Mitchell Round Hand nibs have a separate reservoir that slides onto the bottom of the nib. It can be a little tricky to attach. The Mitchell reservoir is nothing more

than an inexpensive (and not very well machined) piece of metal; you should feel free to bend it so that it fits properly. It has two "ears" (marked A in figure 33) and a "tongue" (marked B). The ears hold the reservoir in place, hugging the sides of the nib. These should not grip the nib so tightly that they put pressure on the nib and distort its shape. You can pull the ears out to loosen them; push them in to tighten them. After sliding the reservoir onto the nib, check the grip by holding the nib over a sheet of white paper and checking the slit: Do you see space? If so, the reservoir is gripping too tightly. Look at the tip: Are the two halves of the writing edge still straight, or do they form a convex shape? If they make a convex shape, the reservoir is too tight.

The tongue of the reservoir should gently touch the underside of the nib. I like to say, "Make sure the tongue touches the roof of the mouth." As with the other reservoirs, make sure that the reservoir is about 1 or 2 millimeters away from the writing tip (see figure 34). You don't want the reservoir to touch the page as you write.

Your pen is now ready to write.

Caring for Your Pen

Metal nibs are inexpensive and easily replaced. Nonetheless, you should take good care of the nib you are using. A small rag and a pot of water should be kept handy at your writing desk. When you find the nib becoming clogged with ink or paint residue, dip it into your waterpot to loosen the accumulated gunk and wipe it gently with your rag. If the buildup is stubborn, you might want to remove the reservoir to wipe the nib more thoroughly. At the end of a writing session, take the pen to a sink and use an old toothbrush to scrub off any residue. Dry the pen off carefully before storing it in a dry place.

35

OTHER WRITING TOOLS

Many of the samples in this book have been written with double pencils—two ordinary pencils wrapped together with masking tape. Double pencils are not used for formal writing, but they are very useful for analyzing a script. The two points act just like an edged pen. You may want to try them as you work through the scripts in the following chapters.

A Note about Fountain Pens and Felt-Tips

These tools may also be used for calligraphy. Both are handy and portable; I find them most useful for casual or spontaneous work. I sometimes use a felt-tip when working on something that will be reproduced, where I can touch up the marks later on. In general, however, the dip pen is the standard tool. It lets you work with the best, most durable inks and colors, comes in many sizes, and encourages a craftsperson's approach to writing. Fountain pen inks are thin (especially colored inks) and usually fugitive (that is, they fade in light). Felt-tips are informal tools, and are rarely crisp enough for finished writing.

RULING UP: THE ESSENTIALS

Many teachers hand out pre-ruled guidesheets. This saves time and gets students writing quickly, but I am a strong advocate of ruling your own lines. I find that when students use prelined sheets, they rarely understand why the lines have been ruled at a particular interval and they have difficulty changing pen size. Prelined sheets, which begin as a convenience, become a trap.

Ruling up may seem like a chore, but it gives you control over your work

and increases your understanding of the structure of your writing. With a little practice, it becomes second nature. I enjoy the quiet time spent ruling my paper as I anticipate the writing I am about to do. (Those who use Chinese ink sticks to grind their ink on an inkstone say similar things about using that time as a preparation for the act of writing.)

The aim of ruling up is to make a set of pencil guidelines for your writing. This is a two-step process: measuring the intervals and ruling the lines. Figure 36 shows the final result: equally spaced parallel lines marching down the page. Note that a penciled x marks the baseline and x-height of the lines of writing (of which I will say much more in the next chapter). The line intervals have been made with prick marks, rather than pencil marks, in this detail.

WRITING

If you are using an inkpot, fill it about half an inch deep with ink. Dip the pen into the ink up to the top of the reservoir, so it fills with a generous supply. Be careful not to dip the pen right up to the end of the penholder—you'll get ink all over your fingers.

Once you have dipped the pen, touch its underside to the edge of the inkpot. I refer to this as "bleeding" the pen. Excess ink will run off the side of the inkpot.

Controlling the amount of ink in your pen is an acquired skill, which eventually becomes second nature. Blobby, wet marks are a sign that there's too much ink in your pen. Some people like to have a little scratch sheet (a sheet of scrap paper) attached to the top of their writing board to test their ink flow before writing.

35. Double pencils for practice exercises.

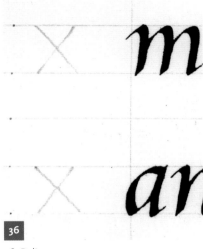

36

36. Ruling up.

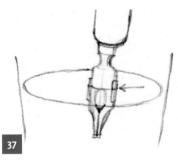

37

37. When dipping your pen into the ink, watch the level of ink filling the reservoir.

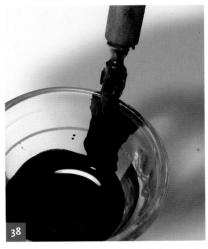

38

38. Removing excess ink, or "bleeding" the pen.

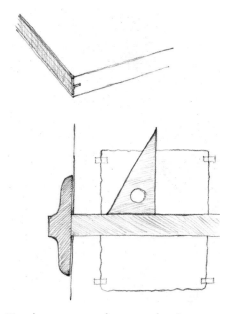

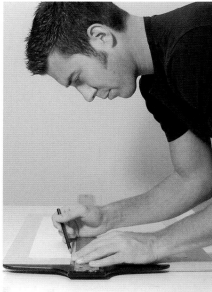

To rule up a page, place your drawing board flat on the table. If your board has metal edges, these should be to the right and left (not the top and bottom). Position your page on the board, using the T-square to align the paper and then tape it down.

When ruling up, it's best to work on a flat table. You should stand over your work so that your eye is directly above it (if you look at the ruling up from a slanted angle, as when sitting, it's hard to see exactly where your pencil is). Precision counts, so be careful—you want your ruling to be as accurate as possible.

Now place the ruler vertically on the far left side of the page and begin marking off equal intervals with a pencil. The marks in the margin of this page are made at 3/8-inch intervals, which is probably a good starting point. (If you wish to use metric measurements, measure out 1-centimeter intervals.)

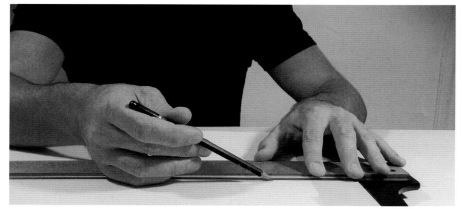

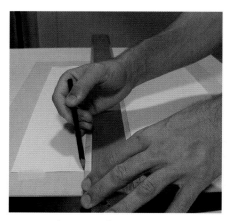

Once you have marked these intervals down the left side of the page, you are ready to begin ruling lines. For this, you need the T-square, which has two components. The long part is the straightedge that you use for ruling; the top of the T fits snugly against the side of the drawing board and keeps your lines parallel. The top of the T is thicker than the straightedge, since it's meant to hook over the edge of your board.

The left-hand side of the drawing board will be your one "true edge"—everything will be aligned with that. As seen above, the T-square is set against this edge, and you slide it up and down with your left hand. As long as you make sure the top of the T is snug to the side of board, all your lines should come out parallel.

Begin at the top and, using the intervals you have marked, draw lines across the page.

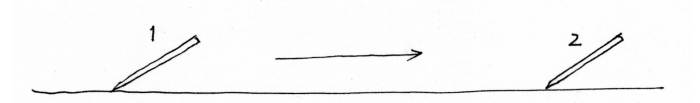

When ruling up, it's important for you to hold the pencil correctly. Hold it lightly at the far end. Do not use too much pressure; the lines should not be dark. The pencil stays in the same position relative to the writing surface as you draw it along the straight edge of the T-square. It begins at 1 and ends at 2. Using your whole arm, simply drag your hand and the pencil across the page. This drawing is made from the perspective of the person doing the ruling up (unlike the photographs, where we are observing from the other side of the table).

Your ruled lines should go directly through the intervals you marked. Try to avoid near misses. Take into account the width of the pencil lead—you may want to position your T-square just a hair below the interval marks.

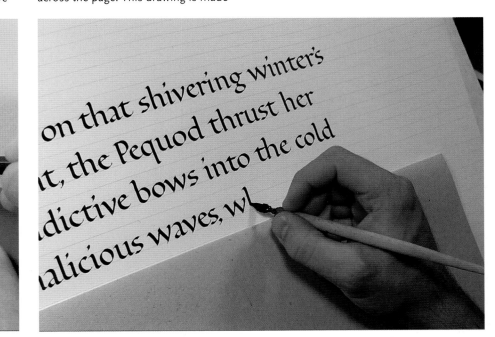

When you rule up a page with lines 3/8 inch apart, you are ready to try your hand at writing. Notice that a guardsheet protects the page of writing in the image above.

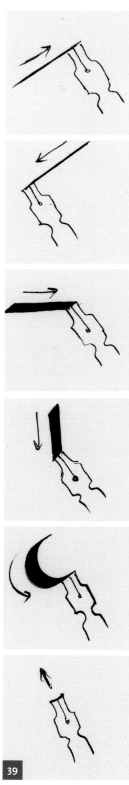

In general, the edged pen likes to move in certain ways, while it balks at others. It's happy moving along its edge, to the right or to the left, leaving a thin line of ink. It also likes making horizontal and vertical marks with some weight to them. It's happy being drawn around a curve—but notice the direction of the first stroke in figure 39, which is pulled toward you. What the pen *doesn't* like is to be pushed, as in the image at the bottom of the figure. There are a few pushed strokes in calligraphy, but, on the whole, these are to be avoided.

The pen will make thick or thin strokes based on the direction in which you move it. Try making the zigzags you see in figure 40. Lift your pen as often as you need to—there is no virtue in keeping your pen glued to the page. In fact, you should probably make no more than one zigzag in a single stroke. Before the next zig, lift your pen and put it down again in the same spot.

PEN ANGLE

What do I mean by *pen angle*? This term refers to the angle of the writing edge of the pen relative to the baseline. (It does not refer to the angle of the pen shaft to the paper.)

For most calligraphic scripts, the pen is held at a fairly constant pen angle. The Foundational Hand, for example,

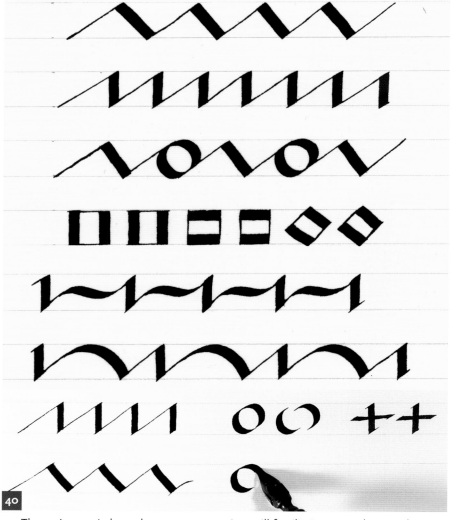

39. The top five strokes shown here are the easiest strokes to make with an edged pen. The bottom stroke, a pushed, stroke, is more difficult, and is generally avoided.

40. These zigzag, circle, and square pen exercises will familiarize you with using the edged pen.

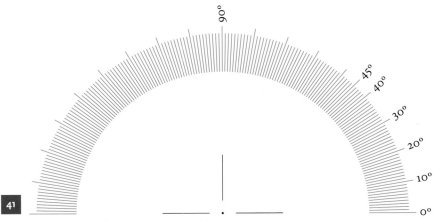

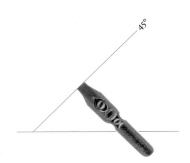

41. A protractor is helpful for measuring angles.

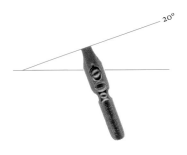

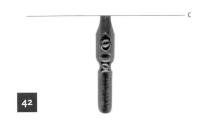

which we will examine in the next chapter, is written at a 30° pen angle. Other hands are written at a 45°, 20°, or even 0° angle. The higher we move up this scale, the steeper the angle is said to be; the lower we move down, the flatter the angle is said to be. So 45° is considered a steep angle, while a 20° angle is considered fairly flat.

The three scripts below demonstrate different pen angles. Notice that by changing the pen angle, the thick and thin strokes come at a different place in each script. In the Semi-Uncial, the thins are right at the top of the letters. The Foundational is written at a steeper angle, and you can see that the thins have rotated to one side. In the Italic, written at yet a steeper angle, the thins have moved further down toward the side of the letters. The standard pen angle for each script plays an important role in giving the script its character. Achieving a consistent pen angle is a basic skill that takes some time to develop (see figures 43–45).

Human beings are not machines, of course, so pen angles do vary slightly. In fact, little variations of a few degrees are usually needed to make a script "sing." The important thing to remember is that a pen angle is a benchmark, a point of reference.

You may want to make a pen-angle checker such as the one in figure 47, which has a 30° angle:

Taking a piece of paper, marking a baseline, and cutting out a little triangular window creates an absolute measure to see if your pen angles are close to the mark. The bottom of the triangle represents the baseline; the diagonal represents the pen angle. To use it, place the baseline of the checker against the baseline of your writing. As you draw it along, you can see whether the end of each stroke is at the correct angle; they should align perfectly to the 30° line of the checker.

RULING BASED ON A PEN LADDER

To rule pages for writing, it is best to use a pen ladder to determine how far apart your lines should be. Each script is written a certain number of nib-widths high. The Foundational Hand in the next chapter, for example, is written at $3\frac{1}{2}$ nib-widths; the Italic in chapter 4 is written at 5 nib-widths. These proportions refer to the x-height of the minuscule letters.

To make a pen ladder, turn the pen to a 90° angle. Make a series of steps, as shown below. They should be crisp,

42. Nibs at various pen angles. For most scripts, you try to keep the pen at the same angle throughout your writing.

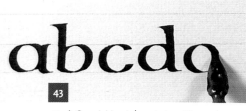

43. A Semi-Uncial script written at a shallow 5° angle.

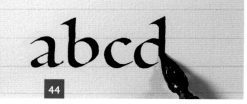

44. The Foundational Hand written at a 30° angle.

45. The Italic written at a 40° angle.

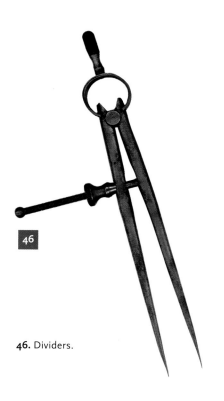

46. Dividers.

clean, and *just touching one another.* Remember that what we're measuring is how many nib-widths fit in an interval. Make as many steps on your ladder as needed for the proportion of the script you are writing. It's helpful to then take a pencil and mark the top and bottom. Measure this, and you have your interval for ruling up.

Now you have a few choices. You can measure the pen ladder with a ruler and use the measurement to mark the intervals down your page. This is a very accurate way of making the marks. Don't move the ruler each time you make a mark; you will need to count off the intervals, which means keeping careful track of what you're doing.

Or you can make a paper scale instead. Having established your desired interval—3 1/2, 4, or 5 nib-widths, for instance—place the scale next to your pen ladder and mark off a sequence of equidistant dashes. Mark off the first interval, slide the paper scale up, aligning it to the bottom of your previous dash, mark off the next interval, and so on. You are making your own custom ruler based on the nib-width interval you've created. The benefit of using a paper scale is that you can simply tape it to the left side of the drawing board; there's no need to transfer the marks to the sheet you plan to rule up. Just put that sheet down next to the paper scale, and rule as usual. This makes ruling multiple sheets very easy.

My favorite method, however, is to use dividers. This is an ancient tool, and a very effective one.

It is important that your dividers have a screw control, as the dividers shown here do. This keeps the two legs an exact distance apart. Dividers with loose legs will not hold their position accurately.

Measure the pen ladder with the dividers. Be sure to use the screw control to adjust the width. You then place your dividers onto the sheet you want to rule and prick little holes to mark your intervals. The beauty of the dividers is that you can do this by simply walking the dividers down the page, making sure you give a little push each time you want to make a mark on the sheet. Do this on top of your self-healing cutting mat, rather than on your drawing board, to avoid making little dents in your board and ruining it. If you have trouble walking the dividers in a straight line, you can rule a straight line to follow.

The one downside to this method is that the little holes you make are permanent. I personally do not think this is bad, but in commercial work, clients won't be pleased to see a line of little holes. Telling them that the best medieval manuscripts were ruled up in this way won't help. So if the holes are bothersome, you have two options: You can trim them off later (since they will be on the far left-hand side of the page, this shouldn't be a problem to do) or you can use one of the other methods for ticking off your intervals.

I find, however, that pricking my intervals with a divider speeds and simplifies the process of ruling enormously. I also think leaving the signs of our creation process makes the work more interesting.

DO YOU WANT YOUR WORK TO LAST?

From the beginning of your practice, you should be aware that some materials will create work that lasts, while other materials will fade or change color. This applies especially to the inks and colors that you choose, as well as to the papers on which you write.

The enemies of a work of calligraphy are light and time. Many inks, watercolors, and gouaches are *fugitive*—that is, if they are exposed to

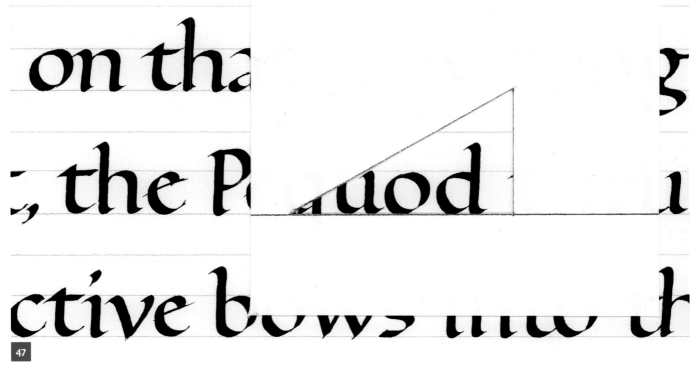

47

47. Using an angle checker to evaluate your stroke angles.

light, they fade. Colored papers may also lose their vibrancy if exposed to light over a long period. Many papers, especially those containing wood pulp, are chemically unstable and become yellow and brittle over time. A child's drawing hung on the refrigerator undergoes this process; within a month or two, the bright colors of the construction paper begin to fade.

Sometimes there is no need to worry about this. Many handmade greeting cards, for instance, are ephemeral. They are unlikely to be framed and hung in a bright room. If, over time, they change color or become too delicate to handle, there is no great loss. A work made for reproduction might also be made with fugitive colors; once it has been photographed and printed, the original becomes less important. If it fades or decays, there is no real loss because the printed piece remains.

On the other hand, there is nothing more disheartening than putting hours of effort into a piece of work, spending good money to frame it,

48

48. Making a pen ladder to ensure proper spacing for ruling up.

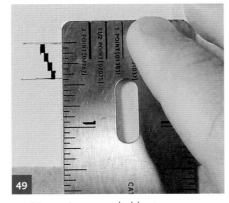

49

49. Measuring a pen ladder to ensure proper spacing for ruling up.

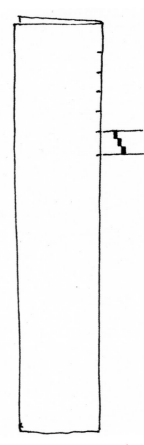

50

50. You can create your custom ruler using your pen ladder.

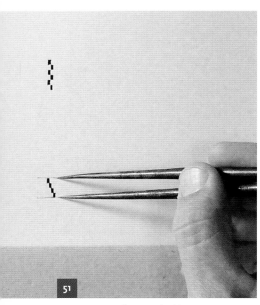

51. Measure the pen ladder using your dividers.

and then discovering after only a few years that its colors have become faded and the paper has turned yellow at the edges.

If you want your work to last, you should only use what are called *archival* materials. These are inks, colors, and papers that are stable and can stand up to exposure to light. Look for inks marked "permanent" on the packaging (Japanese sumi ink is usually quite permanent, although the package may not say so). For watercolor or gouache, look for a permanency rating. Each manufacturer has its own system for rating its colors; use only those tubes that have the highest rating. Good artists' papers are usually safe to use. When in doubt, ask your paper merchant whether the paper is archival.

If you use any kind of adhesive, in mounting a piece to a backboard, for example, avoid using spray adhesives. These are highly acidic and will discolor the work over the course of several years. Their grip will also loosen over time.

When framing your work, make sure that the framer uses archival materials as well. It's worth spending a little extra money on archival mat boards and mounting boards, and making sure that the piece isn't attached to its backing with an acidic adhesive (or worse, with masking tape or scotch tape!).

When storing your work, or when storing your supply of paper, be careful that cheap, acidic papers are not mixed in with anything you are trying to preserve. Newsprint and brown wrapping paper will eventually discolor anything they come into contact with for an extended period of time.

You can also test the lightfastness (the degree to which a substance resists fading due to light exposure) of papers, inks, and colors on your own. If you want to use colored paper, but aren't sure whether it is lightfast, do this: Cut out a little piece of paper about 6 square inches. Mask off the bottom half with a sheet of sturdy paper, so that half the paper is exposed to light, while the other half is shielded from the light. Hang the sample in a bright window. After six months, take it out of the window and pull off the mask: If the colors of the two halves are different, you know the color is not lightfast. Similarly, you can paint several thick, long lines of ink or color onto a sheet of white paper, mask off the bottom half of the lines, and do the same test. You will quickly see which colors can stand up to light exposure.

This may all sound rather complicated. The important thing is to be aware that some materials last while others do not. Early on in my own practice, I was extremely careful to use only the best archival materials. Over the years, I have relaxed my stance somewhat on this point. Use common sense. There are many projects that do not require a high level of permanence. But some things are intended to last. If this is the case, be careful about the materials you use.

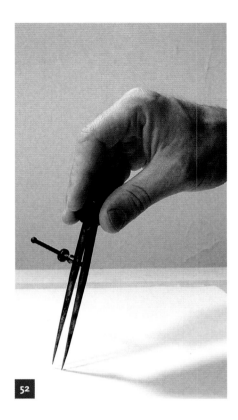

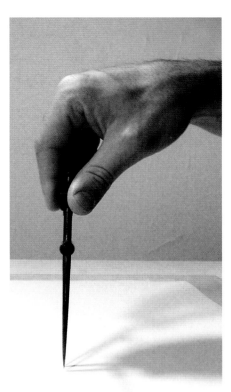

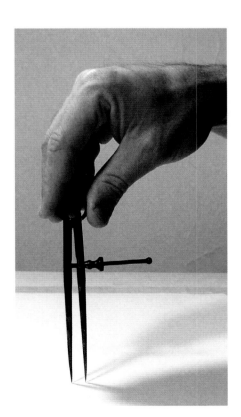

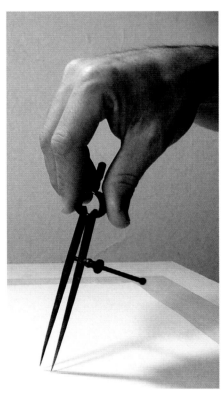

52. Walk your dividers down your page to properly space your ruling-up intervals.

The streets a

aybe because

liday weeken

it the tulips

y yesterday-

ulted. I suspe

t frozen. Tulips

droopy,

The *Foundational Hand*

2

The Foundational Hand is exactly what its name implies—a basic script that's helpful for learning the fundamentals of using an edged pen. It was devised both as a teaching tool and as a practical hand by Edward Johnston.

Johnston based the Foundational Hand on a medieval prototype—the script of the Ramsey Psalter, which is also sometimes referred to by its British Library shelf number, Harley 2904. This book, containing the Psalms, was made in southern England in the late tenth century. It has a remarkably simple and legible script; the letters are full, round, and logically built.

The actual manuscript is fluidly written by an expert scribe. It was made as a practical, working book, not as an exemplar.* There are many small inconsistencies in the script, and quite a few archaic features. The **a** leans backwards and is somewhat unresolved in form; the **g** is more free-form than the rest of the script. The scribe uses the historic, tall **s** (shaped like an **f**) and, of course, as a Latin manuscript, it is missing certain letters used in modern English, for example **w** and **j**.

These peculiarities did not interfere with Johnston's principal aim. He was not trying to make a facsimile of the script, or even anything remotely medieval. Instead, he wanted to discern the method of the scribe, to use the Ramsey Psalter as a basis for developing his own new script. He looked at the basic characteristics of the hand—the round **o**, the clean arches of the **n** and **m**, and the overall texture of the writing. From these he extrapolated a new script: the Foundational Hand.

Since Johnston's day, his students and followers have continued to develop the script. The version I offer here is not entirely identical to the version I was taught.

An exemplar is a carefully prepared sample of a script made for students to copy. An exemplar is stripped of inconsistencies and personal quirks; its purpose is to provide a near-perfect prototype of the script in question.

53. The Foundational Hand is a useful script for learning the basics of using an edged pen.

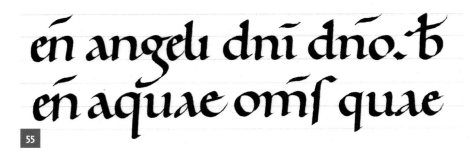

54. This study of the Ramsey Psalter was made by enlarging a reproduction, cutting a felt-tip pen to match the original pen-width, and tracing the image.

WRITING MINUSCULES

Why are we starting with small letters rather than capitals? The reason is simple. The small letters, as I mention in the Introduction, are products of several centuries of development guided by the edged pen. The capitals, by contrast, are more difficult to make with a broad-edged pen because the original forms of the Roman Capitals were made with a more flexible chisel-edged brush. So to begin mastering the edged pen, it's best to use the minuscule letterforms that evolved along with it. We will come to capitals in the next chapter, once we've established a grounding in good practice.

Within each family of related letters, the same (or similar) strokes are used in various configurations. The only exception to this principle is the **k–s–g** group; these letters are the odd men out of the alphabet, each with its own peculiarities.

The basic features of the script are simple. The pen is held at a fairly constant 30° angle, with a few exceptions at the end of the alphabet. The x-height is 3 1/2 nib-widths high. The script has a strongly circular geometric underpinning, starting with the round **o** and carried through the generous arches of **n**, **m**, and their related letters.

The following directions are very detailed and highly directive. I'm aware that people have different learning styles. Some may want to work directly from the diagrams and judge by eye whether their lettering matches the samples; others will want to follow the instructions step-by-step. If you are a more visual learner, the diagrams will probably be sufficient and you will only need to consult the instructions when you run into difficulties. If you are a more verbal learner, you'll probably want to read the instructions first. I encourage you to take the approach that is best for you.

The following examples are made with double pencils, to show most clearly how the letters are constructed. The double-pencil diagrams are accompanied by pen-written words using the letters that have been introduced up to that point.

WRITING THE FOUNDATIONAL HAND

To begin, you will need to choose a nib and rule up several sheets of paper according to the instructions that follow. The alphabet charts in figures 56 and 57 show how the ruling will look and how your letters will sit on the ruled lines. They are reproduced at actual size.

55. This freehand interpretation of the Ramsey Psalter was made with a dip pen. The crisper edges of this tool give a much more precise rendering of the character of the script than the felt-tip does. I have left off the marginal capitals, since these were made with a pen of a different width and are not relevant to the study of the minuscule script.

abcdefghijk
lmnopqrstu
vwxyz

56

56. The Foundational Hand minuscules are shown here in alphabetical order, which seems logical enough. For the scribe, however, it is better to consider the letters grouped by related forms.

ii nmulhtra
oce bdpq fj
ksg vwy xz

57

57. For the scribe, however, it is better to consider the letters grouped by related form: By examining the letters in this order, it is easier to see the links between the individual letters.

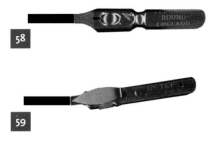

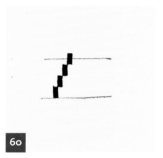

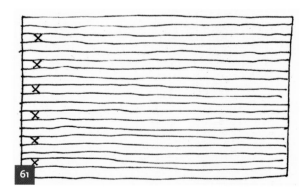

58. Here is a Mitchell Roundhand number 1 1/2 nib shown at actual size. The writing edge of your nib should be about this width.

59. Note that an oblique-cut nib, like the Brause shown here, needs to be held at an angle to judge the width. The width that counts is the flat edge that makes contact with the page

60. A pen scale written with a William Mitchell Roundhand nib (size: 1 1/2) showing a 3 1/2 nib-width interval.

I wrote the samples with a Mitchell Roundhand number 1 1/2 nib, which has an edge about 2.5 millimeters wide. This is a good size for a beginner—it is large enough so you can see how the letters are constructed, but small enough so that your writing is made with small movements of the hand. At this size, you can master the basic strokes and letter construction; the transition to smaller writing will then come naturally. Larger writing (for poster-sized projects, for example) requires moving your whole arm, and can feel more like drawing than writing.

Choose a nib similar in size to the one used in the alphabet charts. Your paper should be fairly large—at least 11 x 17 inches. Make sure the paper is horizontal, so that you have nice long lines on which to write. To determine how wide apart your ruled lines should be, make a pen scale and measure 3 1/2 nib-widths. Rule up several sheets with parallel lines this distance apart.

Using a pencil, mark every interval between the lines with an *x*, as in the alphabet charts on page 31. This *x* marks the baseline and x-height of your lines of writing. As you begin to write, make sure your letters are placed correctly on the baselines, which are indicated in all the images I show in this chapter. Don't give in to the temptation to write on every other line to save paper—this is false thrift. The white space is as important as the marks themselves, and it's hard to judge the quality of your writing if the lines are all jammed together. It's also good to get in the habit of seeing the set of ruled baselines as a fixed point of reference—a perfectly regular interval that gives structure to your lines of writing.

As you work your way through this alphabet, it's good to begin writing whole words as soon as you can. So after trying each letter a few times on its own, try it in combination with some of the other letters you've learned (this gets easier as you get further into the alphabet and have more letters at your fingertips). By writing actual words, you can begin to feel the relationships between the letters. Eventually, you start to sense the rhythm of the script and how it relies on the steady repetition of similar movements. The words I have written in my examples are just suggestions—feel free to come up with your own.

61. This little sketch shows how a ruled page should look. The whole page is ruled with parallel lines, made 3 1/2 nib-widths apart. A small *x* in pencil is marked on every third set of lines. These indicate which lines are to serve as baselines and x-height lines.

62. The Foundational Hand is written with a relatively small number of basic strokes. These are, from left to right: the upright stroke, the two circular strokes (top and bottom), the serif stroke, the ascender stroke, the arched stroke, the tusk-shaped stroke (top and bottom), the reversed arch stroke, the diagonal-to-the-left and diagonal-to-the-right strokes, and the horizontal stroke. I will describe these in more detail as we go through our alphabet. Most of the strokes (with the exception of one of the diagonals) are made using a 30° angle.

63. Text written correctly on the ruled lines. The penciled *x* indicates the baseline and x-height line for each line of writing. Small letters like **a**, **e**, or **x** sit between these ruled lines, while ascenders and descenders extend into the spaces above and below.

64. This is an example of what not to do: The lines of writing in this image are too close together. Don't jam the lines of writing together. The sample on the top is simply illegible. In the sample on the bottom, the ascenders and descenders collide.

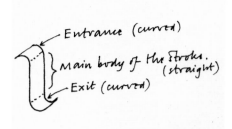

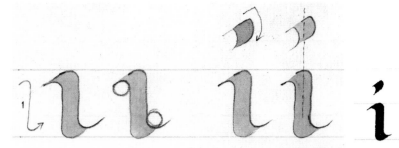

The **i** is a straight stroke that begins and ends with a small curve. These curves give you a clean entrance to and exit from the stroke. Your pen enters the stroke along the edge of the pen, which is held at a 30° angle, and leaves by pulling out along the edge. The curves also add a little weight to the top and bottom of the stroke, which helps establish the rhythm of the Foundational Hand.

The pen is placed just below the x-height line, moves up and around the curve, then comes straight down. Just before you hit the baseline, you begin to curve around again, pulling the pen off along its thin edge. Note the small circles in the second: above it's helpful to picture these circles as your pen travels around the entrance and exit. Be careful to make a definite distinction between the curves and the straight body of the stroke. Most of the stroke should be perfectly straight and upright; the curves are quite small.

The dot is made by sliding the pen up-wards along its edge, and then curving gently down (note the directional mark indicated in pencil). The center of gravity of the dot should align with the center of the downstroke below (because the dot is not symmetrical, its placement has to be judged by eye; it can't be measured precisely). The dot should be placed midway between the x-height line and the next ruled line above.

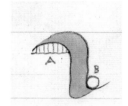

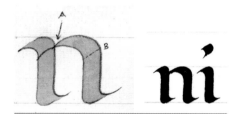

The **n** is made in two strokes. The first stroke is identical to the main body of the **i**. The second stroke is an arched stroke.

The arched stroke is similar to the basic downstroke, except it has a much fuller and wider curve at the top. Note that the arch—the large curve at the top—has a symmetrical underbelly, marked A above. At the exit, marked B, it has the same small curve as the downstroke. The arched stroke is made by placing the pen inside the body of the downstroke right at the transition point where the entrance curve begins to straighten out. It is then drawn up and over in a broad curve; when it reaches the point marked B, the stroke is drawn straight down, and is pulled out at the bottom, just like the downstroke.

Looking at the above character, note that the place where the arch touches the downstroke is a perfect thin point. If you look at the arch itself, you'll notice that it gets wider as it moves to the right. (If your arches have a thin point somewhere else, check your pen angle; it may be too flat or too steep.) You should also see a little triangle of white space, marked A in the diagram, at the juncture between downstroke and arch.

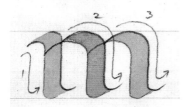

The **m** builds on the structure of the **n**. It is made in three strokes: a downstroke and two identical arched strokes. The **m** should be twice the width of the **n**; avoid the temptation to squeeze it tighter. It should be a nice wide letter.

With the **m**, you can begin to see the rhythm of the script emerging. Make sure that the arches have a symmetrical feel; it should look like an arcade of arches marching across the page.

You may also notice that in the pen-written word above I have made the exit curves under the arches a little less generous than the final exit at the end of the letter. This is a small detail that opens up the internal space of the letter.

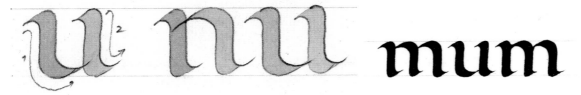

The **u** is literally an upside-down **n**. It begins with an inverted arch stroke, which will feel peculiar at first.

The best test of whether you are getting it right is to write an **n** and a **u** together and turn them 180°. They should look the same from either direction.

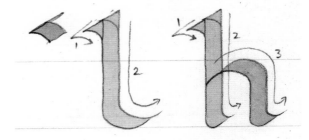

With the **l** and the **h**, we come to our first ascenders. All the ascenders should be the same height. You'll notice above that we haven't drawn an ascender line—the ascenders here go up about two-thirds of the way to the next ruled line, and you have to judge this by eye. I've done this for two reasons. First, I wanted to keep the ruling up as simple as possible. If we'd marked ascender (and descender) lines, we would have had to rule lines at different distances apart, because the ascenders are not as tall as a full additional x-height. Second, I want you to begin learning to judge spaces by eye, rather than always having a firm ruled line for every part of every letter. This is good

practice. Experienced scribes generally need nothing more than a baseline to make even, uniform writing.

The ascenders begin at the top with a little serif stroke. Place the pen about two-thirds of the way up from the x-height and draw it along its edge. As soon as you've made a thin line that is the exact width of the writing edge of the pen, make a sharp corner and draw the pen back to the right. As you'll also notice, this second half of the stroke has the same curvature as the entrance on the downstroke. Note that the two parts of the serif stroke align vertically on the right-hand side.

For the second stroke, place your pen back in the same place where you began your serif stroke. Draw it straight down. Your second stroke overlaps part of the serif stroke, creating a strong, built-up top for the ascender.

The second stroke of the **l** ends, like the **u**, with an inverted arch. With its broad base, the Foundational Hand **i** carries a distant memory of the Roman Capital **L**, of which it is a descendant.

The second stroke of the **h** ends, like the **i**, with a small exit curve. The third stroke of the **h** is an arched stroke, like the **n** or **m**.

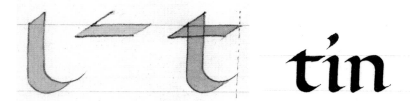

The **t** is an odd duck; although it breaks above the x-height, it is not as tall as the other ascenders. It is made in two strokes. The first is like the inverted arch, but it does not begin with a curved entrance. Instead, you place your nib at the usual 30° angle right above the x-height line. The bottom edge of the nib should be touching the line. Draw it straight down, and end with an inverted arch. The second stroke begins at the same place, but now the pen is drawn along its edge until it is right below the x-height line. You then draw it straight across to the right.

The little triangle at the top of the **t** is unique to that letter. Note that the two strokes overlap perfectly (it should not end up looking like the numeral **4** with an open space within the triangle). The horizontal bar should align with the end of the inverted arch, as shown here. It extends much farther to the right than it does to the left.

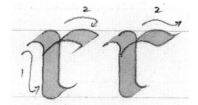

urn

The construction of the **r** is much like that of the **n**. It begins with a downstroke. The second stroke begins just like an arch, with the same curvature, then stops. You may pull off either down or up. If you choose to pull upwards, make sure to maintain the character of the arch—the pull-off shouldn't be large, just a tiny upwards tick.

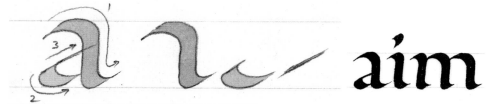

The **a** begins with an arched stroke, just like the second stroke of an **n**. The second stroke, which creates the bottom of the small bowl* of the letter, is made with a segment of an arch. It is the inverse of the second stroke of an **r**, but with a slightly more generous curve at its beginning. The final stroke is a straight diagonal, which should strike the back of the letter at about its midpoint. This third stroke begins right on top of the second stroke; the two should overlap. It ends when it disappears into the back of the letter. I like this diagonal to have a little weight, so although the pen is kept at the usual 30° angle, the stroke itself is made at an angle of about 28°. In other words, instead of sliding the pen directly along its edge, which would give you a perfectly thin line, you pull it along a slightly flatter trajectory, creating a slightly thicker line.

*A bowl is a component of a letter shaped as an enclosed loop.

The **o**, **c**, and **e** are closely related. Let's begin with the **o**, which is made in two strokes. If we look at a finished **o**, we see that its underlying structure is a pair of perfect, overlapping circles. The right side of the nib creates one circle; the left side of the nib creates the other. The double-pencil diagram shows this clearly: If you look closely at the image in above, you will see two perfect circles written in pencil, which overlap.

The **o** is written with two strokes which are semicircular arcs. Each arc is a simple crescent moon, beginning and ending with a thin point. These two crescents should overlap slightly; this makes the joins smoother and keeps the whole letter from becoming too oblong. Looking at the character on right, note that the first stroke of the **o** starts *below* the x-height line, not right on it.

In making a circular **o**, I have often found it useful to think of the image of a desk globe. If you imagine a tilted globe, north and south are at an angle. These axes correspond to the thin parts of the **o**. The equator is tilted at a 90° angle to the poles; this is where the two fattest parts of the **o** should be.

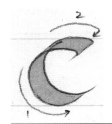

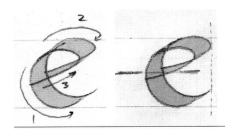

The first stroke of the **c** is identical to the first stroke of the **o**. The top is a slightly flattened curve, pulling to the left at the exit. This is the tusk-shaped stroke. Not quite straight, but only gently curved, the

tusk-shaped stroke is a little flatter in profile than the similar strokes on the **a** and **r**. Like the tusk of an elephant or walrus, it has a very gradual curve.

Using this slightly flattened stroke opens the mouth of the **c**. The two strokes of **c** should align at the right, as shown in the third figure above.

The **e** is constructed in a similar manner. The first stroke is like the first stroke of the **o**. The top, like the tail of the **r**, follows the arc of an arch, and pulls off down and to the left. The third stroke starts at the middle of the letter (or higher, but never

lower), and meets the in-turned end of the second stroke. Like the thin stroke of the **a**, this stroke should have a little weight; like the **c**, the right-hand edge of the **e** should align vertically, as shown above.

Each of the letters in this group combines a round bowl with a long straight stroke. The round bowl is related to the **o**. Above, where the letters are written on top of one another, you can see that the verticals shave off a little bit of the o-shaped bowl. Note that each of these letters has its own small peculiarities; the way the bowls and uprights join is a little different in each instance.

The **b** has an ascender, constructed in the same way as the **l** or the **h**. When the second stroke reaches the point where it turns into the inverted arch shape, it is nice to give it a slightly sharp corner. The third stroke is like the right half of an **o**.

The **p** begins with the same entrance as a standard upright stroke, like an **i**. The bottom of this first stroke ends, however, with what I refer to as the "emphatic terminal"—a simple lift without any exit curve. When you reach this part of the stroke, adding just a little pressure before lifting the nib off the page will ensure that you get a clean, angled end.

The second stroke is like the right half of an **o**. The third stroke is the slightly flat-tened tusk shape, pulled upwards to meet the point left by the second stroke.

The descender of the **p** goes down about two-thirds of the way to the next ruled line, a perfect mirror of the length of the ascenders in the **l**, **h**, and **d**.

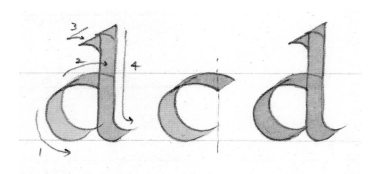

The **d** begins like an **o**, the first stroke being the left crescent. The second stroke is like the tusk-shape stroke of the **c**, but it does a peculiar thing: It overshoots to the right. This anticipates the downstroke, which will overlap it.

bone dane
pelt queen

The first two strokes of the **q** are identical to the first two strokes of the **d**. The downstroke, however, begins right at the x-height line, creating a small pointed end and a little triangular white space, marked A above. The end of the upright stroke has the same "emphatic terminal" as the **p**.

HOW TO Straight Lines Combined with Curves

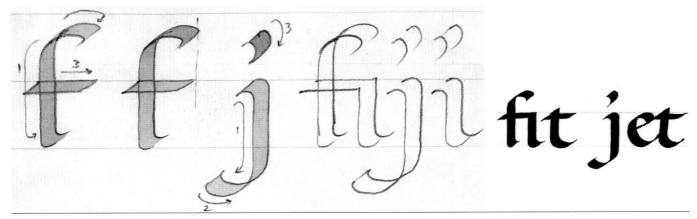

fit jet

The **f**, an ascender, and the **j**, a descender, are basically mirror images of one another. The upright strokes must be curved to join their corresponding tusk-shaped strokes.

For the **f**, begin your downstroke with a slight curve to the left. Then bring it down straight and end it with a small exit curve. The top is tusk-shaped. The horizontal stroke is just like a **t**—and, as in **t**, it should hug the left side of the downstroke and extend far out to the right. Note the right-side alignment of the top stroke and horizontal strokes.

The **j** begins with a standard curved entrance. At the bottom of the downstroke, curve gently to the left. Then add the tusk-shaped stroke. The **j** is dotted like an **i**.

Writing the word *fiji* is a good way to see that you have gotten these letters right. Turn the word upside down, and you will see if the letters have a similar shape. Note the **fi** ligature at right—a good way of dealing with this awkward combination of letters. When the **f** and **i** are joined this way, you can drop the dot of the **i** altogether.

The **k** begins with the same ascender as an **h**. It's the second part that's tricky. The gesture of the third stroke is this: <. But the edged pen held at 30° will make the top of that mark thin and weak. The answer is to make a small hook-shaped stroke. This stroke comes down and kisses the edge of the downstroke (the two strokes should not overlap), then it kicks out and ends with a tiny flick upwards.

The trick of the **s** is to make the letter a continuous series of curves. The top and bottom strokes are tusk-shaped; the sinuous middle stroke begins with a tight curve, flattens out to nearly horizontal in the middle, and ends with a second tight curve. Note that the bottom of the letter is slightly wider than the top.

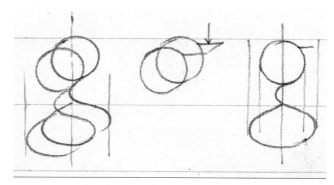

The **g** is the most spectacular letter in this script, and probably the hardest to master. At its top is a small circular bowl. Its long tail loops down into a flattened oval-shaped bowl. Note that the circular bowl is somewhat smaller than an **o** (compare A—the bowl of a **g**—and B—the larger shape of **o**). Like **o**, it is composed of two overlapping circles described by the sides of the nib.

The top bowl is made first. The stroke order matches that of an **o**. The third stroke comes down and turns slightly left at the baseline before looping down to the right. This creates the right half of the oval bowl. The fourth stroke completes the lower bowl. The final stroke is a little tail that pulls away from the upper bowl.

Here, we see that the lower bowl is distinctly wider than the upper bowl. Notice the center line—there is a basic symmetry in the form of the **g**. In the skeleton form, without the added complexity of the thick-and-thin strokes, the symmetry of the letter is clear to see. Also note that the little tail, made last, is written well below the baseline.

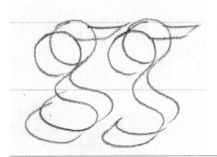

gosh

Double **g**'s pose an interesting problem. One way to deal with this is to abbreviate the tail of the second **g** to avoid collisions.

HOW TO Diagonal Letters

vine

With the diagonal letters, we come to our first deliberate change in pen angle. While the rest of the script is written at a fairly constant 30° angle, the first stroke of **v** is written at a steeper angle, close to 45°. The second stroke is made at about 30°. You want a thick stroke on the left side of the letter that is about the same thickness as an ordinary, upright downstroke. On the right side, you want a thin stroke, much like our horizontal stroke.

Both strokes are written from the top down. They begin with small entrance curves, slightly tighter than the curves on the **l**, and they join at the base. Here, the aim is to achieve a nice, clean point. On the right side of the diagram, the two over-lapping strokes are shown, demonstrating how the second stroke disappears into the first. The pointed bottom of **v** should break slightly below the baseline. This is a visual adjustment; if it sits right on the baseline it will actually appear higher than the base of the other letters.

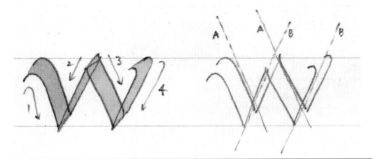

wave

The **w** is a double-**v** (despite its name). Like the **v**, the thick strokes are written at a steep 45° angle, while the thin ones are written at a 30° angle. Thus, the four strokes require some turning of the pen: steep angle, regular angle, steep angle, regular angle.

Note that the **w** has three sharp v-points: two at the bottom, one at the top. The two thick strokes, marked A, are parallel, as are the two thin strokes, marked B.

yes

text

The **y** is constructed just like the **v**. You simply extend the second stroke below the baseline and end with an emphatic terminal. Its depth matches the other descenders—two-thirds of the distance to the next ruled line.

The **x** should be about the same width as the **v**. The legs at the bottom extend a little farther to each side than the legs at the top, giving it a firm base. The crossing point of the two diagonals is just above the midpoint of the letter. The direction of the strokes is slightly steeper than that of the other diagonal letters. Therefore, the first stroke must be made at an even steeper angle than the first stroke of **v**, perhaps about 50°. The second stroke is a bit flatter than 30°, perhaps 25°.

zesty

The horizontal strokes of the **z** are written at 30°. The diagonal, however, must be written with the pen held quite flat—0° to 5°. This gives the stroke some weight. Note that the first stroke begins with a slight upward curve, and then becomes a clean horizontal stroke. The third stroke pulls off at the end with a similar upward curve. The bottom of the letter should be slightly wider than the top.

alpha bravo charlie
delta echo foxtrot
golf hotel india
juliet kilo lima
mike november
oscar papa quebec
romeo sierra tango
uniform victor
whiskey x-ray
yankee zulu

Now that we have gone through the letters in detail and you have begun writing words, it's a good idea to make a word list. The first word should start with **a**, the second with **b**, the third with **c**, and so on through the alphabet. My word list appears above.

Good spacing creates an even "color" to the line. In other words, the amount of black and white in each line remains balanced. Well-spaced letters are not crowded together or positioned far apart; each word has an internal unity, and the rhythm of black and white remains consistent across the page.

The letters of the Foundational Hand, with its generous round **o**'s and wide **n**'s and **m**'s, contain a good deal of internal space. The letters, therefore, need some room to breathe, and should not be packed too tightly together.

maintain

minimum

Two good words for establishing the spacing rhythm in any script are *minimum* and *maintain*. With their repeated **n**'s and **m**'s, these words establish a pattern that can be followed throughout the alphabet. In these two words, note how far apart the upright strokes are from one another; this echoes the white space within the letters. In the case of *maintain*, note that the **ta** combination is written quite close together. These two letters bring a great deal of white space with them. Visually, however, they seem to be separated by a similar amount of white space as the **i** and **n**.

biology

Curved strokes need to be quite close together. The uprights of *biology* are just a nib-width away from their neighboring curves.

As you write your word list, see which combinations of letters seem to need more space, and which need less. Remember: The aim is for the whole word to have an even color.

word spacing

Words are written one **o**-length apart. Imagine an invisible **o** touching the words on each side.

ra ŕ rv fi tt gg gg fl

Certain letter combinations are awkward. The **r** and the **f**, in particular, often need to be abbreviated or adjusted when written next to other letters. Sometimes it's best to tie letters together, as the double **t** demonstrates.

comma, period.
what? wow! "no"
tee-shirt

Once you have worked your way through the minuscule letters, the punctuation marks are fairly easy to master. You have enough experience with the pen at this point to instinctively write these marks. The comma is constructed just like the dot of the **i**. A small diamond shape serves as a period. The downstroke of the exclamation mark needs to be manipulated:

It starts at 30°, but is turned slowly to a steep angle as it descends. Quotation marks are made just like the commas; notice that opening quotation marks are the inverse image of closing quotation marks. The hyphen is a simple horizontal stroke. It should be a little narrower than the cross-bar of the **t**.

In practice, there are many variations on the punctuation marks; you should feel free to experiment.

1234567890

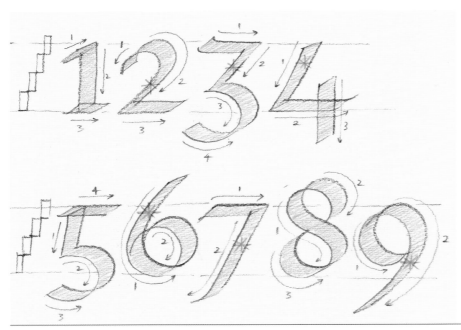

While our letters come from ancient Rome, via a roundabout path through the Middle Ages, our numbers come from the East via the Arab world. Integrating them into the texture of the Latin alphabet always involves some compromise, since the shapes are similar, but not identical to, the shapes of our letters. These figures fit in well with the Foundational minuscule. The diagonal strokes of the **2**, **4**, **6**, and **9** need to be slightly flattened to give them some weight.

larger *smaller*

Varying the size of the letters is straightforward. The basic proportions we have been studying work with any pen you wish to use. If you keep the 3 $^1/_2$ nib-width line measure as your guide, you can write letters of the same proportion at any size. A wider nib will produce large letters; a narrower nib, smaller ones.

weight variations

You can also vary the weight of the letters. This is a little more complex. The letters we have seen so far are written at 3 $^1/_2$ nib-widths high.

elegant

or bold

In the image above, I have not changed the ruling up, but I took a narrower nib to write the word *elegant*. These letters are 6 nib-widths high.

To write the word *bold* I took a wider nib, producing letters 2 $^1/_2$ nib-widths high. The weight changes depending on the ratio of the nib-width to the letter height. Drastic changes in weight require you to rethink the structure of some of the letters. Note that the **t** in *elegant* is constructed quite differently from our standard **t**.

condensed and strong.

By writing letters based on an upright oval **o**, rather than on a circle, you can create a condensed variation of the basic script.

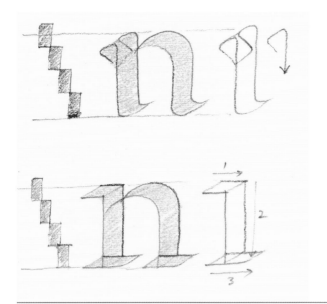

Different serif treatments change the character of the hand a great deal. Notice how these small changes completely alter the feel of the letterforms, even though the underlying shape of the letters remains unchanged.

The next chapter will explore the use of Roman capitals as a companion to the Foundational minuscules.

65. A passage from Gerard Manley Hopkins' unfinished poem "Epithalamion." The text describes boys tumbling into a swimming hole, head over heels. The calligraphy evokes their movement.

plowworld

waterworld

earthworld

airworld

the boys
with dare and with
downdolphinry

and barebright bodies
huddling out, are

thorough hurled,
all by turn
and turn about.

G. M. HOPKINS

A Q

M R

Roman Capitals

Once you have begun to master the Foundational Hand minuscules, the question arises: What capitals shall I use? The Ramsey Psalter does not help us much at this point. Because it is written in verse lines, the capitals at the beginning of each verse are set out in the left margin. And since the capitals serve a decorative function in the manuscript, they are not written with the same pen as the text—they are built-up capitals, written with a smaller nib. For the capital script, then, we must do what other scribes have done throughout history and look back to Rome.

The form of ancient Roman letters best known to us is the inscriptional capital of the first and second centuries. Because these were carved in stone, they have survived the depredations of time in great numbers, unlike the manuscript books of the ancient Roman Empire. Wherever the Romans held sway, they left inscriptions written in these elegant and bold letterforms.

The classic Roman Capital has been revived several times. In the Carolingian Renaissance of the ninth century, it inspired pen-made imitations in the great manuscript Bibles of the era. During the Italian Renaissance of the fifteenth century, it inspired both pen-made letters and inscriptional lettering. In our own time, when we want to give an inscription power and importance, we revert to these ancient forms. Some of the finest Roman Capitals in stone can be found carved around the roofline of the Lincoln Monument in Washington, D.C. In any American city, major public buildings, constructed in the early part of the twentieth century, are almost certain to carry inscriptions in this style.

Although the Roman Capital has remained a touchstone for calligraphers, carvers, and typographers for last 500 years, it has not always been

66. Examples of some Roman Capital letters.

well understood. Only in the last half-century have we come to appreciate the fact that these were not traced, or drawn, or the product of stencils. Instead, they were written directly on the stone with a brush with a flat tip, usually referred to as a chisel-edged brush. These brushes functioned a lot like an edged pen, but had a greater flexibility than a pen. The brush-made capitals were then carved into the stone to make them permanent. For this insight, we are indebted to Father Edward Catich, a Roman Catholic priest, educator, and master letterer, who made a detailed study of the inscription at the base of the Trajan Column in Rome in the 1930s, which he published after World War II. He re-created the process by which the capitals were written, and was able to recapture the freedom and vigor of the originals. His technique was not unlike Johnston's—by rediscovering the method the Romans used, he was able to reproduce the distinct swellings, subtle curvature, and unique freedom of the classic Roman Capital.

How, then, do we take these brush-made, stone-carved letters and render them with an edged pen? Because we're using a different tool, we have to rethink some basic aspects of the letters. There is no way to achieve the fine serifed ends of the brush-made forms using an edged pen. We must go back to basics to create a useful script that sits in harmony with our Foundational minuscules.

67. Tracings from first-century Roman inscriptions, made after rubbings. Reproduced from Frank Chouteau Brown's treatise *Letters & Lettering* (Boston: Bates & Guild, 1902), pages 24 and 25.

68

SKELETON LETTERS: ROMAN CAPITALS DEFINED BY PROPORTION

Roman Capitals come in several distinct widths. Like the Foundational Hand, the Roman Capitals are based on a round **O**, which is one of the reasons the two make a good pairing. Reducing the letters to their skeleton forms gives us a mental picture of the letters before we write them with a pen. Skeleton letters may sometimes be used for finished work, but their most important function is to create an underlying sense of proportion, which will guide our pen-made letters. After

we have looked at the skeleton forms (see page 55), we will examine how to make the pen-made letters.

There are many systems for making the Roman skeletons. For the system I use in this book, I am deeply indebted to my teacher, Ann Camp. However, I have made my own alterations and adjustments; any faults in these letters are my own. These skeletons can be drawn with a compass and ruler if you want to explore them in greater depth. I have chosen to render them here freehand on architects' tracing paper, although I did draw a prototype square-and-circle diagram with

68. Roman Capitals from the Civic Building opposite City Hall in New York City.

69. Rubbings from an inscription by Eric Gill, an English stone carver of the early twentieth century. His Roman Capitals have both classical structure and a grace and freedom that is extraordinary.

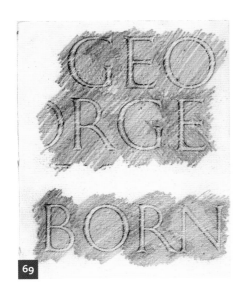

69

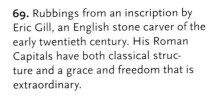

A is for the Ⓐ train that runs express all the way to Harlem.

B is for the Bowery where the drunks no longer gather. &

C is for Central Park.

D is for the Dowagers of Fifth Ave.

E is for the Elevated trains in the outer boroughs. &

F is for "fuggedaboudit"

G is for Grand Central Station, where the commuters come & go.

H is for the halal food sellers in Midtown.

I is for Inwood & its ancient forest.

J is for Jackie O, who saved G.

K is for kreplach.

L is for the lucre that oils this metropolis.

M is for "the Met" — both the Museum & the Opera.

N is for Newtown Creek, between Queens & Brooklyn.

O is for the Ocean seen from Coney Island.

P is for pastrami

Q is for the borough of Queens

R is for the rickshaws that have proliferated of late on 6th Avenue.

S is for street-life, high & low.

T is for Times Square, where the year begins.

U is for uptown.

V is for the Varrazano Narrows, filled with ships.

W is for Wall Street.

X is for X-rated, which the city used to be.

Y is for Yellow cabs.

& Z is for Zeppole at every street festival.

NY. 11 Oct. 2007

SKELETON

PROPORTIC

AND SPACI

a compass, ruler, and triangle before I began. I used this as the foundation for the skeletons since the underlying geometry of these letters is based on a circle inscribed within a square. All the skeleton letters shown here were drawn with a soft 2B pencil. The ruling, as mentioned previously, should be done with a 2H pencil.

Working with the Skeletons
One simple way to work with the skeletons I show in this section is to simply trace over my diagrams. The skeleton caps shown here were drawn 1 inch in height. If you would like to trace them, rule up a sheet of tracing paper with lines 1 inch apart, and then use the diagrams here to

trace the letters. After tracing the letters several times, you will want to try them freehand, using the 1-inch ruling you have made. As you get more confident, you can rule lines a half-inch apart and try them a little smaller.

If, however, you would like to recreate the diagrams using a compass, you will need a compass, a ruler, and a triangle to make the underlying diagrams. All the diagrams are based on simple squares, rectangles, and circles drawn within squares of varying size. Begin by drawing two parallel, horizontal lines 1 inch apart, using your T-square. You will use these lines for all the geometric constructions.

70. A New York ABC, made as a game with a couple of friends sitting over a glass of wine. I did the writing, while my buddies suggested New Yorkisms. The capitals were written with a felt-tipped marker; the handwriting is made with an ordinary fountain pen.

71. Roman Capital skeleton letterforms.

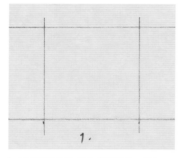

1.

2.

3.

4.

5.

72. Creating a diagram to use as a foundation for most Roman capital letters.

73. Inscribing a circle in a square using a compass.

Let's begin with how to make a circle in a square. Your parallel lines are 1 inch apart. Mark off a 1-inch interval on the bottom horizontal line. Now, with your triangle, draw the two vertical sides of the square, as seen in image 1 in figure 72. Then draw diagonals through the corners of the square (image 2). They will cross at the precise center of your square. Take your triangle and draw a vertical line from the center of the square to the center of the top side of the square (image 3). Place the metal end of your compass on the center point. Use a little pressure so it presses into the paper and stays put. Without moving the metal point, adjust the width of the compass so the pencil end sits exactly on the top middle point of the square. Now your compass is set so that it will create a circle with a diameter exactly half the width of

the square. Turn it on its metal point, inscribing a perfect circle within the square, as seen in figure 73.

If you have made all these lines accurately, the circle should touch all four sides of the square exactly at their midpoints (image 4 in figure 72). From experience, I know that it may take several tries to get this exactly right; the compass is not very forgiving!

Now use your triangle to draw two vertical lines through the points where the circle intersects the diagonals. Finally, draw a vertical line through the center of the square, using your T-square. This gives you the diagram to use as an underlay for drawing most of the letters (image 5).

Some letters are based on a much narrower geometric diagram. The **P**, **R**, **F**, **J**, and **I** are made in a rectangle that is just 1-inch wide. The **E**, **B**, **K**, and **S** are made with a diagram based on a stack of two slightly unequal squares; the curves are based on circles inscribed within these smaller squares. You should read the descriptions of these letters below to see the small adjustments that need to be made in the geometric underdrawing before you create them with compass, T-square, and triangle.

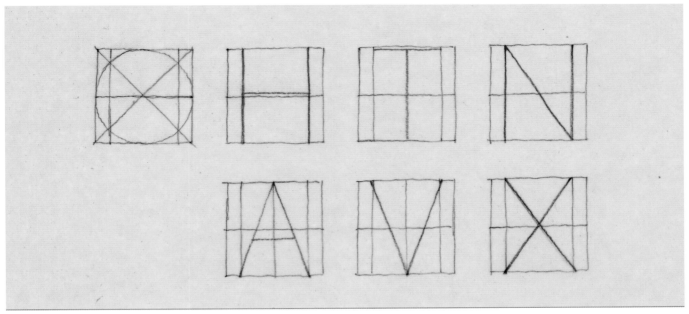

If you look at the samples given here, you will see that the Roman Capitals come in varying widths. The first group of letters is of medium width. We start with these because they are mostly made using simple straight lines.

For visual reasons, we will make some adjustments to the pure geometry of these letters. It is a peculiarity of human perception, for example, that the perfect geometrical center of a square appears to the eye to be slightly below center. We therefore draw these letters with the following details in mind.

The crossbar of the **H** sits slightly above the center line. Visually, this makes it look centered (it would seem rather low if it sat directly on the center line).

The crossbar of the **T** is drawn just below the top line so it does not seem taller than the other letters. The top horizontal stroke of the **Z** is the same.

Where the diagonals of the **A** reach the bottom of the box, they should be just *outside* the box, or the **A** will seem distinctly narrower than the **H**. The crossbar of the **A** is positioned so the small triangle above has about the same area as the large trapezoidal shape at the bottom of the letter. In other words, the crossbar of the **A** is distinctly below the midline; it does not match any other crossbars in this alphabet.

As with the **A**, the outer diagonals of the **V** and **Y** overstep their bounding box. The diagonals of the **X** should be within the bounding box at the top, and just outside it at the bottom. The point at which the diagonals cross is, therefore, slightly above the geometric midpoint.

The points where the uprights of the **U** join the round base should not be made with hard corners, but need to be slightly softened.

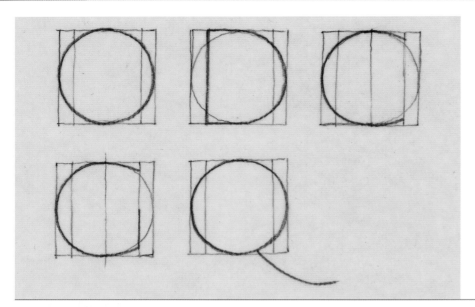

The second group is composed of letters based on a circle.

The **O** is a perfect circle. The **Q** is a circle with an added tail. Note that this tail is the only part of any of the letters for which I give no geometric guideline. Look carefully: the geometry of a perfectly formed tail is extremely complex—it's best just to copy the stroke made here.

The **D**, **C**, and **G** are slightly narrower than a circle. Notice that they each follow one edge of the narrow bounding box used for the letters of the first group. Each of these letters has a section that is a perfect half-circle.

Before the curve of the **D** begins, the top and bottom sections are straight. The top and bottom of the **C** and **G** splay out slightly on their right sides, departing from the curve of the **O**. The leg of the **G** goes up to the halfway mark.

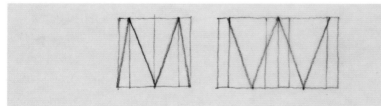

The third group is the wide letters.

The **M** has a **V** at its center. The legs splay out slightly so that **M** fits in a perfect square. The **M** should not be an upside-down **W**. Notice that the two halves of the letter lean away from each other.

The **W** is two **V**s conjoined. It is the widest letter of the alphabet.

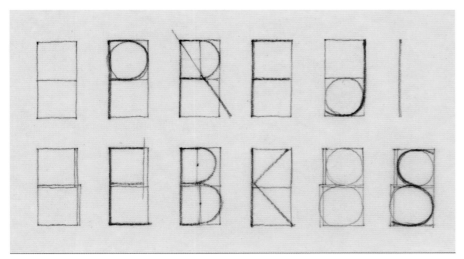

The fourth group is the narrow letters. These letters are based on two stacked squares.

The **P**, **R**, **F**, and **J** sit neatly within the two squares. Note that the bowls of the **P** and **R** are miniature **D**'s and share almost the same proportion as their big brother. Like the **D**, their bowls have straight sections before the half-circle curve begins.

The tail of the **R** is aligned with a line starting at the upper left corner and passing through the point at which the bottom of the bowl makes its transition from straight to curve. It breaks the bounding box significantly.

The skeleton **I** is the narrowest letter of all: It is just a line.

The **E**, **B**, **K**, and **S** have to be visually adjusted. Make the top square slightly smaller than the box for the preceding letters, and the bottom square slightly larger. The bases of these letters are all marginally larger than their tops; with these adjustments they will appear balanced (if this modification weren't made, they would look top-heavy).

The **S** follows the curves of circles inscribed within the squares. At its ends, the curve opens out and away from the circles, just as you saw with the **C** and **G**.

Roman Capitals require generous spacing. With **HH**, **HO**, and **HA**, these intervals can be expressed in purely geometric terms. Notice how the area of red is equal in each of the examples.

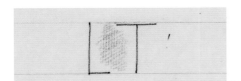

Other letters, like the **L** or **T**, contain a lot of white space that is not enclosed with neat edges. For letters like these, the spacing has to be judged by eye.

This list of words shows the skeleton letters in action. The circular **O**, with its generous internal void, is what makes the wide spacing necessary. If you packed these letters more tightly, the internal spaces of **O**, **C**, and **D** would jump out at you.

One good way to judge your spacing is to use the "rule of three." Use your hands or two pieces of paper to cover all but three letters in a word: Do the three letters look evenly spaced? Then move your hands over by one letter: Does the next group of three look evenly spaced? If you go through a whole word this way, irregu-

larities in spacing become much more apparent.

A little time spent studying the skeleton forms (or better yet, copying out the constructed letters and writing words with them) will help develop your skill in writing pen-made letters.

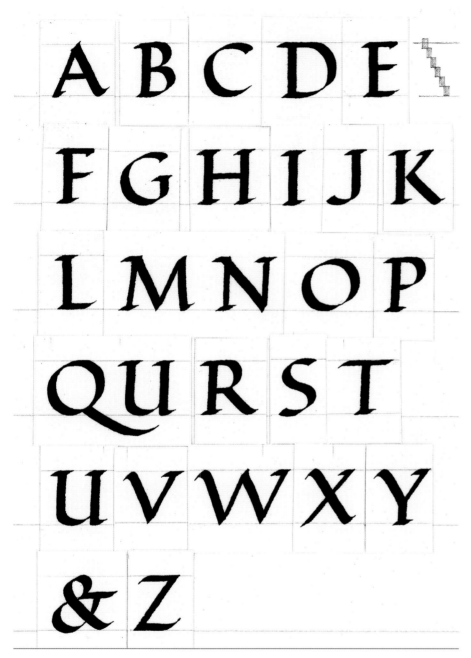

Most of the straight strokes end with added serifs—this is the way of making a mark that evokes the thin serifs of the inscriptional Roman Capital letters. The diagram below shows how the serifs relate to the upright stroke.

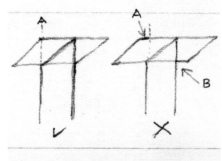

Note that the serifs are actually not long marks. They simply add a little finishing stroke to the ends of the straight strokes. On the left, the serif is made correctly. The top left corner of the serif should align with the line marked A, drawn upwards from the left-hand side of the upright stroke.

The serif on the right side of the diagram is too wide. The left corner of the serif doesn't align with the left-hand side of the upright stroke; on the right, a little shelf (marked B) protrudes from the side of the upright stroke.

The Roman Capitals shown here are written at 5 1/2 nib-widths high, which makes them slightly shorter than the Foundational Hand ascenders. In general, calligraphic capitals aren't as tall as the ascenders of the accompanying minuscules.

They are written at a 30° pen angle, like the Foundational minuscule, with the exception, of course, of certain diagonal strokes.

Stroke orders are given here with each letter, which you should follow as you are learning the script. In practice, I find that people have different preferences about the stroke order and once you have tried the stroke order given here, you may find that a different order is more comfortable for you.

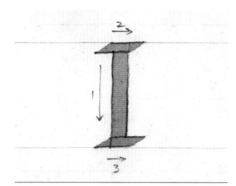

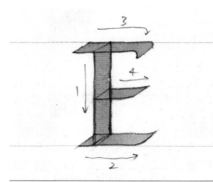

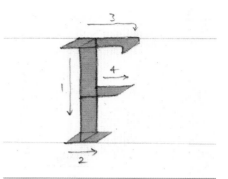

The **I** forms the pattern for all the straight-stroke letters. Note that each part is made with a distinct stroke.

While the capital **E** follows the skeleton quite closely, the addition of weight gives it a rather different appearance. The top and middle horizontal strokes are essentially the same length, but one has a pulled-down terminal, while the other ends with a sharp point, thus appearing shorter. The bottom stroke pulls off with a slight upward movement.

Make sure the bottom serif of the **F** isn't too long, lest it resemble an **E**.

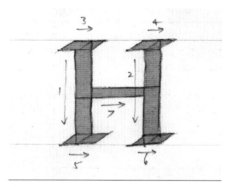

The **H** is constructed using two I's joined by a crossbar.

The **L** is identical to the corresponding parts of the **E**. Add a serif to the top of the upright stroke.

The **T** is like an I with a long horizontal stroke at the top. As in the skeleton forms, this is about three-quarters as long as the downstroke. As we saw in the skeleton caps, the **T** should be the same width as the **H**.

The **J** begins like an I, but at the bottom of the first stroke, veers left. The tusk-shaped stroke should join it with smooth curves.

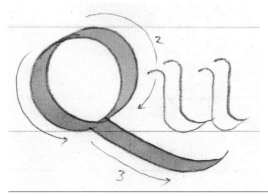

The **O** will be familiar from the Foundational minuscule **o**. As with the minuscule, the two curved strokes overlap slightly.

There are two ways of thinking about how the tail of the **Q** attaches to the round **O**. You can think of it as attaching just below the thin point at the bottom or you can think of it attaching near the baseline. I have drawn a small **u** next to it because, except for a few words transliterated from Arabic, that is always the next letter. Making the **u** helps you judge the direction of

the tailstroke. Note that the curve of the **Q** starts as a broad arc, and then tightens up at the end. The tail should always end with a graceful thin upstroke. The tail is written at the same 30° angle as the other strokes of the letter. I like to make the tail long enough so it terminates under the far end of the **Q**.

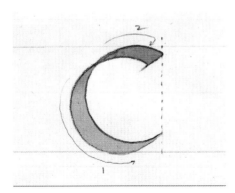

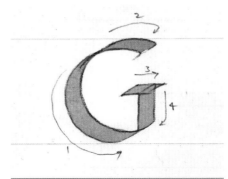

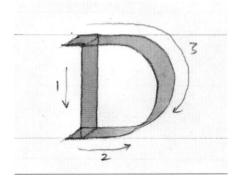

The structure of the **C**, like that of the **O**, will be familiar from the minuscules.

The leg of the **G** is constructed like the top part of the **I**. Note that the right edge of the leg's upright stroke aligns with the terminal of the top curve of the letter. The serif on the leg extends on the right beyond this line.

The **D** sets the pattern for the next three letters. It is crucial to remember that the bowl has two straight parts before the curve begins, and the curve on the right-hand side of the letter is a perfect half-circle. Compare this pen-made letter to the proportions of the skeleton capitals.

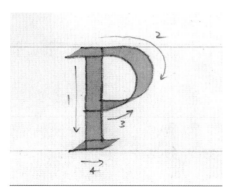

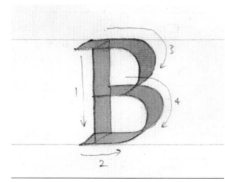

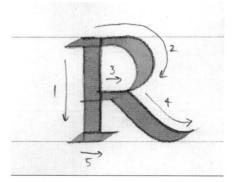

The top of the **P** mimics the **D**, only in miniature.

The lower bowl of the **B** must be slightly wider and taller than the top bowl.

Unlike the skeleton form, the tail of the pen-made **R** has a slight upward curve at the end, distantly echoing the tail of a **Q**.

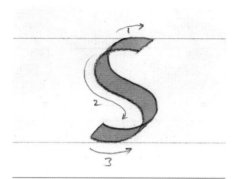

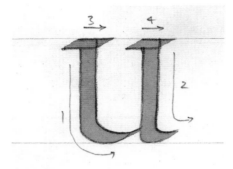

The **S** should have seamless curves throughout, even where the strokes join inside the arcs.

In the Roman Capital **U**, we have an inverted arch stroke similar to the one used in the Foundational minuscules. This is the only occurrence of that stroke in this alphabet. Due to the join of the arch to the second stroke, there is not room for the full serif that is used to end other straight strokes. Instead, pull the second stroke out horizontally, rather than pulling upwards, as we did with the minuscule **u**.

Some diagonal strokes involve changes in pen angle, just as they did in the Foundational Hand minuscules. Some of the diagonal letters also pose the problem of making sharp **V**-shaped points at top and bottom.

The sharp **V**-points are made with overlapping strokes. The steeper thick stroke should define the point. The flatter thin stroke disappears into the thick stroke, as shown above. An added refinement (not to be overexaggerated) is to make the thick stroke with a slight curve where the letter comes to a point. This sharpens the point, and makes it join more elegantly with the other stroke.

The first stroke of the **A** ends with a sharp corner, which turns into a serif. This is slightly different from the serifs we have been making with a separate stroke, but the visual effect is largely the same. The second stroke of the **A** is made at 45°. Instead of a serif, the end of this stroke is a curved exit stroke. The third stroke returns to the 30° angle. The top of this letter (and all the sharp **V**-points) should break the line so that the letter doesn't appear shorter than the more full-bodied letters.

The first stroke of the **V** begins with a simple curved entrance, as we saw in the minuscules. Note the added serif on the second stroke of the **V**.

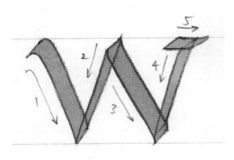

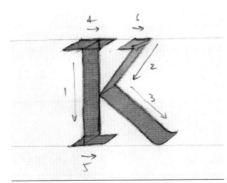

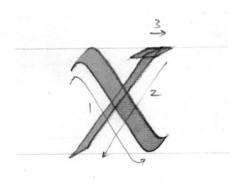

As with the minuscule version, the **W** has three points. Make sure that the two thick strokes are parallel, as are the thin strokes.

The second stroke of the **K** is written at a flattish 25° angle to give it some weight. The second and third strokes should just kiss the first stroke, not overlap it.

The first stroke of the **X** is written at about a 50° angle; the second stroke is written at a flattish 20–25°. The two strokes should cross just above the middle and the base should be slightly wider than the top.

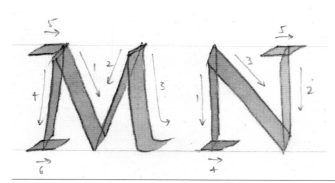

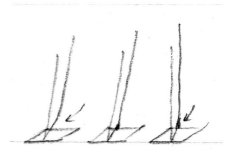

The **M** and **N** are classified together since they are, in some ways, the most complex of the Roman Capitals.

First of all, remember the skeleton form of the **M**: The letter is basically square, and its outer legs splay out slightly. It is not an upside-down **W**; none of the strokes are parallel. I think it's best to make the V-shape at the heart of the **M** first. Then I make the right-hand leg, adding a little serif at the end, much as we saw with the first stroke of the **A**. This third stroke is made at a 30° angle. Then I go back and make the left-hand leg. This fourth stroke

is made at a 45° angle. The serifs are added last. Others might find this stroke order perverse; if you want to make the letter in a different order, do so, but I find that making the **V** first helps me align the legs correctly.

The "armpits" of the **M** should be the same height. In other words, the tops of the two upright triangles of white space should be the same height.

The first three strokes of the **N** are written at 60°—a very sharp pen angle. The serifs are at 30°.

A problem arises in attaching the serifs to the steeply written strokes of the **M** and **N**. The angle on the downstrokes of these letters is so acute that the added serif leaves a small dent in the side of the letter. This is particularly evident at the top left-hand side of the **M**. You can simply leave these little gaps—there's something refreshingly direct about letting the pen shows its nature—but the better solution is to use the corner of the nib to drag some ink into the gap. In other words, draw it in.

The first stroke of the **Y** is written at a steep 45° angle. The second stroke is written at about 22°, while the third stroke, which adjoins it, returns to the 30° norm.

The diagonal stroke of the **Z** is written at a very flat 0–5° angle.

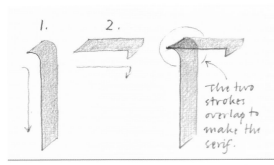

The capitals that have been shown so far are quite formal with their flat serifs. An alternative is to make a bracketed serif, as shown in this diagram. The downstroke begins with a little quarter-circle entry. The horizontal stroke completely overlaps this entry section. It can be a nice detail to let the bottoms of the letters go without serifs entirely. This variation on the standard capitals has a much lighter, less formal feel.

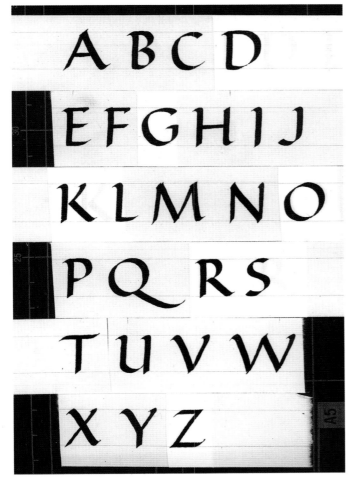

An experimental capital alphabet, seen here, imports elements from the Foundational minuscules into the caps.

These capitals, written with walnut ink and a large pen, show off the possibilities of using thinner ink for decorative work. While you would not usually want your ink to be so thin (especially for writing entire texts), in certain contexts the variations can have a strikingly ornamental effect.

Aspic Butter Crepe

Duck Eclair Fruit

Grill Haricot Iced te

Jambalaya Knish

Lamb Minced mea

Nuts Offal Pears

The Italic Hand

4

The Italic Hand was the script of the Humanists of Renaissance Italy. Beginning in the early fifteenth century, these scholars of ancient texts began to develop a cursive variant of their Humanist Minuscule, an upright Roman Hand, and thus the Italic script was born. The scribes of the Papal Chancery adopted a form of the Italic in the latter part of the fifteenth century, and it spread through Europe with every diplomatic pouch that left Rome. In Elizabethan England, it was adopted by the nobility as a standard hand for correspondence. Queen Elizabeth I wrote using a beautiful Italic script (although I've heard that when she was angry, she lapsed into a Gothic Cursive). The Italic Hand is characterized by its branching strokes, asymmetrical arches, and a distinct forward slope. Its letterforms are usually compressed and rather tall.

One of the most variable calligraphic scripts, the Italic can be written quickly and informally or slowly and with great dignity. Because its shapes are fairly fluid, they can take many forms. The Foundational Hand is based on a pure shape: the perfectly round **o**. A circle is a circle, and if you change that basic shape, you will get quite a different hand. But the Italic script is based on an oval **o**, and ovals can take on many shapes and still retain a familial resemblance.

The Italic is one of the few calligraphic scripts that directly inform ordinary handwriting—there are many people today who base their day-to-day writing on Italic prototypes. Any calligrapher who spends time mastering the Italic Hand will find her handwriting subtly—or not so subtly—influenced by this engaging script.

The sample in figure 75 (see next page), copied freely from a manuscript book from c. 1490, shows how well the Italic lends itself to use as ordinary handwriting. Even without the thick and thin modulations of the edged pen, these monoline* letters show the basic Italic features listed above. One of the reasons the Italic Hand morphs so easily into ordinary writing is its cursive nature.

The word *cursive* derives from the Latin word *currere*, which means "to

*The word monoline *means a stroke with an unvarying thickness.*

74. Words written in the Italic Hand.

75. A monoline writing sample.

run," indicating a script that is written with some speed. Such writing lends itself to ligatures, which are little strokes that tie the letters together. The monoline writing sample in figure 75 is full of them.

When you move to the Italic Hand from the Foundational Hand, you can immediately sense a change in rhythm. The Foundational marches along to a steady metronome beat, every letter coming to a clean conclusion with its little round exit stroke. The Italic feels quicker; its shapes propel you forward, and every upward flick of the exit stroke leads your hand and your eye to the next letter.

The Foundational Hand was designed as a basic script to introduce the fundamental principles of using an edged pen. Throughout the previous two chapters, I have been very directive, going through the alphabet letter by letter. In this chapter, I want to pull away from that step-by-step approach and encourage you to look closely at the exemplars, read the text, and begin a more independent kind of study. We will look at the basic features of the Italic Hand and dis-

cuss the interrelationships between the various letters. I've also provided a word list, so you have an example of every letter from the script. However, this chapter will require you to take the general principles I describe and, by looking at the exemplars, to work out on your own how they apply through the letters of the script. The letters I discuss in detail give you the basic forms that you will find in other letters. Once you have mastered the shape of an **n**, for example, you will be able to make an **h** or an **m**, which are made of almost identical components.

One of the guiding ideas of the Italic Hand is that its rhythm is one of equidistant parallel lines. I like to refer to it as the "picket fence" rhythm, although you have to picture a picket fence leaning to one side. This rhythm is quite obvious with words like *minimum* and *maintain*, with their repeated upright strokes. But it should also be apparent in words full of curves. Looking at figure 76, notice how the curves, while never losing their roundedness, begin to echo the upright straight strokes.

76. An Italic Hand word list for all letters.

minimum maintain

albacore brandy carob

damson edamame fennel

glace ham insalata jam

knish lemon meringue

nan octopus pie quince

risotto spinach tripe

ugli fruit vichyssoise

watermelon xanthan gum

yoghurt zabaglione

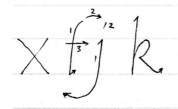

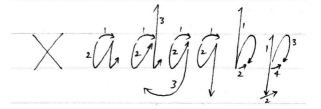

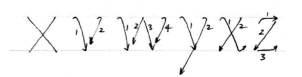

In the Foundational Hand, the stroke order stays consistent, no matter what size you are writing. In the Italic Hand, however, it is quite variable. The suggested stroke orders shown above are based on smaller writing, similar to the size of conventional hand-writing. Many of the letters can be made in a single stroke. This is particularly true of the branching letters. You can even make the **o** in a single stroke, letting your hand carry through around the oval.

Bigger writing requires more pen lifts because it is awkward to try to make large letters without lifting the pen between strokes. When writing the Italic at a large size—say, with an x-height larger than half an inch—I tend to lift the pen after a downstroke, as in the **n** or **h**, and place it back *in the exact same spot from which I lifted it* to make my branch and arch. In really small writing, there is even less need to lift the pen; the top stroke of the

a or **c**, for instance, can be written first, and then you double back on it to make the bowl. In the case of the **a**, the pen does not need to be lifted at all. In fact, if you begin to write with real speed at small sizes, you may find the letters beginning to connect of their own accord.

As seen with the **i** here, the entrance and exit parts of many Italic upright strokes are tight, parabolic arches.

These samples show a 5-nib-width x-height. The slope (the angle at which the letters lean) is about 7° off the vertical axis. You can see here that I have ruled a slope line to keep my slope consistent, as I have done on many of the samples given here.

People often casually say that the Italic Hand is written at a 45°-pen angle, but if you measure their writing you will find it is nowhere near that; the pen angle is actually about 45° *to the slope*. The angle of the pen to the baseline is thus 38° (45° − 7° = 38°). I should note that we don't generally get out our protractors to measure these angles. But a skilled calligrapher can usually judge a 45° angle by eye and adjust it to accommodate the slope.

The **n** holds the key to the script. Notice how the arch branches out from the first downstroke. This branching part of the stroke is *pushed* until it comes to its thin point, at which point it becomes a pulled stroke as it goes around the arch. Having this second stroke come out of a wet downstroke helps the ink flow when making the pushed stroke.

The branching stroke should be as gradual as possible. Think of an exit ramp on a highway, which pulls gradually out of the highway. A branching stroke in the Italic Hand ought to do the same thing, pulling almost imperceptibly out of the downstroke until it emerges cleanly and curves into the arch.

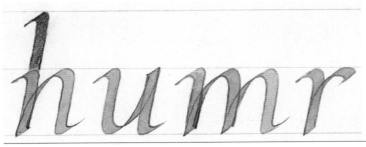

Different kinds of branching create different rhythms in the Italic Hand. Three variations are shown above. The second letter in the series most closely matches the exemplars in this chapter. It is a *middle branching* letter—the branch begins to emerge about one-third of the way up the downstroke; it completely leaves about two-thirds of the way up. Other forms of Italic letters are *low branching* or *high branching*. In a low-branching Italic letter, the branches emerge directly at the base of the downstroke. These arches are usually quite pointy. A high-branching Italic

character exits the downstroke at the last possible moment; it tends to have rounder arches as a result.

The arch itself is an asymmetrical shape, unlike the circle-based arches of the Foundational Hand. Looking at the Italic samples, you can sense the kinetic energy of the hand moving the pen around the curves. Like a rocket trail, the curves shift and change, but rarely make a hard corner or sharp turn. The parabolic Italic arch is formed with one continuous sweep of the pen.

In judging an Italic script, one thing to look for is the consistency of the little triangles of white space at the tops and bottoms of the letters. I have marked these with black triangles here. Ideally, your upper and lower triangles will be identical in shape and size.

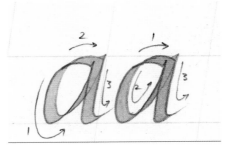

Once you can write the **n**, you can write the **h**, **u**, **m**, and **r**. Turn your writing upside down to make sure your arches are consistent on both the top and the bottom.

The figure here shows two **a**'s with different stroke orders. I was taught to use the second of these two, a stroke order recommended by Ludovico degli Arrighi, an Italian writing master of the sixteenth century. However, recently I have experimented with the stroke order of the first example, which was recently shown to me by an American scribe. This method makes it easier to judge the position of the **a** within a line of writing; it reiterates the picket fence rhythm of the ordinary downstrokes. By making the back of the **a** first, rather than the top, you are adding a picket to your fence, and can judge the spacing more accurately.

The top of the italic **t** sits halfway between the ascender and descender lines.

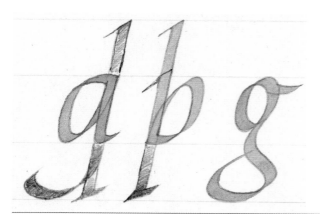

Whichever stroke order you use for the a can be applied equally well to the **d**, **g**, and **q**. In the above figure, the letters **a**, **g**, **d**, and **q** are superimposed upon one another, as are the **b** and **p**. By superimposing the letters, the interrelationships between the different letters are plain to see. Cursive hands weed out the differences between the letters. The hand, moving rapidly, tends to find the commonalities within letters, rather than preserving their individual quirks.

The alternative **g** shown on the right can also be used. Note that, despite its complexity, it still respects the general slope established by the upright strokes of the other letters. You will recognize this form of **g** from the Foundational Hand. The stroke order in Italic is essentially the same as that for the Foundational version of this **g**.

Curved letters also follow the slope. None of the curves in the **s** or **o** quite match the arches of the preceding letters, but the gesture is similar. Note how flat the ends of the **s** have become without losing a feeling of curvature.

The **c** has a very flat topstroke, while the **e** has turned into a simple two-stroke letter.

The **f** and **j** mirror each other, as they did in the Foundational Hand.

If you are feeling bold, you can make the **f** with a bottom tail like the **j**. Written that way, it becomes the one letter of the alphabet to be both an ascender and a descender.

The Italic **k** is clearly related to the **h**. Both these letters have the same vertical ascender, and branch in essentially the same manner. The **k**, however, loops back to almost touch the ascender, and then has an added tail. The letter is made in two strokes. You'll notice that I have branched a little higher on the **k** than on the **h** to allow the loop-and-tail part to have room to kick back toward the downstroke. Despite the narrowness of the Italic letterforms, you should not be afraid to let the tail of your **k** kick outwards—it would be a pity to make it cramped.

The diagonal letters make the same kinds of angle adjustments that we saw in the two previous scripts. The **v** begins with a steeper stroke, and returns to the master pen angle for its second stroke. Once you can write the **v**, you can write the **w** and **y**.

Aspic Butter Crepe
Duck Eclair Fruit
Grill Haricot Iced tea
Jambalaya Knish
Lamb Minced meat
Nuts Offal Pears

Quiche Roast
Succotash Tiramisu
Unagi Vol-au-vent
Water X
Yeast Zest

The capitals that go with the Italic Hand can be drawn from several sources. One possibility is to use Roman Capitals, which many Renaissance scribes employed. The full-bodied upright capitals make an interesting counterpoint to the forward-leaning Italic minuscules. Or you can squeeze the Roman Capitals to make them a little narrower and tilt them at the same slope as the minuscules.

Another alternative is to use gently flourished Roman Capitals like those shown in the figures here. The Renaissance scribes were wildly inventive with their Italic capitals, and there's no reason we shouldn't treat ours in the same manner. In fact, some people will find these free, expressive capitals easier to make than the more plodding forms of the standard Roman Capitals; their looseness and more gestural quality suit certain people's natural cursive inclinations.

Annie Bert Clive Dan
Eliza Fran Gerdy Hugo
Ignatius June Knut
Laura Minnie Niobe
Olav Pete Quentin Ruth
Sven Thetis Urosh
Victor Walter Xenophon
Yves Zelda

WRITING SAMPLES

This chapter closes with writing samples by two highly skilled contemporary American scribes, Carol Pallesen and Anna Pinto. Remember that the Italic Hand is infinitely variable. These pieces demonstrate that fact. Carol's lettering hews close to the classic Italic script we've been looking at thus far. Anna's is a far looser interpretation of the tradition, with twisted exit strokes and a great deal of pen manipulation (turning the pen through several angles while making a single stroke).

Carol Pallesen

The Boomerang Theory

When you give your best to the world, the world returns the favor.

H. JACKSON BROWN, JR.

78

The Handcrafted Greeting Card

Carol Pallesen Hicks

Anna Pinto

Please remember to keep this Hush Hush, for when she walks through the door, we want her to blush!

Rebecca Adelaide to Mr. Raphael Carland

Deep in the sun-searched growths the dragon-fly Hangs like a blue thread Loosened from the sky

DANTE GABRIEL ROSSETTI

77. A sample of the Italic Hand using both minuscules and majuscules.

78. Clockwise from top left: A quote from inspirational author H. Jackson Brown, Jr.; a calling card for the scribe's business; a poem by Dante Gabriel Rossetti; a card created to celebrate nuptials; a card from a surprise party.

ria in excelsi

, et in terra p

inibus bona

ntatis. ЗЗ

A Repertoire of Scripts

ne could make a whole career as a calligrapher using only the Foundational Hand, Roman Capitals, and the Italic Hand. If you master these scripts, and learn to vary their weight (thickness), you can undertake almost any calligraphy work. Most calligraphers do, however, branch out and add new scripts to their repertoire. In this chapter, we look at three additional scripts—Uncials, Carolingian Minuscules, and a Gothic script.

In the second chapter, when I introduced the Foundational Hand, the instructions were explicit; in chapter 4, I asked you to begin deducing the construction of the Italic script using fewer given guidelines. In this chapter, the three scripts we look at will not be analyzed and explained in such detail. If you have worked through the previous chapters, you should have begun to develop an instinctive grasp of the logic of fine writing. Stroke order and direction will have become second nature. So I encourage you to look carefully at the images in this chapter and make your own deductions about the construction of the letters.

The calligraphers of the early twentieth century who began the revival of historical scripts did just that. At that time, no one could explain precisely how each of the great medieval hands was constructed. By careful observation and thinking through the process of using an edged pen, Edward Johnston and other twentieth-century scribes slowly grew to understand the nature of the historic scripts. Now you are invited to engage in a similar process.

The Uncial Hand

The Uncial, a majuscule or all-capital script, was a major bookhand from late antiquity until about the seventh century. With the Uncial Hand, you can see forms beginning to emerge that are familiar to us as minuscule letters. These are mixed in with forms that we recognize as capitals. The Uncial Hand is very legible and is based on an **O**, with a circular shape similar to what we saw in the Foundational Hand.

79. An example of the Gothic script discussed in this chapter.

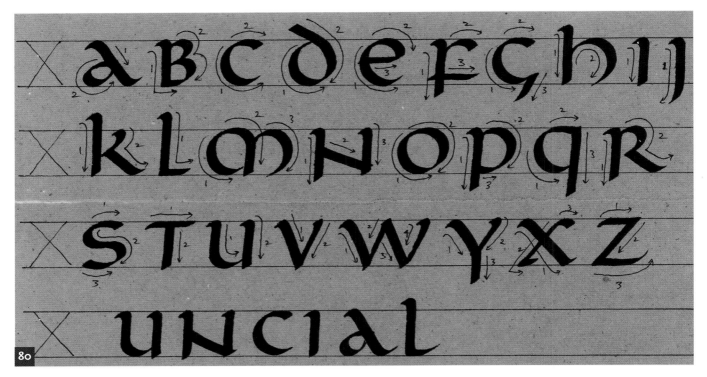

80. This exemplar shows the stroke order for the Uncial Hand.

81. This exemplar was written using the same pen as figure 82, but with a different x-height, making for denser writing. It was written spontaneously, without ruling.

82. This pangram, written using walnut ink, shows variations in Uncial letterforms.

Historic examples of the Uncial script have many variants, some of which are highly elaborate and involve delicate turnings of the pen. The three samples shown in this chapter use a very simple Uncial that gives a good sense of the spirit of the script.

Looking at figure 80, you'll notice that the script has very short ascenders and descenders and that the placement of the writing on the ruling lines is different from what we have seen before: You only need to skip one line between lines of writing, as opposed to the two lines in Foundational and Italic. Lines of Uncial writing can be packed tightly together since the ascenders and descenders are so minimal.

The exemplar in figure 80 was made in a class demonstration using easily available materials. The paper was ordinary brown wrapping paper; the pen was a felt-tip marker. Oddly enough, the absorbent, textured nature of the brown paper suited the felt-tip pen perfectly—one of those instances in which a certain writing tool works beautifully with a specific surface. Although felt-tips are cheap, disposable tools, and brown paper is ephemeral and decays quickly, the combination of the two tools made for a lovely bit of writing. Of course, these tools would be too informal for any piece of finished work, but they were ideal for a demonstration in class.

The text in figure 82 is a pangram, or abecedarian sentence, which contains all the letters of the alphabet. This sample was written spontaneously, without line ruling. Notice how variant letterforms coexist happily within a single piece of writing; for example, there are two forms of **T** and two forms of **E** in the piece. The variations of these two letters are common in Uncial scripts. Calligraphers have the luxury of mixing

UNCIALS LEND
themselves TO
DENSE, TIGHTLY
PACKED MASSES
OF WRITING ·

AND FROM EVERY QUARTER FLOWING, JOYFUL CROWDS ASSEMBLED ROUND AND SPAKE WITH EXALTED ZEAL

Carolingian is an elegant, fluid bookhand with tall ascenders and descenders & generous line spacing.

83

83. Carolingian has a smooth cursive quality to it, making it an efficient script for long texts.

84

84. The l in the Carolingian Minuscule is made entirely with one stroke.

bawds jog, flick quartz, & vex nymphs.

85

85. This pangram shows a variation of the Carolingian **y**.

86. An exemplar using the Carolingian Minuscule.

87. For capitals, a tilted, free variant of the Uncial may be used. Note the small size of the capitals used here. I have made them just a little less than twice the x-height. The ascenders are much taller than the capitals.

variants into their writing, as I have done here. The sample was written using walnut ink, which varies enormously in tone and creates a texture of its own in contrast to the geometrical regularity of the script.

The Carolingian Hand

The Foundational Hand that we explored in chapter 2 is actually derived from a late form of the Carolingian Minuscule. The version discussed here is based loosely on a ninth-century manuscript known as the Moutier-Grandval Bible, housed at the British Library, which is one of the loveliest examples of an early Carolingian Minuscule.

Unlike the Uncial Hand, the letters of the Carolingian script have long ascenders and descenders, and the whole script has a forward-leaning, cursive quality. Note that the underlying shape of the o is an elongated oval.

In the sample in figure 83, I refer to Carolingian as a "bookhand"—in other words, a script suitable for long passages of text. Because of its cursive character, it lends itself to projects like manuscript books. Many scribes find it an efficient and easy script for long blocks of text. It has fewer pen lifts than, say, the Foundational Hand, making the words go down on the

page quickly, smoothly, and efficiently.

The Carolingian benefits from generous line spacing. The thickness at the top of the ascenders is achieved by making a pushed stroke, as shown in the pencil drawing to the right of the right-hand l in figure 84. Note that this pushed stroke goes up, across, and down into the main stoke of the letter in one motion; the entire l is made without lifting the pen.

Figure 85 is another pangram. In this piece of writing, I have used a slightly different form of the y than what is shown in figure 86. This y has a vertical, rather than diagonal, descender, which follows the same slope as the other upright strokes. Note also that the f has been made shorter than the other ascenders. With its long arched top, it becomes ungainly if it is the same height as the tall ascenders. This form of the shorter f can be seen in medieval manuscripts.

In the examplar in figure 86, the cap height is approximately 3 nib-widths; the ascenders extend 4 nib-widths above the x-height, and the descenders extend 4 nib-widths below the base line.

The Gothic Hand

Gothic, the classic script of the late Middle Ages in Northern Europe, is

A version of Carolingian Minuscule based on the writing from the ninth-century Moutier-Grandval Bible | *abg*

abcdefghijklmnopqrstuvwxyz

86

carolingian

Alpha Bravo Charlie Delta

Echo Foxtrot Golf Hotel

India Juliet Kilo Lima

Mike November Oscar

Papa Quebec Romeo Sierra

Tango Uniform Victor

Whiskey X-ray Yankee Zulu

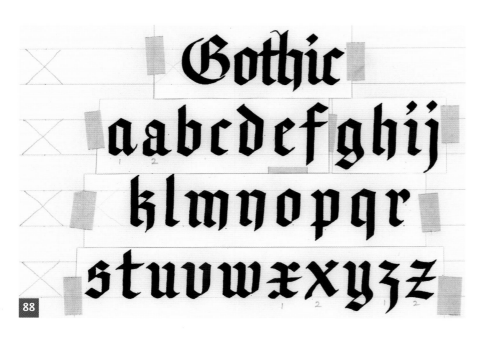

dense and rich. Its compressed character and angled, diamond-shaped strokes give it an almost threatening appearance.

Notice the close line spacing in figure 88—the short ascenders and descenders allow the lines to be packed tightly together. Instead of skipping two lines between each row of letters, you only need to skip one.

Gothic capitals can be enormously playful. The samples given in figure 89 are fairly simple, but if you look at medieval manuscripts, you will often see that scribes used the capitals as opportunities to experiment. The capitals stand out in contrast to the even texture of the minuscules.

88. The Gothic Hand minuscule alphabet.

89. The Gothic Hand majuscule alphabet.

90. A Latin liturgical text written in the Gothic Hand. It roughly translates to "Glory to God in the highest and on Earth peace to men of good will."

Gloria in ex
Deo, et in te
hominibus
voluntatis.

PER ME SI VA NELLA
CITTÀ DOLENTE

*By me you enter
the Sorrowful City*

PER ME SI VA NELL'
ETERNO DOLORE

*by me you enter
Eternal Sorrow*

PER ME SI VA TRA LA
PERDUTA GENTE

*by me you go
among the lost*

GIUSTIZIA MOSSE
IL MIO ALTO FATTORE
FECEMI LA

*Justice was what
moved my creator*

*Divine Power made me the Highest
Knowledge and the First Love.*

DIVINA POTESTATE
LA SOMMA SAPIENZA
E IL PRIMO AMORE

DINANZI A ME NON
FUR COSE CREATE
SE NON ETERNE ED

*Nothing was
made before me*

IO ETERNO DURO

*save the Eternal, and
I shall endure forever*

LASCIATE OGNI
SPERANZA

Abandon all Hope,

You that enter.

VOI CH'ENTRATE

Working with Color

6

The principle of working with color is fairly simple. If you want to move away from pure black ink, you should write with gouache, an opaque watercolor that comes in a full range of hues. Calligraphers tend to avoid colored inks and ordinary watercolors for a simple reason: They are too watery and don't produce a solid tone. Colored inks tend to pool at the end of strokes, giving your work an uneven appearance; your strokes vary from dark to light in ways you can't control. Gouache, however, creates a nice, uniform tone. Just as you want your black ink to give you even, solid strokes, you want your gouache to do the same thing.

One of the benefits of gouache is that you can write in a light color on dark, colored paper—for example, you can write white letters on black paper, or yellow letters on dark green paper. In these instances, the opacity of the gouache is especially important; you don't want the dark paper to show through at all.

The trick to writing with gouache is to get the correct consistency. Gouache usually comes in tubes; when squirted out, it is thick—about the consistency of toothpaste. You will need to add water to produce a liquid that can be loaded into your pen with a brush. The consistency of the gouache should be that of heavy cream, liquid but dense. If you add too much water, the gouache becomes thin and functions more like an ordinary watercolor, lacking the opacity you need.

The Technique

Let's start with a simple task: Choose a color of gouache, and write using the color straight from the tube. You may find that some colors run through the pen better than others, depending on the pigment they contain. Most calligraphers have certain favorite colors that they find work well in their pen, and not everyone agrees about which colors are difficult to use. But all calligraphers agree that the "feel" of different colors of gouache can be very variable. Some colors, even when thinned with water, are rather viscous, and do not flow freely. Experimentation will help you figure out which colors work best for you.

91. A writing sample by Christopher Calderhead, from Dante's *Inferno*, done in gray and red gouache on Frabriano Ingres black paper. The large Roman Capitals are heavy versions of the capitals in chapter 3. The small red writing is in the Italic Hand.

92. *Erthe took of Erthe*, a Middle English poem.

In my experience, the colors listed below work well. Many of these are not pure hues, meaning their colors are not bright and clean. For example, chromium oxide, my favorite green in terms of its performance in the pen, is a decidedly olive-drab color, rather than being a bright leaf green. The following list is not exhaustive by any means, but comprises the never-fail colors that I use most.

Blues	**Oranges and Yellows**
Cobalt blue	Cadmium orange
Indigo	Cadmium yellow
Earth tones	Chinese orange
Burnt sienna	Naples yellow
Burnt umber	**Reds**
Raw umber	Cadmium red
Yellow ochre	Red ochre
Greens	**Whites**
Chromium oxide	Permanent white
	Zinc white

There are some brands of gouache, such as Schmincke Calligraphy Gouache, that have been specially formulated to work in the pen. These come in a range of standard colors, and include purer hues than those listed here.

A small artist's palette with individual compartments for different colors is ideal for mixing the gouache. These small plastic or ceramic palettes can be found in art supply stores. There is no functional difference between plastic or ceramic; I find the inexpensive plastic ones are less aesthetically pleasing, but they are just as practical and far more portable than the ceramic variety. The plastic ones are very lightweight, which is sometimes a problem, as they can be tipped over or jostled easily. The ceramic palettes are heavier and stay in place better.

Alternatively, a small, white ceramic dish may be used instead. If you decide to use a ceramic dish, keep in mind that the paint will probably seep into cracks and discolor the plate, so don't use a dish you intend to eat from in the future. Be aware, as well, that some of the pigments in gouache are toxic if ingested, which also mitigates

Storing Your Gouache

The ideal container in which to store your gouache for future use is a small jar with a lid. It should contain no more than about a tablespoon of gouache. The tiny individual jam jars provided by some hotels are my favorites, but you can also purchase small plastic or glass jars at stores that sell storage or art supplies. In a pinch, a shot glass can be used. Cover it with plastic kitchen wrap sealed with a rubber band between writing sessions.

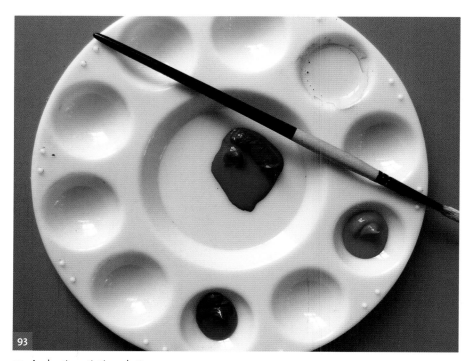

93. A plastic artist's palette.

Squeeze a small amount of gouache onto your palette. You may find that an oily-looking liquid comes out of the tube alongside the thicker gouache paste. This is glycerine residue and can be wiped away with a brush or mixed back into the gouache.

Now add a small amount of water. You can do this using a water dropper or by dipping your brush into your waterpot and transferring the water in increments with the brush. Don't pour the water on top of the gouache; put it next to the gouache, as shown here.

Now you have a little mountain of gouache and a lake of water. Using your brush, pull some of the gouache from the mountain into the lake, and mix it. Continue pulling from the mountain into the lake until you have a little puddle of color that is the consistency of heavy cream. You will fill your pen from this lake of watered-down gouache.

against using the same plate for painting and eating.

The photographs in the above "How To" section prepare your gouache using the mountain-and-lake technique.

One benefit of this mountain-and-lake technique for beginners is that you can continually adjust the consistency of the gouache lake. If it is too thick, you can add a few drops of water and stir. If it is too watery, you can pull additional pure gouache into the lake with your brush.

Gouache dries fairly quickly, so don't spread your lake too thin. Every time you dip your brush into the lake, give the lake a little stir to make sure the pigment isn't settling to the bottom. You will probably want to add a few drops of water as the lake evaporates about every ten or fifteen minutes. If the edges of your lake begin to dry out, use your brush to pull the dried edges back into the lake.

This method sounds much more labor-intensive than it actually is in practice. Once you get used to the technique, it becomes second nature. You will discover what consistency of gouache flows best through your pen, and you'll be able to feel whether the consistency is correct every time you dip your brush into the lake. If you find that the gouache in your lake is lumpy, then blend the lumps into the lake, or add a little more water.

Now you are ready to load your pen. Your palette should be on a flat surface next to your left hand, which will hold the brush. Your pen is in

I generally load my pen from the top.

Then I turn it on its side and load it again from the side.

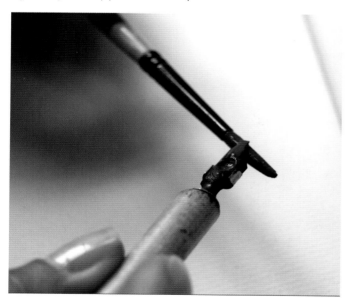

Next I run the nib through the brush bristles to make sure the entire nib is coated with a layer of gouache.

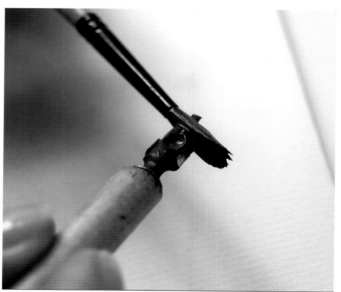

As with ink, the reservoir should be filled with liquid, but should not be so loaded that the pen will drip.

your right hand. (Left-handers should do the reverse.) Dip your brush into the lake, stir, and then lift it to the pen. As you pass the bristles along the top of the pen, the brush will release its store of gouache into the space between the nib and the reservoir. Look closely at the "How To" section, which shows a properly loaded nib up close.

Once the pen has been loaded with color, write as you would with ink. This is where you discover whether you have mixed your gouache to the correct consistency. If the writing is

not opaque—if it is thin and watery— pull more gouache into your lake to make it thicker. Reload the pen and try again. If, on the other hand, the gouache is not flowing from the pen, it is probably too thick. Rinse the pen, add more water to your lake, remix, and reload the pen.

A little trial and error should quickly accustom you to the technique. As you write, continue to hold the brush in your nondominant hand; you can usually load the pen several times from a well-laden brush before you need to refresh it from your palette. Every time you load the pen, be sure to run the brush across the top and bottom surface of the nib to avoid a buildup of dried gouache.

You will find that, over time, the pen will become slightly clogged. Simply dip the pen into your waterpot, swish it around, and then touch it on a rag to remove any water. Reload the pen as before and continue.

When you are done, be sure to wash out the pen thoroughly. If you have any gouache left on your palette, simply cover it to protect it from dust. It's not a problem if the gouache dries out; dried gouache works just as well as the paste from the tube. The next time you want to use it, just re-activate it with water. To do this, put water in the dried lake area, and wet one side of the dried mountain. The gouache will soften and begin to flow into the lake, much as it did when the gouache was placed on the palette straight from the tube. You may have to spend some time massaging the mountain with your wet brush to release enough paint into the lake.

Writing with gouache is often slightly less crisp than writing with ink—the paint is, after all, a little thicker in consistency than ink is. You should aim for the crispest writing you can achieve. With time, as you learn to control the paint, you will find that your writing in gouache is almost as sharp as what you can achieve with ink.

Certain colors—indigo and red ochre come to mind—have very strong staining properties, and can be used in a very watery state without losing their opacity and evenness of tone. Others, such as Naples yellow, need to be thicker to retain these desirable qualities. When writing with a light color on dark paper, the paint has to be on the thicker side. Once again, as you gain experience, you will adjust your practice, mixing certain colors to a more fluid consistency while mixing others to a slightly thicker consistency. The variations are slight, but a sensitive scribe is aware of the ideal consistency for each color.

Mixing Colors

Once you've mastered the basic technique of working with gouache, you can try mixing colors. Do this on the flat surface of your palette, pulling from two mountains of different color into a central lake, or you can prepare a batch of color in a small container with a lid, to keep for later use.

By mixing your own colors, you're not limited to the color range available directly from the tubes. For example, you might want to add white to a strong color to create a softer pastel shade, or you might want to mix a complex color like salmon pink (a pure warm red, plus white, plus a dash of yellow) or blue-green (indigo and chromium oxide).

If you choose to mix your colors on an open palette, you will discover, as you write, that there are slight variations in tone; each time you replenish the lake from the two mountains of different-colored gouache, the color balance will shift slightly. This can produce a pleasantly varied effect, as the tone gradually shifts along the spectrum between the two colors.

A year in Shakespeare's knot garden

94.

94. The large letters in this piece were written with ultramarine gouache. The tiny capitals were made with a very fine-pointed brush using Venetian red gouache. The illustrations were made with a pointed brush and highly diluted gouache.

If, however, you desire a perfectly consistent color, it is best to make a small batch of mixed gouache and keep it in a container with a lid. As long as you work from one batch of paint, your color will remain exactly the same.

When working from a batch in a container, be sure to stir the mixture at the beginning of each session; you want to make sure the various pigments and the water that you've added are evenly distributed in the container. You also need to make sure that the mixture does not begin to thicken due to evaporation. If it remains open for longer than an hour, you will need to

add a few drops of water from time to time to make sure the mixture maintains the necessary creamy consistency. To use the gouache, you don't need to pour it into a dish; simply dip the brush directly into the container. When you are done writing, seal the lid tightly. Liquid gouache that is kept in a container will eventually evaporate, just as gouache in a dish or palette will, but it will evaporate more slowly since only the top surface is exposed to air.

AN EXCEPTION TO THE RULE
Although you usually want your writing to be solid, with a consistent tonality, there are times when, for artistic

effect, you may want your colors to be thin and watery. Watery color may come into play if you opt to do a passage of writing that has more tonal variations. In this case, you can water down your gouache until it becomes less opaque.

Two classic inks that create variations of dark and light are oak gall ink and walnut ink. Both of these inks produce lovely brown shades that are much less opaque than your standard black inks. With small writing, if you control your ink flow properly, the variations are not very extreme, but with large writing, these inks give a range of tone that can be very attractive.

This exception illustrates the fact that all the principles I am laying down in this book are not so much inviolable laws as they are rules of thumb. Establishing a good foundation and following the way of the craftsperson will allow you to break the rules later on. The craftsperson aims for good letterforms, properly spaced, and made with strong ink or color. The artist may want to break these rules and make something that is looser and more free. You need to realize that watery color can give a superficially pleasant appearance to weak letterforms, while opaque color is far less forgiving. Learn to be a craftsperson first, and the rest will follow.

USING GLAIR

Gouache, used in the way I described, will adhere to your paper with no difficulty. Gently run your hand across the page after the gouache had dried thoroughly; it will feel chalky. If you rub it hard, as when you erase the lines, you may find that it smudges easily. Plain gouache requires very gentle treatment. Gouache has just enough binding agent to hold the pigments to the surface of the page, but it can't be disturbed. Work executed

It's the sheer physicality of writing that's gone missing.

95

in gouache needs to be protected in a frame with glass to make sure the pigments do not get smudged or rub off.

The delicate nature of gouache is no problem for broadsides, which are flat works that will likely be protected under glass. I don't want to exaggerate the risks—a work in gouache will generally be fine if it is stored in a dry, clean place.

There are times, however, when you will want your gouache to adhere more strongly to the paper on which it is written. This is particularly true when you make writings for books. Bookplates, which are inscriptions in the front of books, or whole manuscripts need to be made with greater care than framed broadsides. In a book, your writing is sealed between the pages; it touches the opposite page. Changes in humidity can activate the gouache, causing it to transfer a ghost image to the facing page. The friction of pages rubbing against one another or the pressure of a book press can

95. An example of writing using walnut ink, showing dark and light variation.

96. Making glair; whipped meringues at left, and the mixture draining at right.

also cause your writing to smudge the opposite page. This is called "offsetting" and is a major headache for a scribe, ruining the neat, tidy appearance of your work.

To address this problem, you can add a few drops of gum arabic (available in art supply stores) to your gouache when mixing it in your palette or container. This gum is a binding agent that makes the pigment stick to the paper better. Be careful—only a drop or two is needed for a small, teaspoon sized batch of gouache.

Another way to keep the pigment sticking to the paper is to make a powerful binding agent composed of egg whites, called glair, to use in place of water when you are mixing your gouache.

Making the Glair

The first step to making glair is just like making a meringue. Carefully crack open an egg over a bowl, being careful to not break the yolk. Separate the yolk from the egg white and discard the yolk. Beat the egg white with a whisk or fork until the mixture is white, fluffy, and stiff (you may also use an electric mixer if your wrist isn't up to the challenge of hand-beating the egg). When you can raise the whisked egg white to a strong peak, you are ready for the next stage.

Transfer the whisked egg white to a colander placed over a small bowl or dish. Let this set, either in the refrigerator or on a countertop. A clear, slightly yellow liquid will distill from the colander into the dish. The distilling should take about an hour.

Discard the fluffy residue left in your colander. Pour the egg distillate from the dish into a small pot. Now add water (one part water to one part egg distillate) and mix. This is your glair.

Working with Glair

Use your glair just as you would plain water. Follow the same mountain-and-lake steps outlined previously. The glair is slightly more viscous than plain water, so the balance of glair to gouache will be slightly different than the balance of water to gouache. As before, aim to make a glair/gouache mixture that is the consistency of heavy cream. (For rinsing your brushes and pens, continue to use the plain water in your waterpot. When you are done writing, rinse all your tools throughly under the kitchen tap. You don't want your brush to dry out with any residue of glair in it.)

You will find that the glair has a subtle effect on the color of the gouache, giving it a slightly yellow cast, and maybe darkening it just a bit. The effect is not pronounced, and is more noticeable in subtle colors than in strong ones. You will also notice the egg-inflected odor of the glair. When your writing dries, it will have a subtle eggshell sheen.

When you are done writing, cover your pot of glair and store it in the refrigerator. Glair can keep for several days if stored properly. After a few days, make a fresh batch.

Treating Paper with Gum Sandarac

Gum sandarac is a powdered resin, from the African sandarac tree, which can be purchased from specialty art suppliers. Similar to the rosin (a type of resin) used by baseball pitchers to remove perspiration from their hands, it has the property of resisting water.

Classically, gum sandarac was used as a preparation for vellum, the parchment skins used for writing medieval manuscripts. The grittiness of the sandarac, when rubbed into the vellum, disturbed the surface and helped create the slightly textured surface that held ink best.

Many calligraphers still use sandarac to prepare paper. You will find that paper prepared with sandarac resists your ink as you write, giving your characters sharper edges. If a sheet of paper feels too slick, or if you find that your ink is bleeding slightly, soaking too deeply into the page and not leaving you crisp, even writing, then a dusting with sandarac may help. Finally, some calligraphers like to paint a wash of watercolor or thin gouache as a background before writing. Untreated, the painted surface will not take ink or gouache properly, as it will draw the liquid out of the pen too fast, causing a blobby, uncontrolled ink flow. Dusting a painted page with sandarac and gently rubbing it in will not damage the underlayer of paint, and it will produce a surface more conducive to writing.

Place a small amount of sandarac powder (slightly more than a teaspoon) in a cloth pouch and tie off the top. For the cloth pouch, use an old handkerchief or a rag cut from an old

97

white T-shirt. Using a dabbing motion, pat the pouch across the surface of the paper to release a fine dusting of sandarac. The fine particles will filter through the cloth as you move the pouch against the paper. Next, gently rub the powder into the paper with broad, circular motions of your hand (you can use another rag to protect your hand). With a wide, dry paintbrush, sweep away the excess powder. I like to use a wide housepainter's brush for this purpose.

You can, of course, overdo it: Too much sandarac makes the paper hard to write on. Sometimes, overprepared papers cause your strokes to split in the middle: As the ink settles on the page, a little channel opens down the center of each stroke. I advise you, then, to start slowly on a test paper to gauge how much sandarac is helpful.

97. A small handmade pouch sits next to a sample of ground sandarac.

MENE

ng,
rink
ld,
the
rote

MEN

TEKE

PHARS

The Broadside

7

By far the most common kind of calligraphic work being made today is the broadside, which is writing made on a flat piece of paper designed to be put into a frame and hung on a wall. The term *broadside* comes from printing, where it refers to a single printed sheet. Broadsides are sometimes described as *panels* or *panel* pieces. The best thing about the broadside—as opposed to, say, a manuscript book—is that it can be hung and displayed with minimum fuss; it requires only a frame to make it a finished piece of work.

In this chapter, I'll describe the classic ways to lay out a broadside by considering the arrangement and placement of text on ruled lines and the balance of the various parts of a composition—titles, texts, and attributions—to make it a harmonious, whole work of art. The following discussions are not intended to straightjacket your creativity, but to give a sound basis for its development. Other possibilities—writing freely without guidelines, using colors to create layered backgrounds, or the use of illegible, gestural marks—are very much part of contemporary calligraphic practice, but I want to educate beginners in the traditional, craft-based techniques that form a firm foundation for later innovation.

WRITING A QUOTATION

The quotation is the simplest form of broadside. The approach for this project assumes you will do a good deal of writing, copying out the text several times until you achieve a balanced composition.

What You Will Need
• 5–10 sheets of good art paper (see the section on types of paper in chapter 1 if you are unsure of what to buy)
• A prose quotation, between 15 and 50 words in length
• 4 long strips of a neutral-colored paper (brown wrapping paper works well)
• Your usual calligraphy supplies

At this stage, it's not important to come up with a clever "design." In fact, the last thing you want to do is design the piece. The scripts you have learned are a complete system; let the system carry you. Trust it—the piece will come together of its own accord.

98. Detail of *Mene Mene* by Christopher Calderhead.

This approach is very craftsman-like. After all, the great medieval scribes rarely thought, "Shall I write a book on blue paper today?" Or "What script shall I use?" Those decisions had been made for them already. Instead, their sole task, as Johnston said, was "to make good letters and arrange them well." This is the attitude you should bring to this project.

For your text, it's best to choose a piece of prose, rather than poetry. Poetry has fixed line divisions, which have to be respected. Prose is more flexible. Your text should be at least 15 words long, but not over 50 words. This gives you enough text to play with, but not so much that the writing becomes burdensome (you will be writing the text out a number of times).

If you have been working with the Foundational or Italic Hand from this book, almost all your design questions have probably already been addressed. You have been writing letters of a certain weight and scale and your line ruling is fixed; stick with these. It's best to work with a simple layout, writing your text flush left and leaving uneven, or ragged, edges on the right. There are only two layout decisions you will need to make. First: Where should you break the lines? In other words, at what point do you stop writing on one line, and begin writing on the next? Second: Where are the trimmed edges of the piece? The margins (the blank spaces surrounding the writing) are as important in the finished piece as the writing itself.

Once you have chosen your text, begin by simply writing it out on a sheet of good paper. Don't worry about how it will look. Just get it down on the page. Now you're working with text that is right there on the page. We work with what's in front of us, not an idea in our heads. Pure ideas seem so wonderful, so coherent, so balanced. They rarely survive being translated onto the page.

Now that you see the text in front of you, where do you think the lines naturally break, according to their meaning? It can be helpful to write it out a few times in pencil to see where line breaks make sense. These are some of the ways one could write out the quotation shown in figures 99 to 101:

1.

The greater part
of what my neighbors
call good
I believe in my soul
to be bad,
and if I repent
of anything,
it is very likely
to be my
good behavior.

2.

The greater part of what my
neighbors call good
I believe in my soul to be bad,
and if I repent of anything,
it is very likely to be my good
behavior.

3.

The greater part of what
my neighbors call good
I believe in my soul to be bad,
and if I repent of anything,
it is very likely to be my
good behavior. THOREAU

99. Begin by writing out your text on a sheet of good paper. Don't worry about the design yet; just get the words down on paper so you have a sense of what you're working with.

In the preceeding example, the first version was an attempt to create a tall column, but the two longer lines do not work visually; besides, the text becomes choppy. The second version breaks the lines where each thought ends. This way of breaking the text is referred to as using "sense breaks." Dividing a text this way mirrors the way we might read the text out loud. This could be a good solution, but it creates a hole in the center, between the two longer lines. The third version makes a fairly coherent shape, especially if the attribution is added. The line breaks don't match the sense breaks, but, since this is prose, they simply impel you on to the next line.

Having made a tentative decision about a layout, write it again.

Go over the line breaks you tried. You are looking to see both if they respect the text, and if they make a nice shape on the page.

No layout is complete until it has margins. Take your long strips of neutral color paper and make two L-shaped "ears." Slide these back and forth until you have a set of margins you like.

At this stage, you may see that the margins create problems in your design. Or you may be pleased with what you see. Keep writing the text and checking with your L-shaped ears until you have a piece that seems balanced to you. It is better to write out a piece ten times in various configurations than to fret over the design. Just choose your best one.

Once you are happy with your layout, lightly mark the position of your margins using a 2H pencil, then check that your margins are square using your T-square. The triangle set along the T-square is used to check the verticals to make sure they are perfectly perpendicular to the horizontals (don't disturb the T-square as you slide the triangle back and forth

The greater part of what
my neighbors call good
I believe in my soul to be bad,
& if I repent of anything,
it is very likely to be my
good behavior. —THOREAU

100. Look at what you've written with fresh eyes. How does it sit on the page? Do the line breaks make sense? Think about any adjustments you might make and write it again, still using your good paper.

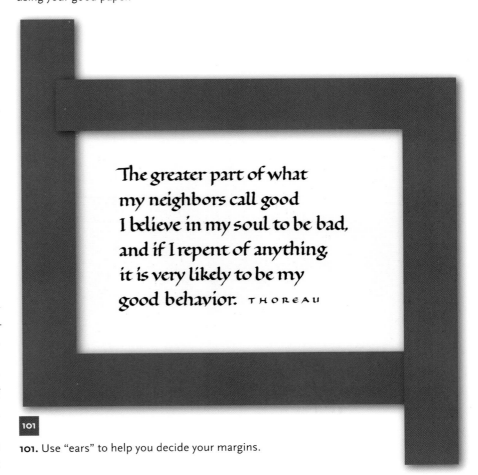

101. Use "ears" to help you decide your margins.

> # If you slow down, everything will go faster.
>
> ## A SERBIAN PROVERB

102. If you're framing your work with a mat, draw a larger rectangle around your margin line and trim the work using that. This leaves extra paper that will sit under the mat, allowing you to maintain your desired margins.

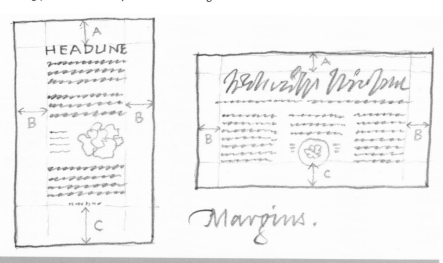

A Note about Margins

The basic design rule of thumb is this: All the margins around your piece need to be larger than the space between the lines of writing. The top margin is usually the smallest of the four; the two side margins are slightly larger; and the bottom margin is the largest. With a ragged edge, you have to make a judgment call about how wide the margin should be, since there is nothing firm to measure.

along the straight edge). Using your T-square and triangle, mark the margins more firmly in pencil.

You will need to trim your piece down so it can fit into a frame. I prefer to frame work without a mat, so I usually cut the piece along the margin lines. The frame will cover only about one-eighth of the edge of the piece. But if you prefer to frame the work with a mat, it is advisable to draw a larger rectangle around your margin line, to leave some extra paper that will sit under the mat. This new, larger rectangle can be about 1 inch wider on each side of the piece. With a ruler, measure and mark 1 inch from each side. Then using your T-square and triangle, draw the trim lines. Cut out the piece along your trim lines.

Now you should erase your ruling up. When erasing, be careful not to rub your lettering with any pressure. In fact, it's best to erase around the lettering. You don't need to erase every single line; the small line fragments right next to the letters usually become visually insignificant next to the dark black writing.

BROADSIDE PROJECTS: DESIGN CONSIDERATIONS

The first thing to do is consider the purpose of your broadside. What is it you're making? The possibilities are endless. Perhaps you want to make a little notice to hang on your porch that says, "Please wipe your feet before coming in the house." Or maybe you want to write out a poem for the foyer that welcomes people to your home. Then again, you could be making an intimate piece for someone you love, which will be framed and sit on his or her desk. Or you might be so moved by a passage from a favorite book that you want to write it out in a large and bold composition to hang on the living room wall. Broadsides can be practical (you want

If you slow down, everything will go faster.
If you slow down, everything will go faster.
If you slow down, everything will go faster.
will go faster.

103

people to wipe their feet) or artistic (you want someone to experience the beauty or wisdom of a text you find meaningful).

Each of these projects requires certain design elements. A notice on the porch should probably be a simple black-and-white affair, easily spotted, with large writing and small margins. It shouldn't be any bigger than, say, 9 x 12 inches. An intimate poem for a desk might be written in color in a delicate script, and be 8 x 10 inches or smaller. A long text, such as a whole poem for hanging on a wall, could be very large indeed—perhaps 2 x 3 feet.

In England, for the last hundred years or so, there has been a tradition of posting little calligraphic notices on churches that remind visitors to kneel and say a prayer while they visit. These beautiful examples of calligraphy are often relatively small—about 10 x 20 inches—as befits their placement in the narrow porches of ancient parish churches. Inside the church, a larger calligraphic panel might list the vicars of the parish, going all the

way back to the twelfth century. Each project brings its own sense of scale.

While thinking about the purpose of your broadside, consider the experience viewers will have when they see it. In the examples above, I've mentioned the context in which a piece might be viewed—on a house porch, in a medieval church, in a small frame on a desk. Looking at a small object at a very close range, you can see every little detail; a carefully written poem in subtle colors makes us look at the writing itself very attentively. Small margins and a simple layout can be very effective at this small size.

Looking at a large piece from across a room, we see it differently. We usually are attracted to a bold composition; strong contrasts in the sizes of the written texts may work well. The arrangement of the elements on the panel might pit dense areas of writing against large areas of white space. A large piece may also need finer details that will come into play and be appreciated when it is viewed at close range. I typically feel that a big piece should

103. Don't spend too much time imagining what your piece will look like—focus on getting multiple versions of the text on paper. Write slowly and deliberately, paying attention to letterform. You can choose the best version to use in the final piece.

look good from far away, but still have a payoff for approaching it more closely—as when a large text, boldly written, is carefully interwoven with finer, more delicately written text.

Design

Design and layout are best done with a pen in your hand—you shouldn't spend much time imagining what the piece will look like. As soon as you have sense of what you would like to make, get something down on paper. Once you have a real piece of writing in front of you, the process of design is concrete. If you just think about a piece without doing any writing, you're liable to be disappointed with the results when you actually try to put your idea onto paper. It's far better to get your pen dirty and work out your design on the page.

You should rule up for your writing, even at this preliminary stage. The ruled lines will come in handy later, and they give you control over what you're doing. Don't be tempted to write quickly—the rhythm of speedy writing will not match the nice, formal writing you'll use in your final draft. It pays to write slowly and deliberately, and to pay attention to good letterform—this is the building block of a good design.

Script

Choose a script that doesn't fight with the meaning of the words you're using in your project. For example, a lovely, lightweight Italic Hand might be perfect for a Renaissance sonnet, but it would be a strange script for a text like the Gettysburg Address or Martin Luther King Jr.'s "Letter from Birmingham Jail," both of which require a script with greater gravitas. The poetry of E. E. Cummings would look awfully peculiar in Gothic. The standard Foundational and medium-weight Italic Hands are self-effacing enough to work with most texts.

Scale

Size is important in two ways. The first way—the size of the piece of work—was discussed earlier in this section. The second aspect of scale has to do with the size of the various elements within a more complex piece. If you are writing more than one short text—that is, if you are combining a number of texts in a single composition—you'll need to decide which part of the composition should draw the viewer's attention first. In other words, what will be the "hero" on the page? Typically, it's the largest writing on the page; other elements play supporting roles.

The title may be the first thing to draw attention, especially if it's rendered in large letters above a block of text. Many times, however, some part of the main text is the hero, and the title takes a back seat. Think carefully about the hierarchy you want to establish on the page: What should be looked at first? Second? Third? Your design decisions will flow from that.

Positioning the Elements

Blank spaces are as important to a successful piece of work as the writing itself. All compositions are made by balancing the positive elements (the marks you make on the page) with the negative spaces (the intervals between each element on the page). We use the negative spaces to give coherence to our design; well-proportioned spacing guides our eye and makes each component of the whole composition distinct.

Here is a rule of thumb for spacing: The margins should be the widest blank spaces on the page, visually separating the writing from the world outside the frame. The next largest spaces should separate the different elements of the composition—the title, attribution, main text, and subsidiary text(s). Smaller still should be

the spaces between the lines of each component. Even smaller should be the spacing between words. The tightest interval should be that between individual letters. If you follow this simple rule of thumb, you can't go wrong.

Size and Weight Variations

Learning to vary the size and weight of your writing is akin to a musician learning to play scales and move from one key to another. In chapter 2, we saw how the Foundational Hand could be transformed in size or weight. When you begin to design more ambitious broadsides, you should explore larger and smaller writing, changing the number of nib-widths to correspond with the x-height. These variations become an important part of your repertoire and help you balance different sizes and scales of writing in a single piece.

Rough Drafts and Pasteups

The quotation project described earlier involves a simple process of writing out a quote several times without making any elaborate rough drafts. This kind of basic approach is practical for short, simple texts. The labor of writing a text several times is none too great if the text is short and the composition is straightforward. With more complex pieces, however, it's best to make a rough draft of some kind. This is especially important if you are combining several different elements in a larger composition.

Most calligraphers will make a rough draft of a complex piece through the process of making a pasteup. In other words, they will write a text on one piece of paper, cut it out, and put it in position on a separate, larger piece of paper, which I refer to as the "backing sheet." Then they will write a heading and put that in place, too. Each element is written out and positioned in turn, until the whole composition has been

3 Proverbs
Collected in the neighborhood.

If you dig a hole to trap your foe, you'll fall into it.
Serbian

A closed mouth don't get fed.
American

It is better to be born without an eye than without happiness.
Croatian

104

104. The way you scale your text is important; always consider the hierarchy you want to establish on the page.

105. A rough draft with all the elements attached to the backing sheet with tape.

106. A rough draft with all the elements glued to the backing sheet with spray adhesive.

worked out. The term *pasteup* comes from the practice of pasting these elements down onto the backing sheet. Below, I will explain how this is done. Every element in your pasteup should be movable, so a low-tack adhesive or tape is recommended. This allows you to move the elements around on the backing sheet until you have a satisfying composition. Sometimes, the elements are positioned without being pasted down until the design is fairly resolved. I find it helpful, however, if a project is large, to affix each element to the backing sheet as I go along.

The pasteup is a work in progress. As you assemble the different elements of the composition, you can see whether the balance and scale are right for the piece as a whole. You may find that your original idea for the heading is too big or too small. Perhaps it has too much weight, or too little. You can then simply write another heading and put it in place of the previous version. You continue to do this with each design element until you have worked out a satisfying layout.

The pasteup also allows you to move elements around on the page. Perhaps the author attribution at the bottom of the piece is too far away from the main text—just move it up. Maybe the columns along the sides are cramping the central text; move them farther out toward the sides.

It is important to make your roughs on the same paper you intend to use for the final piece. Every paper has its own unique qualities—it will absorb the ink in a certain way; it will either have texture or not, which affects the way the pen moves across the page. If you do your roughs on cheap layout paper and then try to reproduce the same writing on a good paper with more tooth—texture—you'll find that your writing will change. It will often have a slightly different rhythm, and the degree of crispness will change. So it's better to use five or six sheets of good paper to make a rough, rather than indulging in the false economy of using an inferior paper at the design stage.

Once your rough has been thoroughly worked out, you can rule up several sheets of good paper and write out the finished piece. It's important to have several sheets ready for the final version, because then you have less fear of making a mistake. Many scribes will write out two or three versions of the final piece and choose the best one.

Tape or Spray Adhesive?

As you make a rough draft, you can simply lay each piece of writing on a piece of paper sitting flat on a table. But for any pieces projected to take an extended period, you will want to attach each piece to the backing sheet. Clear tape, especially the mat-finish variety, works well—it holds your work in place and is not visually intrusive.

Spray adhesive is another alternative. It is messier, since any excess residue on the piece will attract dirt and dust. You also have to use it in a space with good ventilation. Professionals who use spray adhesives always have a hood, which is a machine that sucks air away from you, like a vent in a kitchen over a stove.

To use a spray adhesive, cut out the elements you want to paste down. Lay them upside down on a waste sheet (old newspapers are fine). Spray gently, holding the can several inches above the piece (spraying from close range will leave a gooey mess). Allow a few seconds for the spray to dry a bit. It should not feel wet to the touch, just sticky. Lift the piece off the waste paper and stick it to your design.

Spray adhesives are not strong, permanent glues. They lose their adhesion over time. This is actually

Having described the basic principles involved in making a rough draft, I'd like to take you step-by-step through a specific project. This will illustrate the principles in more concrete detail. The project discussed here is a pair of quotations by Walt Whitman from the preface to the 1855 edition of *Leaves of Grass*. It was designed to hang on a wall, and sized around 18 x 12 inches. A key portion of the text was chosen to be the "hero," and was thus written larger than the other text. The second quotation was meant to be clearly subsidiary to the first.

At the outset of the process, I haven't made any other design decisions. These will come as I work through the rough draft stage.

When writing out the text for the first time, I don't worry about line breaks—I just think about how large each element might be written and get something down on paper. All these bits of writing will be cut out and assembled into my rough draft. I use the paper freely here, trying out different sizes and styles without worrying about placement on the page.

Now, using a T-square and a self-healing cutting map, I cut the elements apart. In this photo, I've cut every line individually since I want to play with the interlinear spaces and line breaks. (If at this stage you're satisfied with a whole paragraph, you can certainly cut it out as a unit all its own.)

The next step is to lay down the elements—without using adhesives—on a sheet of the same type of paper, laid flat. I can attach them when the design becomes more resolved. The downside of not pasting things down is that, in order to see the work as it grows, I need to stand on a stool so I can look straight down at it.

Having chosen a centered layout, I draw a vertical line, using a pencil and a ruler, down the middle of the page on the backing sheet. Take each element and fold it in half; center it by holding it up to the light and lining up the first and last letters. When placing the elements on the backing sheet, I align the center creases with the vertical ruled line.

When placing the lines of text into the layout, you may want to use your T-square to make sure they are all perfectly straight. Often, you will only need to do this for the first line and you can judge the rest visually. Laying down the lines of my second quotation, I am very concerned with line breaks. It is not hard to cut long lines apart and move words down to the next line if needed. This makes the next line longer still, so I may cut additional words off the next line and move them down. When a line is the desired length, I tape the string of words in each line together and center it. Eventually, I decide that the lines look best tapering toward the bottom of the page; a simple, defined shape.

I also look at the line spacing at this point: I pull the lines of the large text close together so they create a denser mass. These lines are supposed to be the visual "hero," after all. I move the lines of small text a little farther apart. It's important to realize that just because some lines are smaller than others, that doesn't mean the writing becomes less important

visually. For example, a tightly packed text at the bottom of the page could be a more imposing visual presence than the larger writing at the top. This is also why I settle on a slightly lighter-weight script for the small writing than the more standard Foundational Hand I used for the main quotation.

Finally, I position the attribution at the bottom of the page and the title at the top. Notice that the title is quite small—it's not the most important thing on the page. In the first step of my process, I wrote out several versions of the title. Placing each version on the layout and taking a good look, I decide that this small, quiet version works best.

In order to judge the layout, I need to see it without the strong shadows cast by the strips of paper. A large sheet of glass placed gently on top of the design flattens all the strips of paper and reduces the amount of shadow they cast. Note that the edges of the glass have been wrapped in masking tape for safety.

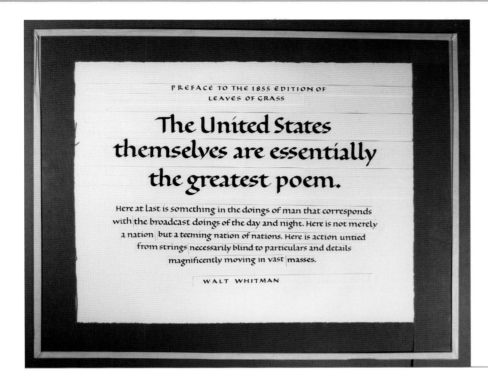

Now I need to add the margins. Using strips of contrasting paper along each edge defines the exact dimensions of my piece. In order to lay these down, I need to lift the glass slowly to avoid static electricity (with thinner papers, static electricity can cause parts to stick to the glass and the composition gets messed up as the pieces move). I lay down my margins, moving the ears back and forth until I am pleased with the layout.

Now I lay down the sheet of glass again and have another look. I check to make sure that I've followed my own rule of thumb about negative space. The largest white spaces are the margins, and there's a little less space between the elements. The spaces within each element are smaller still. All the elements hold together as a unit within a border of white space, but each one is separated from the others by clear channels of negative space.

PREFACE TO THE 1855 EDITION OF
LEAVES OF GRASS

The United States themselves are essentially the greatest poem.

Here at last is something in the doings of man that corresponds with the broadcast doings of the day and night. Here is not merely a nation, but a teeming nation of nations. Here is action untied from strings necessarily blind to particulars and details magnificently moving in vast masses.

WALT WHITMAN

At this stage, I am ready to remove the glass and tape everything into position. Because I judged many of the intervals by eye, I will need to measure everything carefully. Are the lines in the main quotation spaced exactly the same distance apart? Are the lines in the bottom paragraph evenly spaced? Are all the lines straight and parallel? Now is the time to fine-tune everything. I may have to fine-tune the placement of the margins as well. If I've been careful up to now, however, the adjustments should be relatively minor and not affect the overall composition very much. I am now ready to rule up several sheets of good paper and write out the whole piece.

handy for layout purposes—as you continue to work on a piece, you want each pasted-down element to only stick lightly so it can be removed and replaced.

A SUGGESTION ON FRAMING

The conventional frame comes in several parts: the frame, the glass, the mat, the artwork itself, a backing, and, sometimes, a layer of finishing on the back, usually consisting of a clean sheet of craft paper across the back to cover the inner workings of the framed ensemble. All the layers serve to protect the work from dust and insect damage. The glass may be UV-coated to protect the work from harmful light rays.

This standard setup works well for paintings or prints. For calligraphy, one element—the mat—is usually not visually helpful. When we frame a painting, the entire surface of the painting itself is usually a dense, colorful image. The mat serves to visually isolate this strong composition, while the frame itself creates a clean visual separation between the framed piece and the wall on which it hangs. A work of calligraphy, by contrast, often has a wide margin as part of its design. When the writing is done on a sheet of light-colored paper, then most of the surface of the piece is fairly plain. Putting a mat around the calligraphy simply adds an extraneous band of blank space around your composition. The calligraphy dies in this sea of space. If, on the other hand, the work is written on a piece of strongly colored paper, a mat in a neutral color does not have this negative effect.

I generally recommend framing works of calligraphy without the mat. The empty margins of your calligraphy composition should be wide enough to visually concentrate the viewer's attention on the writing. The frame should come up to the edges of your work, without an intervening mat.

The mat, however, serves a practical function: It keeps the glass from touching the work. If you dispense with it, you need to add a spacer (available at any art supply or frame store), which sits under the lip of the frame, and, like a mat, holds the glass away from the surface of your work.

Matless framing has, in fact, been the norm in a number of calligraphy traditions. The Pennsylvania Dutch, who in the eighteenth and nineteenth centuries produced beautiful hand-made baptismal certificates, always framed these pieces without mats. Much of the work of Edward Johnston was similarly framed.

In the end, of course, the piece itself, along with your own taste, will dictate the best framing solution.

A NOTE ON USING COPYRIGHTED TEXTS

Copyright is a vexing issue for calligraphers, and is generally not well understood. Most calligraphers prefer to write out other people's words, choosing their texts from literary masterpieces, poems, or sayings they come across. If you do this, you need to be aware of whether the words themselves are copyrighted. If the words you are using are copyrighted, then you must have permission to use them.

Practically speaking, if you find a poem by Wendell Berry or E. E. Cummings, and you want to write it out for your own pleasure and hang it in your own home, there is no problem. You can even write out a copyrighted text and give it to your mother. But the moment you make the work public, you have to deal with the person or institution that owns the rights to the words. So if you have any intention of either showing your work in a public place (even in an amateur artists' exhibition) or of submitting it to be published in a magazine or book,

Belshazzar the king made a great feast to a thousand of his lords, & drank wine before them. Belshazzar, whiles he tasted the wine, commanded to bring the golden & silver vessels which his father Nebuchadnezzar had taken out of the temple in Jerusalem, that the king, & his princes, his wives, & his concubines, might drink therein. They drank wine, & praised the gods of gold, & of silver, of brass, of iron, of wood, & of stone. In the same hour came forth fingers of a man's hand, & wrote

107

107. Another detail from *Mene Mene* by Christopher Calderhead.

you need to seek permission from the copyright holder, or use a work that is in the public domain. A good rule of thumb is to assume that texts over a hundred years old are safely outside copyright, and you are free to use them. When in doubt, consult the publisher of your chosen text.

Permissions are usually not hard to get, and many authors are only too happy to give their consent for their words to be used in an original piece of calligraphy. They may set some conditions—for instance, they may ask for a credit line on any label that accompanies the work or in any program distributed as part of an exhibition. Fortunately, if you just want to make a single handwritten copy of a text, permission will frequently be given without your having to pay a royalty. If, however you want to print the work in some form, such as on a greeting card or in an edition of prints,

then you will need to arrange a flat fee or work out a royalty arrangement.

Some very common texts are actually copyrighted—the prose poem known by the name "Desiderata," for instance, is not in the public domain, and the copyright holder does, in fact, defend its rights to the words. You should note, as well, that while an original text in a foreign language may be out of copyright, any English translation that has been recently made will be protected by the translator. So while you may freely write out a passage from Dante's *Inferno* in Italian, you may not be so blithe about a modern translation.

For amateur calligraphers who write for their own pleasure, this is not a huge impediment, but it's smart to play it safe and be sensitive to the rules that govern the use of the words of others.

Then first I saw the solemn Nile,
flowing gloomily; a ray just shining
out of the cloudy horizon from the
setting sun upon him. He was still
very high; the current rapid.
The solemnity is not produced by
sluggishness, but by the dark
colour of the water; the enormous

The Manuscript Book

8

For most of its history, Western calligraphy has been an art found primarily in books. Throughout the Middle Ages and into the Italian Renaissance, during the periods when the major edged-pen scripts that I have been describing in this book were created, the principal activity of the scribe was the making of manuscript (which literally means "handwritten") books. When we look back at the best examples of historical edged-pen calligraphy (as opposed to brush-based calligraphy), most of them are found in bound manuscripts.

With the invention of printing, calligraphers turned to other tasks. Legal documents, personal letters, and bills of trade became much more central to scribal practice than the making of books. In the twentieth century, however, when the historical edged-pen scripts were revived, a renewed interest in the art of the manuscript book arose.

A HISTORICAL AND COMPARATIVE DIGRESSION

Every tradition of world calligraphy favors its own particular graphic formats. In the highly developed traditions of East Asia, the scroll has been the standard format for calligraphy. Hanging scrolls function very much like framed artworks in the West: They are large and hang on a wall. Hand scrolls are small, and may contain either important texts or paintings, or a combination of the two.

Hebrew scribes, by contrast, have been called on to make scrolls for ritual purposes. The great traditional work of the *sofer*, or Jewish ritual scribe, involves making Torah scrolls for use in the synagogue as well as small vellum rolls with important religious texts to be encased in *mezuzot* or *tefillin*.* Traditional Hebrew work is sometimes made to be framed and hung on a wall.

A mezuzah (pl. mezuzot) is composed of two Torah passages—Deuteronomy 6:4–9 and Deuteronomy 11:13–21—written on vellum and encased in a small box. The mezuzah is hung on the doorpost of an observant Jewish home. Tefillin are small boxes containing four texts from the Torah. They are connected to long strips of leather, and are tied onto the arm and forehead of observant Jewish men, especially Orthodox Jews, at times of prayer. In recent years, some observant Jewish women have adopted the practice of tefillin as well.

108. Some examples of handmade manuscript books.

109. A silk hanging scroll, thought to be created in 1672 by the Chinese artist Kawama Jakushi, from the Shomyo-ji Temple at Kanazawa-ku, Yokohama, Japan.

Arabic calligraphers have worked in a wide variety of formats, including books similar to those of the West. One of the standard formats for Arabic calligraphy is the album, a collection of stiff cardboard leaves on which collages of calligraphy are combined with decorative papers. But in the Muslim world, calligraphy has also been widely used in large-scale architectural settings. Arabic calligraphers have also worked in the panel or broadside format, making pieces that are framed, as in the West.

Each of these different ways of approaching calligraphy informs attitudes about the appropriate scale of writing and the purposes for which it is used.

In the West, the book was the dominant format for calligraphy until about 1500 CE. Western calligraphy was very much a craft tradition, with calligraphers concentrating on the best techniques for writing beautifully and legibly in order to copy out important texts, such as the Bible. Once printing with movable type became the norm for bookmaking, calligraphy moved more into the realm of business and fine penmanship. The great writing masters from the late Renaissance until the beginning of the twentieth century were focused on training ordinary people to write beautifully, and eighteenth-century books, such as George Bickham's *The Universal Penman* (c. 1740), announced the usefulness of fine writing for commerce and correspondence.

In the early twentieth century, when the historical edged-pen scripts were revived, noted calligraphers like Edward Johnston concentrated on renewing craft practices, such as the making of manuscript books. Many early twentieth-century calligraphers were particularly concerned about reviving not only the writing styles of the past, but also the art of the hand-made book. Since then, Western calligraphers have branched away from craft and into making works with specifically artistic aims in mind. And because in our society the principal way to display works of art is to frame them and hang them on the wall, this is the format many calligraphers now prefer to use. This has enlarged the scale at which many calligraphers work and has also encouraged new ways of working, such as using acrylic paints to write large letters or incorporating calligraphy with collage or mixed media to create pieces to hang on walls.

To make a manuscript book, then, is to return to our craft roots and to shift our focus back onto the clear presentation of text. Books are smaller in physical scale than works to be hung on a wall, and they require a certain discipline to work within the constraints of the page. A book composition is small, carefully organized, and follows its own conventions.

The benefit of creating manuscript books is that it puts us in touch with the format in which the great scripts with which we write were originally created. It also fosters the discipline of writing long passages of text, which helps scribes achieve the muscle memory and the regular, even writing that is crucial to calligraphy.

MANUSCRIPT BOOKS, PRINTED BOOKS, AND ARTISTS' BOOKS

Let's make some distinctions between different kinds of books. In this chapter, we explore the ways of making a manuscript book. Manuscripts function very much like printed books, but they have their own particular logic and differ from their printed counterparts in some important ways, which are discussed below. Artists' books are a more recent phenomenon; in the last century, many visual

artists began to use the book format, exploring a more painterly approach to the form.

What all three kinds of books have in common is the central idea of what a book is: a series of two-page openings (also referred to as *spreads*) that are viewed in a sequence. They differ, however, in their attitude toward the text that makes up a book and in the layout of the pages.

Manuscript Books

In the centuries before printing, the only way to make a book was to write it by hand. The purpose of manuscripts was to preserve text. So manuscript books are text-based, rather than image-based, although illuminated manuscripts include decorative art and embellishments. The layout is based on the consistent placement of a column (or multiple columns) of text on the page. The text usually runs continuously from page to page, and you write on both sides of each page.

The placement of the column of text on the page creates what is known as a grid. *Grid* is a contemporary graphic design term that refers to the guidelines that govern the placement of design elements on a page. The grid is not a hard frame for the text area; it is more like a sculptor's armature—a supporting network onto which the visual elements may be hung. In other words, it is simply a starting point for laying out the pages, and can be used with some flexibility.

Medieval scribes had the advantage of working in a highly developed tradition. Individual scribes worked in organized scriptoria (professional calligraphic workshops), and followed the conventions of the time. They did not have to make many decisions; the way a book was made was largely a matter of standard workshop practices. They had a customary division of labor: Apprentices cut and ruled pages to standard sizes. A trained scribe did

the writing. Another scribe might add headings in red, as well as embellished initial capitals. Purely decorative and pictorial elements, such as vine-leaf patterning in the margins or miniature paintings, might be added by yet another hand. The work of all these artists was guided by the gridlines ruled onto the page.

Figure 112 is a little Book of Hours, an intimate object to be held in the hand. The text contains prayers, psalms, and hymns to be recited at different hours of prayer throughout the course of a day. I have overlaid the system of ruling up in red. Because a book should be considered a series of two-page spreads, rather than as a set of single pages, I have indicated the facing page of our single leaf.

The single column on the page has 17 lines. In this manuscript, the Gothic text is written floating just above the baselines. As we saw in chapter 5, the Gothic Hand, with its short ascenders and descenders, may be written with the lines packed closely together, as they are here. The expert scribe who wrote this manuscript only needed a baseline to make neat, even lettering and did not need to rule x-height lines. Notice, as well, that the scribe used the top line of ruling as his first baseline.

The grid is not a rigid box inside which all the elements must sit. For example, you'll notice that the initial capitals at the beginning of each verse overstep the boundary and break into the left-hand margin. Red rubrics at the top indicate a division of the text. The beginning of the text is marked with a large initial capital, which was written using three of the guidelines.

In many manuscripts of this period, the vertical margin lines on either side of the column were often extended to the top and bottom of the page, just as the top and bottom horizontal lines of the text area were extended to the

110. This *ketubah*, a special type of Jewish prenuptial agreement, was made by a *sofer*, or Jewish scribe, in Venice around 1750.

111. A detail of the main dome of Selimiye Mosque in Edirne, Turkey, built between 1568 and 1574, displays the architectural application of Arabic calligraphy.

112. A manuscript book. If we look closely at the manuscript page shown here, we can see the logic of the grid in action.

113. The grid of ruled lines in this manuscript book defines different zones on the page to be filled with writing, ornament, or illustration.

Another popular design strategy found in Books of Hours involved using the entire outer margin (indicated in yellow on the right-hand page of figure 113) as a place for elaborate border designs. A portion of the text area might be used for a major illumination (indicated in blue on the right-hand page).

The number of decorative treatments used in a medieval manuscript depended on the wealth of the client. Many manuscripts were simply written documents, without decoration of any kind. The text was written within the text column, and the margins were left blank. Very wealthy patrons might request highly elaborate decorations throughout the book.

What can we learn from these medieval scribes? The most important lesson to take away is that a carefully designed grid is the structural core of a manuscript book. However, the grid is not a hard frame, arbitrarily boxing off all the page elements from one another, but is instead meant to provide a set of guidelines on which to carry out our work.

What can we not learn from these scribes? It is almost impossible to render an English text using the format of this little Book of Hours. The Latin text is full of abbreviations, and the words are simply fragmented when they reach the end of a line in order to create an aligned, justified edge. In modern English, we can't break words anywhere we like. We have fixed conventions about these things. So if you were to try to write a text simply by copying this design, you would find it impossible to achieve the even right-hand margin that the medieval scribe was able to create. This is why we always look to the *methods* of the past scribes, but we never simply copy an antique style.

sides of the page. By extending these lines, the entire page is broken up into several zones. I have indicated this manner of ruling on the right-hand page in figure 112.

The four zones marked in pink in figure 113 show the areas where illustrations or decorative elements might be placed. In our manuscript, a painter has used the lowermost zone as a place for an illumination.

Printed Books

Let's take a moment to consider how printed books differ from manuscripts. We are surrounded by printed books and are used to their particular conventions, but there are some things of which we should be wary.

First of all, any printed book is just one copy of an edition. And like any other manufactured thing, it is expected to be perfect. Accidents, flaws, or anything interfering with the machine-made slickness of the object is considered objectionable. A handmade object like a manuscript will never have that kind of glossy perfection.

See-through, or *show-through*—a publishing term that refers to type from the back of a page showing through—is considered a major faux pas in printing. The pages are opaque, so you should not be able to see anything from the opposite side of a page. In manuscripts, show-through is often considered desirable, as it gives a faint shadow under your lines of writing, which has the effect of emphasizing the linear quality of the lines of writing.

The elaborate title page we are used to seeing in contemporary books first appeared when books began to be printed. Manuscripts were commissioned by individuals, who didn't need to be attracted by a fancy title page; they knew what the book contained. Early printers quickly realized that with the new flood of books on the market and the increased number of booksellers, a beautiful title page would help attract buyers. In manuscripts, by contrast, the text is the hero. While one might choose to make an ornamental title page, it is not necessary for a manuscript book. A simple line of writing stating the title of the work on the first page is often sufficient.

Finally, the practice of centering lines is easy with printing—on

114

a computer, it just takes a click of a button. Thus, many printed books use centered lines for titles and other elements. For a scribe, centering is laborious. Many manuscript writers simply align their lines at the left, as is natural when writing by hand.

Artists' Books

The artist's book is another genre of book that needs to be considered. In the last hundred years, many fine artists have experimented with the book format. An artist's book is not usually text-based. Although there may be text on the page, the visual interest comes from the

114. A printed book. Although this fifteenth-century book was printed instead of handmade, it was clearly based on a handwritten prototype. This is a woodblock book; a calligrapher wrote the text, which was then carved into a single block of wood. Unlike movable type, the lettering here reflects the freedom of the scribe. Letters can touch, and every letter is subtly different.

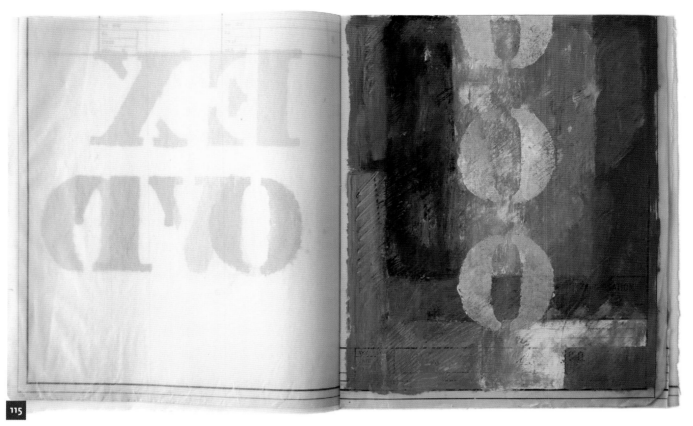

115. An artist's book. *Ex Voto*, a book made with acrylic paints, rubber stamps, and gold leaf. Although there are text elements in the book, its structure is completely free-form.

composition of abstract or figurative elements arranged on a spread.

Unlike manuscript books, artists' books rarely make use of a grid; the pages are free-form and often painterly. Each spread is generally considered a stand-alone composition.

Many calligraphers have branched out into the realm of artists' books, combining calligraphy with painted backgrounds, illustrations, or abstract gestural marks to create free-flowing compositions.

MAKING A MANUSCRIPT BOOK

The bookmaking methods we will now explore are based on the principles of the manuscript book. By mastering the craft-based technique first, you give yourself a good foundation of practice. Most calligraphers who explore the world of artists' books have already mastered the basics of making a book by hand in the traditional manner. Let us turn, then, to

some methods for making a manuscript book.

THE STRUCTURE OF THE BOOK

When undertaking a book project, you need to bear in mind the physical structure of the book from the very start. Think about the scale at which you want to work—is this a small, intimate book to be held in a person's hand; a medium-sized book to be examined while sitting at a table; or a large, atlas-sized book that you need to examine standing at a large table or lectern? The scale will affect which paper you choose to use. You also need to bear in mind the way a book is constructed. Let's look at how a book is put together.

The book structures we discuss in this chapter are made of sets of sheets of paper, folded in half, and arranged in a specific manner. Each folded sheet is referred to as a folio. One half of a folio is called a *leaf.* One side of

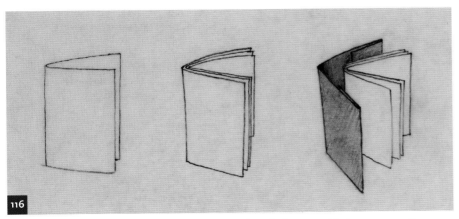

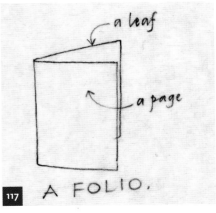

116. From left to right: a single folio; a set of folios nested together to make a single section; a section placed within a cover.

117. A folio is a single sheet with a fold in the middle and is the basic building block of a bound book. Folios are nested to make sections. Each half of a folio may be described as a leaf; each side of a leaf is a page.

a leaf is called a *page*. Each folio, then, contains two leaves, or four pages.

A book has two distinct parts: the inside pages, known as the *text block*, and the cover. The text block is composed of folios placed one inside the other, which creates a *quire*, or section. Depending on the thickness of your paper, between two and eight sheets usually make up a section. The text block may be composed of just one section (this is called a single-section book), or it may be made up of a series of sections, stacked one on top of the other (this is called a multiple-section book).

Sewing the interleaved folios of your section or sections holds a book together; this is called binding a book. Binding the book always happens after all the inside pages are finished (it is very difficult to write in an already-bound book). The cover

The whole ensemble is sewn together through the spine.

(which I will discuss shortly) may either be sewn directly into the text block or folded around the sewn text block, like the dust jacket of a printed hardcover book.

This chapter is concerned with teaching you how to make the text block. At the end of the chapter, I will explain a very simple method to make a presentation binding by sewing the finished pages into a paper cover. This is not a formal, hardcover binding, but it holds the pages together so they function as a book. For many calligraphic projects, this simple binding technique will be sufficient. For very formal work, however, calligraphers usually ask a trained bookbinder to do the binding for them. You can search online to find one in your area; there are trained binders in many major cities.

118. In a multiple-section book, a set of sections is stacked one on top of the other. The cover needs to accommodate this extra girth by including a wide spine (unlike the simple spine of a single-section book). The pages are sewn into the cover in a method somewhat different from that used for a single section.

The STEPS for BOOKMAKING

This is the classic order of working:

1. Do some trial layouts to decide on the size of the book, the style and size of your writing, and what the structure of the grid will be.

2. Cut and fold a few sets of pages. Arrange them in sections. Make more pages than you will use, just in case you make mistakes.

3. Rule up your pages.

4. Write the main text first. Add headings after the text had been written.

5. Add any illustrations.

6. When all the writing and artwork is finished, make the cover and bind the manuscript.

How Much Should You Plan Out a Book?

In designing broadsides, most calligraphers will resolve all the design issues before beginning to rule up and write out the final version. Books, because of their length, are often designed somewhat differently. I rarely do a finished layout of every page of a book. Instead, I work out a system that I can use throughout the book, and I only do rough drafts of the most complex pages. The other pages simply follow the rules I have set up at the outset.

Before you begin your design, consider what visual elements need to be included. A simple book might be a single long text, with a title page and perhaps a heading on the first page of the text. A more complex book might be made up of prose and poetry and include chapter headings, subheads, and illustrations. Think about what kinds of elements you want to include in your book. As you work on your rough drafts, decide how each of these elements will be treated.

For any book project, from the simplest to the most complex, the column (or columns) of text on each page is the basic building block of the composition, as we saw in our Book of Hours at the beginning of this chapter.

The most important design stage involves the plan for your column of writing. This should take the bulk of your design time. Deciding how large your columns will be and where they will sit on the page establishes the basic grid for your book. Once you have a grid established and know what the main text will look like, create some rough drafts of headings and other text styles, along with some sample illustrations, if any will be featured in the book. Usually, calligraphers will make rough drafts of about three spreads that show how the various visual elements will fit together on the pages of the book. With the fashioning of these rough drafts, all the basic design questions are answered. You should make sure that all the different styles of text that will appear in your book are represented on your three spreads—text, headings, captions, large quotations, and so on.

Once you have done this, you won't need to lay out the whole book. The system you worked out in your roughs should carry you through the process of writing. Any problems that arise are solved as you write out the book.

Consider the Texture and Weight of Your Paper

Before you begin creating a book, you need to choose an appropriate paper. Remember that you will be writing on both sides of the paper, so choose a sheet that has an even texture on both sides. Some papers are distinctly rougher on one side; these are not ideal for making books. In addition, you need to consider the thickness of the paper. I advise making a full-size trial mock-up of one folio of your book to test the performance of the paper.

The weight of the paper you should use depends entirely on the scale of your book. Look at figure 119. Take a sample of the paper you plan to use. Fold it and cut it to the size of the page you intend to make. Lay it on a table. The pages should not be so thick that they stand up stiffly, but not so thin that they flop over and accidentally get folded when the book is handled.

You may find that a large sheet that seems quite supple and thin enough for a book is too stiff when it is cut down to a smaller page size; this is why it is important to cut out a sample folio just to make sure.

Consider the Grain Direction of Your Paper

Paper is made of tiny particles or fibers. In handmade paper, these fibers are usually evenly distributed in a random pattern, and the paper folds equally well in either direction. Machine-made paper, by contrast, has what is called a grain direction. That is to say that, during the process of manufacturing, the fibers become aligned in a particular direction. The result is that

the paper is better at folding in one direction than in the other direction.

Since the structure of the book depends on folded sheets of paper, you need to bear in mind the grain direction of the paper you intend to use. If you fold your pages against the grain, not only will you probably end up with a cracked, messy fold, but the pages themselves won't fold properly and will lie open. A book made with paper folded against the grain functions less well than a book that respects the paper's natural tendencies.

Good paper merchants can tell you whether the sheets of paper you are buying are "long grain" or "short grain." The former folds in the same direction as its long edge, while the latter folds parallel to its short edge.

You can determine the grain direction on your own by gently folding the sheet over lengthwise without creasing it. Then fold it over widthwise. If you gently press down on it, as shown by the arrows in figure 121, you can feel that the paper is more resistant when folded in one direction than it is when folded in the other direction. The paper is telling you which way it likes to fold—follow its advice.

If you are still not sure about the grain direction, try this: Cut out a 4-inch square. With a brush, wet *one side* of the paper. As the water soaks in on that one side, it will expand, while the dry side does not. The paper will curl in line with the grain direction, as shown in figure 122.

Once you have determined the grain direction of your paper, you know how to cut your paper to make the folios for your book, so that the folds are aligned with the grain.

Working with Large Sheets

For most books, it's best to buy large sheets of good paper. You will want to fold the sheets and cut them down to make your book, as described below. You can make a book any size or proportion you wish. The two guiding principles to bear in mind are these: (1) When cutting out folios from a large sheet of paper, keep the grain direction aligned with the fold, and (2) make sure the paper is of the right weight.

Instead of deciding on a page size beforehand, many calligraphers just fold a large sheet down, see what size it becomes, and then use that organic

119

119. From top to bottom: Paper that stands up stiffly when folded to the size of your planned book is too thick. A paper of the appropriate weight will lie open easily, with either a single or a double curve, as shown. Paper that is too lightweight may fold over on itself and be damaged when the book is handled.

120

120. Paper comes in long grain or short grain. Long grain paper folds in the same direction as its long edge; short grain paper folds in the same direction as its short edge.

121

121. Determine the grain direction of your paper by folding it gently, once lengthwise and once widthwise. The paper will be fold more easily in the direction of its grain.

122

122. As it dries, damp paper will curl in line with its grain direction.

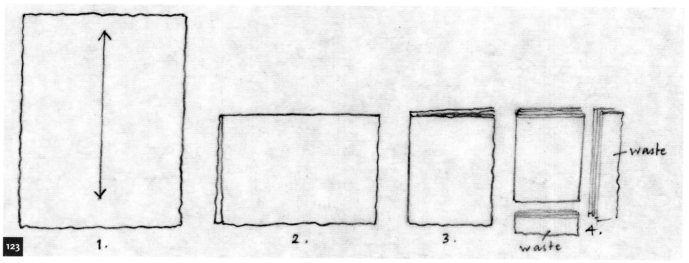

123. This is the best way to fold a manuscript book without wasting any paper.

size for their book. Take, for example, a long-grain sheet as shown above (number 1 in figure 123). The first fold is against the grain. Fold the sheet and cut along the crease (2). Next, fold both halves of the paper over in alignment with the grain (3). Now you have two folios, or eight pages. You can then fold another sheet in the same way, and place the second pair of folios inside the first to make a section of four folios. Of course, if you wish, you can trim these down further to make a precise page size (4). Or you can use the natural page size you get after folding the paper down, and leave the folios untrimmed.

I prefer to work this way; often the proportions of the folded-down sheets are quite pleasing, and I design my book based on the size of the paper, rather than imposing my own measurements on the paper. There is also no waste—when I work this way, I am using the whole sheet, rather than trimming off the edges.

In the old days, that is to say, before the twentieth century, the size of a book was described according to how many times the original sheet of paper was folded to make the book. A *folio*-sized book was very large; each sheet was folded just once to produce each folio. A *quarto* was made of twice-folded sheets, as I described above; the

page size was one-quarter the size of the original sheet. An *octavo* was even smaller, with the original sheet folded four times. There were also duodecimo and *sextodecimo* books, folded even smaller.

Papers Recommended for Bookmaking

There are numerous papers you can use to make books, and I encourage you to experiment with them. However, certain papers are tried and true—I list these below. All these papers have deckle edges (the crinkled, wavy edges of untrimmed papers that reflect the mold in which they were made). If you fold them without trimming them, you can keep these edges as an attractive feature of your book. You can purchase all these papers online.

Rives BFK, made in France at the Arches mill, is a rather thick white paper, good for large-format books.

Arches Text, also made in France at the Arches mill, comes in white or ivory. It is a little lighter in weight than the Rives, and I have found it to be a good standard paper for bookmaking.

Nideggen and **Frankfurt**, made by the Zerkall mill in Germany, are similar in weight to Ingres papers.

Nideggen is a tan sheet; Frankfurt is a light cream color.

Ingres papers are even lighter in weight, come in many colors, and are good for books at small sizes. The term "Ingres" refers to the finish of the paper; it is not a brand name. Many mills, including Hahnemühle in Germany, make Ingres papers. Be aware that one side of Ingres paper is slightly rougher than the other side and some beginners have trouble writing on the rougher side. You should test it with a pen and ink first to make sure you are comfortable writing on both sides.

Handmade papers can also be good—inexpensive sheets of plain white and other colors are available from the Khadi mill in India. The quality of these sheets varies from batch to batch, but the irregularities often add to the character of the book. European and American handmade papers are also available, although they tend to be pricier.

MAKING A SIMPLE MANUSCRIPT BOOK USING A TRADITIONAL FORMAT

For your first manuscript book, you should take a relatively short passage of prose, no longer than 2,000 words. Do not use poetry, since poems demand specific line breaks and are therefore quite tricky to lay out. A prose text will fill your writing columns very well.

One system that many calligraphers use to lay out book pages was devised by Jan Tschichold (1902–1974). Tschichold, a master calligrapher, typographer, and book designer, published an essay in 1962, titled "Consistent Correlation Between Book Page and Type Area."* In this essay, Tschichold describes a system for placing a column of text on a given page using a simple geometrical diagram. Calligraphers who use his system agree that it creates a pleasing page, but they also feel free to take liberties with it and make adjustments to it once they see what it produces. The diagram is a starting point for page design, not a fixed and firm rule.

Before Tschichold's time, it had long been known that medieval bookmakers had used certain conventions in laying out their book pages. Their inner margins were consistently narrower than their outer margins; their top margins were narrower than those at the bottom. To be even more precise, the inner margin was usually half the width of the outer margin, and the top margin was half the width of the bottom margin. But how these exact measurements were decided remained a mystery.

Tschichold felt that there must have been a method for placing the text column on the page that was based on the principles of geometry. He was convinced that there must have been an organized ratio of text and margins to the size of the page.** Examining many early books, he devised his geometric system for placing text on the page. His diagram is beautiful in its simplicity, and functions no matter what size or shape your pages may be.

Here is how it works: Take a folio and cut it to the size at which you want to make your book.

*The essay can be found in English in The Form of the Book, a collection of Tschichold's writings on book design. Translated by Hajo Hadeler and edited by Robert Bringhurst, it was published by the London-based publisher Hartley & Marks in 1991.

**It should be noted that Tschichold's diagram does not reflect the design of every medieval book. His system explains the construction of many ancient manuscripts, but it is clearly not the only system that was used. The Book of Hours at the beginning of this chapter does not, in fact, follow Tschichold's diagram.

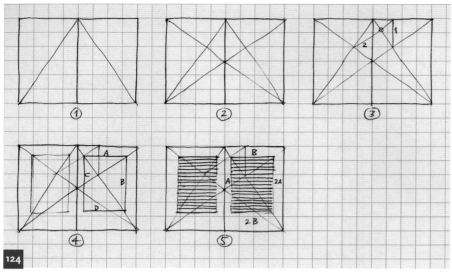

124. How to create a Tschichold diagram.

125. A square page demonstrates precisely how the Tschichold Method divides the page into intervals of ninths.

1. Draw a diagonal across each page, from the middle of the top where the two pages meet to the outer bottom corner of each page.

2. Draw two diagonals across the whole folio.

3. From the intersection of the two diagonals on one page, draw a vertical line straight up to the top of the page. Next, draw a diagonal from the top of this line to the intersection of the diagonals on the opposite page. The point circled in step 3 of figure 124 shows the key point for drawing your margin lines.

4. Now, using a T-square, draw line A from that point to the place where it intersects the long diagonal line. Draw line B with the T-square and triangle until it hits the short diagonal. Then draw in lines C and D to create a rectangle. Draw a corresponding rectangle in this same manner on the opposite page.

5. The rectangle ABCD from step 4 defines the text area for your manuscript. The margins have a fixed relationship: The inner margin (A) is half the width of the outer (2A); the top margin (B) is half the width of the bottom (2B).

Several features of the Tschichold diagram stand out. For one, the text area is enclosed in a rectangle of the same proportions as the page itself. For another, its placement grows naturally from the shape and size of the page with which you started—you can apply the diagram to any page proportion, whether vertical, horizontal, or square. Geometrically speaking, the diagram divides the page into ninths. The inner margin is one-ninth the width of the page, while the top margin is one-ninth the height of the page. This becomes quite clear when you use the diagram on a square page, as seen in figure 125.

Putting the Diagram into Practice

Once you have chosen your text, take some good paper and fold and cut several sheets to size. For beginners, I recommend a page size between 8 x 10 inches and 9 x 12 inches. This gives you a fairly large book, so that you don't need to take on the burden of writing extremely small, but it is not such a large page size that the book becomes ungainly to write in. Remember to respect the grain direction and to choose a paper of the correct weight. Also remember that your folios are twice the width of your pages: a folio of 16 x 10 inches folds to a page size of 8 x 10 inches.

Now, using the Tschichold diagram, draw the diagonals and construct the rectangles that will define your text area. You now have most of your grid in place.

You will notice that the diagram doesn't tell you how many lines to rule, or how large your writing should be. The next step, then, is to try out some lines of writing on a trial page. Your goal is to write small enough so that you get between five and eight words per line on average. If your writing is too large, you will have a shorter word count per line, which

The figures below show a book designed according the system I just described. The text is a selection of passages from Thoreau's *Walden* that I made for my own pleasure. The book is relatively small, about 6 x 9 inches. In it, I use just one size and style of writing throughout. You can vary this pattern by writing headings in a contrasting color, such as red, or by designing headings in a different size or style.

126. The Tschichold diagram was used to determine the width and depth of the text column. The diagram was made on tracing paper. Here it has been laid over the pages of the finished book.

127. The text begins on a right-hand page (also known as a recto page). Note that paragraphs are "outdented" rather than indented, a common scribal technique in which the first capital of each paragraph breaks into the left margin. You may also indent paragraphs, as you would in a printed text, but keep in mind that the first paragraph is never indented. The pages do not align perfectly at the tail, or bottom, of the book. The paper used here was handmade, and therefore slightly irregular. Rather than trimming them to be perfectly even, I decided to keep the deckle edge at the bottom. The fore edge and tail of your text block can be slightly inconsistent in this way. Always be sure, however, that the pages are perfectly aligned at the top.

128. The right-hand side of each column is slightly ragged. Note that some lines slightly overstep the margin on the right. You want to get the lines as flush to the margin as possible, while keeping hyphenated words to a minimum.

will make it hard to get an even edge on the right-hand side of the column. You will need to make several trials in order to decide on the best size for your writing, so that it fits your established column width. Try nibs of various sizes. It's good, if you are a beginner, to respect the proportions of the scripts you have mastered, rather than trying to write heavier or lighter weights. On your trial sheets, be sure to note which size nib you have used for each sample.

Once you have decided on a size of the writing, decide how far apart the lines should be. You can simply use the proportions for line spacing that are discussed in chapters 2 and 4. This is probably the best thing to do if this is your first book. However you may, if you wish, rule your lines a little closer or a little farther apart, but never pack lines so close together that the ascenders and descenders touch. Space your lines so that the channels of white in between each line are distinct and clearly lead the eye across the page (if you follow the proportions from the earlier chapters, you will encounter no difficulty with this).

Once you have established the ideal interlinear space, write out a sample of a whole column, matching the rectangle the Tschichold diagram created on your page. If your line spacing does not perfectly align with the bottom margin created by the diagram, you have two choices: You can alter the line spacing slightly to bring it into alignment, or you can alter the bottom margin slightly to accommodate your line spacing. The diagram is a starting point, not a prison for your writing. Count the number of lines that you have made.

Ruling Up

The Tschichold diagram has now served its purpose—you don't have to draw these diagonals on every page! Measure the inner and outer margins and rule them onto your folios. Now measure the top margin and rule your lines with that as a starting point. Then rule the number of lines you counted in the previous step.

Writing Your Book

Now you are ready to write. You should leave one or two leaves blank at the beginning of the book and always begin on a right-hand page.

BOOKS AND PRACTICE

Making books is an ideal way for beginner and intermediate scribes to hone their writing skills. As I mentioned in chapter 7, it takes a long time to develop your skill to the point of proficiency. Most new calligraphers need to spend about three years of sustained practice before they are truly fluent, graceful writers.

The beauty of making books is that the design decisions, once they have been made, guide the work from then on. All you need to do is keep writing until the book is finished. In this way, writing out a long text in book format builds the discipline of writing, page by page. You don't have to come up with an elaborate project every time you want some practice. At the same time, you are not just practicing for practice's sake; you are actually making a real thing with intrinsic worth.

In my own calligraphic development, I spent several years making simple, relatively short books. At the beginning of each workday, I would write in a book for an hour. Quantity didn't matter; quality did. When my hour was done, I moved on to the practical work of the day. After a few months, I would complete whatever text I was writing and I would bind the finished book. At the end of several years, I had six or seven finished books. My writing improved immeasurably and the books, even with all their flaws,

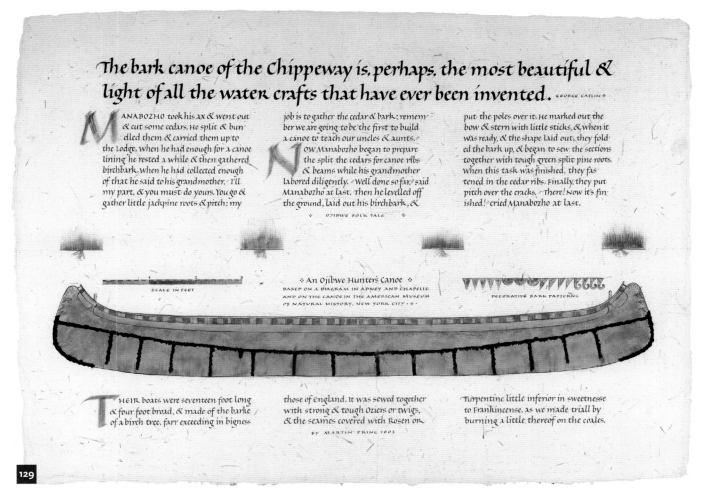

The bark canoe of the Chippeway is, perhaps, the most beautiful & light of all the water crafts that have ever been invented. GEORGE CATLIN

MANABOZHO took his ax & went out & cut some cedars. He split & bundled them & carried them up to the Lodge. When he had enough for a canoe lining, he rested a while & then gathered birchbark. When he had collected enough of that he said to his grandmother, I'll my part, & you must do yours. You go & gather little jackpine roots & pitch; my

job is to gather the cedar & bark: remember we are going to be the first to build a canoe to teach our uncles & aunts.

NOW Manabozho began to prepare the split cedars for canoe ribs & beams while his grandmother labored diligently. Well done so far, said Manabozho at last. Then he levelled off the ground, laid out his birchbark, &

put the poles over it. He marked out the bow & stern with little sticks, & when it was ready, & the shape laid out, they folded the bark up, & began to sew the sections together with tough green split pine roots. When this task was finished, they fastened in the cedar ribs. Finally, they put pitch over the cracks. There! Now it's finished! cried Manabozho at last.

✧ OJIBWE FOLK TALE ✧

SCALE IN FEET

✧ An Ojibwe Hunter's Canoe ✧
BASED ON A DIAGRAM IN ADNEY AND CHAPELLE AND ON THE CANOE IN THE AMERICAN MUSEUM OF NATURAL HISTORY, NEW YORK CITY ✧

DECORATIVE BARK PATTERNS

THEIR boats were seventeen foot long & four foot broad, & made of the barke of a birch tree, farr exceeding in bigness

those of England. It was sewed together with strong & tough oziers or twigs, & the seames covered with Rosen or

Turpentine little inferior in sweetnesse to Frankincense, as we made triall by burning a little thereof on the coales.

BY MARTIN PRING 1603

129

were enormously satisfying to have at the end of the process.

THE ORGANIC MANUSCRIPT BOOK

The Tschichold diagram is an excellent way to construct a book using a traditional format, but it is not the only way. Another technique builds the book using its component parts in an organic process. As you will see, this technique differs markedly from the more prescriptive Tschichold diagram method.

This technique actually has a bit of personal history behind it. Many years ago, I was making a manuscript book on the theme of birchbark canoes. I had chosen a beautiful handmade paper that folded to create a lovely, vertical-format page. For several months, I made rough drafts,

but nothing seemed to jell design-wise. Reaching a point of frustration, one day I decided to take out a big sheet of paper and work out what it was that interested me about my subject. I took out a brush and drew a big picture of a canoe. Immediately, I knew where I had gone wrong. Laughably wrong. I had chosen a vertical format and designed a beautifully worked-out text column for the page. But the canoe staring straight at me was a *horizontal* shape. By imposing a design decision on the book, I had completely missed the point: This book had to be horizontal.

This experience made me think hard about the method I was using to design manuscript books. It also illustrated the importance of working with what was right in front of me, rather than thinking about the project in my

129. A manuscript book created using the organic method. Due to its wide, long shape, this book was designed to open from the top like a drawing pad, rather than on the left-hand side like a traditional book. Two scripts were combined on the pages: a Roman Hand in two sizes, and capitals executed with both brush (for the large capitals) and pen (for the small captions). One set of ruling guided all the sizes of writing. The same dry brush technique used for the illustrations was used to make the large initial caps.

they do no
impertíne
the círcum
and pertír

head and imposing a design solution on the page. When I considered this, I turned back to the manuscript tradition and noticed that a lot of the work of the medieval scribes was improvised on the page. They didn't design things the way we do today; instead, they worked things out directly on the page itself, leaving a lot of the marks of their working process, whether in the form of scored lines, pricked ruling marks, or quickly drawn sketches later overlaid with formal pen-made letters or illuminations.

This organic approach to book design is the technique I developed trying to bring fresh life to the design of manuscripts. It is based on the principle of allowing the page and the design elements to suggest their own solutions; you let *them* speak to you, not the other way around. It's a much more playful, experimental way of working than the Tschichold method. This is how it works.

Decide on a Theme

The organic approach works best if you want to try combining a number of sizes, styles, and colors of writing within a manuscript book. Rather than starting with a single, continuous text, it's best to choose a range of short texts related to some theme, so that you can blend different design solutions together in the finished book.

Once you have chosen a theme, collect as many quotations, passages of text, images, and ideas pertaining to that theme as you can. This collection provides the source material for your book.

Create a Column of Text

Now write a line of text as small as you can on good paper. Choose a hand that suits the theme of your book. At this size and in this style, how wide would your column be if it had five to eight words per line?

Now write another line below your first line. How far should you space it? Try out both tight line spacing and generous line spacing, keeping your line length between five and eight words.

Once the line spacing has been established, rule up a long column (around 15 lines or so) at your designated width, with the line spacing you've chosen.

Fold and Cut Your Paper

Take a sheet of nice paper and, observing the rules about grain direction and weight, fold it down: What page size naturally emerges? The idea here is that you are not imposing a page design on your book; you are seeing to what proportion the paper naturally folds. You may end up with a page of vertical "upright" proportions (also known as "portrait" style), or you may get a horizontal, "landscape" format.

Combine Text Column and Page

The column you just wrote was made without reference to the page proportion (and thus breaks Tschichold's rules!). Now you will decide how to position it on the page you've made by folding your paper. Here's how it works: You should retain the width, but you can vary the number of lines, depending on what you think looks best. At this stage, treat your column like a window blind: It can be longer or shorter. Some people like to make a set of photocopies of their column at this stage and paste up a number of variations to see which they like best.

Place your column on the page you've created. How many lines make

130. Use the column as a forum for experimentation. Notice how one set of line ruling can support many different text treatments.

The principal text looks like
this: an elegantly proportioned
roman minuscule hand.

But NEW paragraphs might
begin with big capital letters,
followed by smaller caps.

OTHER WAYS

Change the color or the size.

experiment WITH

MANY VARIATIONS...

Don't fret about mistakes; it

*There's a fine
mistake—a
fiber caught
by the pen.* is just a game, after all!

being bold ⁝

And always return again to
your regular text.

The theme of this manuscript is trees from my neighborhood. The text is my own. Notice how the heading is written in large capitals two lines tall. The small text uses each ruled line as a baseline and the larger text uses every other line as a baseline.

The ash tree near the corner thrives, I don't know how.

There's a punctured mylar balloon stuck high in its crown. The cable company swithing box is lodged in its branches, so workmen in cherry-pickers harrass it with their pruners. Its base is fenced with iron posts, and tree lights thrust electrical wiring between its roots. Yet every year, its generous leaf-cover returns in full force.

THE PIN OAKS

on Thirty-first Avenue are old and very tall. I rarely notice their leaves, which are so high above the sidewalk and fully out of reach. But the shade they offer— that I always note on a hot summer day. The trees make a perfect canopy over the avenue; the branches almost meet over the middle of the street. What

a contrast to Thirtieth Avenue, only one block north, which has so few mature trees. The pin oaks are the last trees in the neighborhood to lose their leaves in the autumn. With their thick, dark brown trunks and crowns filled with unshed brown leaves, they make the street a sombre scene come late in October, a contrast to July's rich green.

131

131. The line ruling is left in place as an integral part of the finished pages. Note the spelling mistake on the first spread: A missing letter has been added with a caret. Errors are part of the process. While a missing letter would be a disaster on a document like a diploma, it is a natural part of making a manuscript book.

An appreciation of **URBAN** **TREES**

A stem from a young locust tree

The trees on the street, urban survivors, welcome green presents amidst the city's noise & dirt, bloom silently and unsung.

132

132. A two-column grid organizes this little manuscript. Notice how freely the lettering hangs on the grid, which functions loosely, not as a hard frame for the work.

a strong column? Where should you place it on the page—centered or to one side? Do you want two columns on every page or just one?

Once you have experimented with placing your column(s) on the page, paste or tape them into position. You have just created a grid. Now you can refine the design if you wish, making small adjustments to the size or style of the lettering, and tinkering with the proportions of the margins. At this stage you can also decide to trim the page down if you dislike the naturally occurring proportions of the page.

Working Other Elements into the Columns

Measure what you've decided upon and use your measurements to rule up several folios for experimentation. Now the fun begins.

As we saw at the beginning of this chapter, medieval scribes would often use one pattern of ruling for several sizes and styles of writing. You have ruled your grid based on the style that will be used for the principal texts in your book. You could simply fill the book with text in this size, but the ruling up allows you to play around. Try out different sizes and scales of writing, using the ruling you have done in different ways. You may want to try writing in different colors as well.

Feel free to experiment extensively. When you have played with a number of options, hone your choices. It's best to have about three or four different text sizes, styles, or colors that will form the basic repertoire of your book. I generally choose no more than two different scripts and vary the size and color.

Illustrations?

There are many techniques you can use if you wish to illustrate your work, including collage, monoprints, and rubber stamps. If you have the skills, of course, you can execute original illustrations. Try out some rough drafts of these. Make sure your illustrations will relate in some way to your grid. They might be bounded by the column guides, or they might spill into the margins. Whatever approach you choose, plan to keep it consistent throughout your book.

Make a Book

If you have followed all the steps listed, you will have created a page with a grid and given yourself a repertoire of letterforms and perhaps illustrations to create your finished book. The design stages of the organic system are intended to get you working directly on the page without imposing a preplanned idea. All your design decisions grow out of a spirit of play and experimentation.

This approach may create a highly finished, formal manuscript or the book may be treated as a looser sketchbook—it's up to you. In either case, rule up a whole stack of pages and plunge in, creating the pages as you go, using the repertoire of writing styles and illustrations you've just designed.

Is the Organic Approach for Everyone?

The simple answer is no; it depends on your artistic temperament. For some people, the uncertainty of letting a book work itself out will be anxiety-producing and they will prefer to make fully worked-out rough drafts of every page of their manuscript. If that's how you like to work, then I encourage you to try the experimental stages of the process, but in the last step, to use your experiments to make a rough draft before embarking on the final book.

Many calligraphers, however, find this organic approach liberating. It makes the work more spontaneous

133. An X-acto knife and a bone folder. The bone folder, as the name suggests, is used to gently smooth the paper folds you have made.

and less precious. Mistakes are simply incorporated into the process, and the calligrapher is released from the obligation to make a mechanically perfect thing.

PRESENTATION BINDINGS

When you have completed your manuscript, it is time to bind it. The system described here is a book structure that requires no glue and uses a paper cover. This is a practical way to keep the pages of your manuscript together so that they function as a book. Your bound manuscript can be displayed in an exhibition in a cover of this kind. Books bound in this manner should be stored flat; the binding generally will not be strong enough to stand upright in a bookcase with other books. Treated properly, though, these simple paperbound books are quite durable. For a more permanent, strong binding with a hard cover, I advise you to work with a professional bookbinder.

Tools You Will Need
- Self-healing cutting mat
- X-acto knife*
- Long metal ruler
- Triangle
- Linen bookbinder's thread (or embroidery thread)
- A large, thick sewing needle (such as an embroidery needle)
- A bone folder

Binding a Single-Section Book
Let's begin with a book composed of just one section, which is the simplest kind of book you can make. If this is your first foray into binding, it is probably wise to make a dummy first. A dummy is a blank book exactly the size of your manuscript, made with the same papers you've used in your finished book. It's best to practice with a dummy so that you have the method down before you bind the manuscript you've put so much time into.

The instructions that follow use the terms bookbinders employ for describing the text block: the *head* is the top of the book; the *tail* is the bottom; the *fore edge* is the side on which the page open; and the *spine* is the side that is sewn to hold the pages together.

Knock It Up
Take your single section in two hands, just as you would a sheaf of loose papers. Make sure the folios are neatly nested, with the folds pressed together at the spine. Turn the section upside down and, holding it gently, tap the head lightly on a table. This is called "knocking up." You want to tap the folios so that the tops of all the pages are aligned.

Measure the Text Block
Now lay your section down on the table. Measure its height and width. If you've used paper with a deckle edge, making the fore edge and tail of the section uneven, measure the longest distances.

Please read the section "Using an X-acto Knife" in chapter 10, page 151, before using this tool.

134. This diagram shows how to measure your cover. Note that the grain direction should run parallel to the height of your book.

Choose a Cover Paper

For the cover, choose a paper slightly thicker than the paper you used for the text block. The cover is designed to protect your book, so it should be able to withstand the weight of the text block. Your cover paper should be sturdy, about the thickness of card stock. You will be folding the cover paper, so it needs to be supple; don't use cardboard. I prefer to use heavy handmade papers when possible, as they are usually quite strong.

When you select a cover paper, take into account the grain direction; be sure that your cover sheet is large enough so that you can cut out a large piece that folds properly with the grain. The cover is made of a single sheet of paper that folds around the text block and is then folded over at the fore edge.

Measure the Cover Sheet

Now measure out the cover using the instructions below. When folded, the cover should be about $1/8$ inch larger than your text block at the head, tail, and fore edge. The extra width and height creates a cover that visually frames the text when the book is open and that protects the pages by protruding beyond their edges. The part of the cover that extends beyond the pages is referred to as the "square."

Figure 134 is a diagram showing how to measure out your cover.

For a single-section book, the cover has to be cut from a large enough piece of paper to include the front cover, the back cover, and two flaps. Use a pencil to mark out all the measurements given below.

1. Measure out the width of the front and back covers (A). This should be the width of the text block plus a $1/8$ inch square: Width + $1/8$ inch.

2. Measure out the height of the cover (B). This should be the height of the text block plus two $1/8$ inch squares: Height + $1/4$ inch.

3. Measure the width of the flaps (C). This is variable. A rule of thumb: The flaps should be at least one-half the width of the front and back covers: $1/2$ of measurement A.

Note the grain direction of the cover paper in the diagram in figure 134. The grain direction of your cover should match this.

Make the first cuts and folds: Now cut the paper along the head and tail; leave some excess—about 2 inches—on either side. Do not trim the right or left sides yet. Your cover now looks like the diagram in figure 138. "Ex" indicates the excess you have remaining at each side.

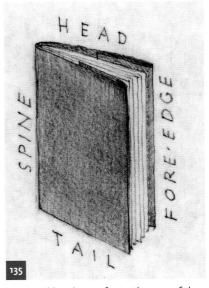

135. Bookbinders refer to the top of the book as the head; the bottom is the tail. The side that is sewn together is the spine, and the side on which the leaves open is referred to as the fore edge.

136. The upper right-hand corner of the book of Thoreau quotations. Notice how the "square" protects the edges of the text pages. All the tops of the pages are neatly aligned.

137. The bottom right-hand corner. The bottoms of the pages are not aligned; notice that the square is large enough to protect the pages that stick out the farthest.

138. The book cover extended to its full length.

139. The book cover folded. Make sure the top and bottom edges align.

Now fold the cover neatly in half. Be sure that the top and bottom edges are carefully aligned.

If the cover is stiff, score it before folding, using a blunt, pointed tool like a bone folder. You just want to dent the paper to facilitate folding, not cut or damage it. To make sure the score is perfectly perpendicular to the top and bottom edges of the cover, use a triangle to guide your bone folder.

Now set the cover aside for a moment.

Prick Holes for Sewing

The text block and the cover are pricked separately. Begin with the text block. Now you need to pierce holes through the fold at the spine of your text block. Open the section to its middle. Using a ruler for accuracy, mark the position of your holes with a pencil (see figure 140). You should mark the central hole (1) directly at the midpoint of the fold. Then mark the top (2) and bottom (3) holes each an inch from the head and tail of the book.

Knock up the text block one more time to make sure the tops of the pages have stayed in alignment.

Carefully open the section, but not too wide. The needle is placed in the fold inside the section, and pierces through the fold until it comes out the back, or spine side, of the section. Pierce all three holes you have marked.

I find it easiest to pierce sewing

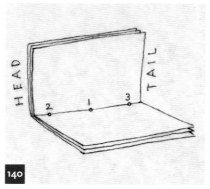

140. This shows where the locations of the holes for sewing should be.

holes if I hold the section in my left hand. The thumb sits in the fold of the center of the section; my other fingers cradle the section from below. The section is thus held in a V-shape and the folios are snugly nested together. With my right hand, I use the V-shape to guide the needle straight through the folds at the back of the section.

After piercing, gently flip the book over—being very careful that the folios do not shift position—and check that you pierced through all the folios accurately. The needle should be coming out straight through the fold of the outermost folio.

Now take the cover and, using a pencil, make three marks that align with the holes in your text block. Remember that the cover is $1/4$ inch taller than the text pages, so measure the cover holes from the center point of the fold. The holes on the cover should align perfectly with the holes in the fold of your text block. Prick the three holes you have marked through the fold on your cover.

Sew the Book

Cut a length of thread $2\,1/2$ times the height of your book. Thread your needle. Place your text block into the cover and align the holes in the text block and the cover.

This is the order of sewing; begin from the inside of the book.

1. Push the needle out the middle hole toward the outside.

2. Push it in the top hole toward the inside.

3. Push it out the bottom hole toward the outside.

4. Push it in the middle hole toward the inside. Be careful: There is already one thread going through that hole; don't pierce it as you come back in through the same hole.

Now gently pull the thread tight. Do this carefully; if you pull too hard,

the thread will rip the folios and cover. The thread should be pulled until it is taut, but it should not be so tight that it bends the book or tears the holes. Look at the back of the cover to make sure there's no excess thread; the thread should be lying neatly against the fold on the outer cover.

Tie off the thread using a double square knot. A length of thread should be running down the middle of the inner fold. Use the two ends of your thread to straddle this thread, as shown in figure 142, before making your knot. This holds that long thread down in the middle.

Finally, trim off the excess thread about ¹/₄ inch from the knot. A nice way to finish is to use your needle to unravel the two loose ends of thread, creating two soft tufts rather than hard-edged thread ends. Place the tip of your needle between the rolled strands of thread and gently pull them apart.

Fold Your Flaps

This stage is the very last. The flaps are a lot like the flaps of a dust jacket. Here, however, their function is to give a little more strength to the cover. By making these flaps, the fore edge of the cover is more rigid than it would be without them and the cover itself is a double layer, front and back. When we measured out the cover, we made no allowance for the thickness of the text block. Once you have wrapped the cover around the text block, you may find that you need to shift the position of the flap folds outward slightly. This is why we left a little excess on the right and left sides of the cover.

Since the cover is now attached to your text block, you should measure the position of these folds again. Make sure that the folds are ⅛ inch away from the fore edge of the text block. Now fold in each flap.

To trim off the excess, fold out each flap and neatly slice the excess off. Fold the flaps back, and your book is finished. It's helpful to lay the finished book under a weight overnight to allow the folds to settle.

BINDING A MULTIPLE-SECTION BOOK

The method for binding a book with multiple sections differs from the method described above in two ways: (1) You need to add a spine to the cover when you measure it out, and (2) instead of piercing holes in the cover, you cut horizontal slits.

This is how you measure out the cover for a multisection book:

The length of sections A, B, and C are the same as those in the single-section diagram shown earlier. Add another portion (D) for the spine. In a multisection book, for the spine to lie flat requires two folds, rather than one.

To determine the width of the spine, lay your stack of sections flat on

141. Piercing a hole to bind your book.

142. Binding your manuscript book with thread. The flaps are shown here in their folded position. This shows the structure of the finished book most clearly. As noted in the instructions, the flaps are not cut and folded until after the sewing.

143. This is how your measure out the cover for a multiple-section book.

144. This detail of a multiple-section book, seen from the tail, shows how the three sections nestle comfortably within the two folds that make up the spine.

145. Measuring the spine of a multiple-section book.

146. Two multiple-section books show the exposed sewing on the spine. Both of these handmade sketchbooks have taken a beating; the handmade paper covers prove quite durable.

147. Handmade manuscript books can be both functional and ornamental.

a table. Press them down gently at the spine. Unsewn sections tend to puff up; when bound, they will be more tightly packed, so push down on them to see what thickness they have when under pressure.

To measure the depth of the stacked sections, you can simply use a ruler, or you can use this method: Cut the top and bottom of the cover as you would for a single section, leaving plenty of excess to the left and right. Fold as before. This fold marks one side of the spine. Now you have to decide where to make your second fold. Place your stack of sections against the first fold.

The back of the cover is lying flat on the table while you hold the front up at a 90° angle to the table surface. Place your stack of sections flush against the spine. Press them down and use a pencil to mark the width of the spine.

Now remove your text block, and fold the other side of the spine.

Cut Sewing Slits

Lay the cover flat on your cutting mat. Mark the position of your sewing holes as described previously. Instead of piercing these with a needle, however, cut a neat horizontal slit across the spine from fold to fold.

Sewing the Book Together

Each section is sewn in separately, using the same sewing sequence we used for a single-section book. Start from the back of the book, with the hindmost section. Put it in position, sew it in, and knot and trim the thread. Now put your next section on top of the first. Sew it in. Keep adding sections until you reach the topmost one, which is the first section you encounter when you open the book.

Each time you add a new section, gently press the existing sections down. You want to make sure they are snugly pushed against the back cover.

The port would fain give succour;
the port is pitiful; in the port is
safety, comfort, hearthstone, supper,
warm blankets, friends, all that's
kind to our mortalities. But in that
gale, the port, the land, is that ship's
direst jeopardy; she must fly all
...and;
...el, would
...gh and
...she
...in so
...ry winds
...home-
...sea's
...efuge's
...into

g at her helm bu
I looked with sympa
nd fearfulness upon
ho in midwinter just
a four years' dangerous
ld so unrestingly push

r by
e life

our
very
hum'
an,
our
h whom
the

mother earth, who sustains
& keeps us, & who brings
forth divers, colorful fruits
& flowers, & the grass.
Praised be my Lord for all who
pardon one another for his
love's sake, & who endure
weakness & tribulation;
blessed are they who peace-
fully endure, for you, Most

HERD IS IN THE WATER WITH
SH HE SPEAKS WITH THE SHAD
EETS THE PERCH WEST!
NCE IS THE SHEPHERD?
SHEPHERD OF THE WEST

EUROPE 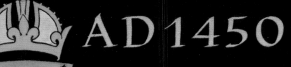 AD 1450

After 1438, the elective throne of the Holy Rom-
an Empire, whose doubleheaded eagle appears at
right, stayed firmly in the hands of the Habsburgs. In
1452, Frederick the third was crowned in Rome; he was
the last emperor to accept his crown at th
hands of the Pope. His most lasting achiev
was the arranged marriage of his son, Max
Mary, heiress to the Duchy of Burgundy in

CASTILE

ENGLAND

DENMARK

The Battle of Agincourt delivered the whole
of northern France into the hands of the English,
and with it, the promise of the French throne.
With the advent of Jeanne d'Arc, how-
ever, the tide began to turn against the
Plantagenet pretenders. Then, in 1
the Good, the wealthy Duke of Burg
arms appear at left, defected to the
Valois. By 1453, only Calais remaine
England's once proud continental em

Mapmaking

very map tells a story about a place—a particular story about a particular place. What you include in your map, and how you choose to make it, depends entirely on the story you want to tell.

Many beginner mapmakers worry that they don't know enough about maps to make a "real" map, but if you think about the most common kinds of maps that we encounter, you'll see that there is no such thing as a "real" map. What story do commercially produced maps tell? A road atlas tells you how to get from point A to point B in an automobile, but it tells you very little about the political boundaries of the places it portrays. A map showing the nations of the world, each one a different color, won't tell you how to drive from one city to another, nor will it tell you what railroad lines serve various destinations. But it will tell you which city is the capital of each country and where each nation's boundaries lie.

And so it goes. You could collect many maps of a single place or region and learn completely different facts from each of them. Geological maps will tell you what rocks lie underground and how they have been folded and formed to create today's landscapes. Maps of ecoregions will tell you what vegetation grows where. Historical maps might chart the positions of opposing armies in a long-forgotten war, or show how the political boundaries of states have moved over time. A sea chart will tell you nothing about the land areas, except for indicating relevant beacons and lighthouses and marking the shoreline; all interest shifts to the water, with indications of depths, notes on tides, and markings denoting the position of sea lanes. Each map looks at the same landscape and tells a different story.

If you want to make a specific kind of map, such as the road map mentioned above, you would have to learn the conventions of that particular genre. So, for instance, you would discover that major divided highways, such as interstates, are often represented by solid colored lines outlined in black; a thin black line down the middle indicates the division between the two directions of traffic. If you worked for the U.S. Geological Survey, you would have to learn the visual vocabulary surveyors use on a standard basis.

The kinds of maps I've listed above do not exhaust the potential for telling stories about the landscape. For calligraphers, mapmaking opens

148. A map made by Christopher Calderhead showing Europe circa 1450.

149. Two maps, two different stories, one landscape. Neither map is more "real" than the other. The nineteenth-century map (1864) is concerned with political boundaries and geographical accuracy. The one below deals with dimensions of personal experience and memory. Each tells its own story as well as it can.

a different set of possibilities. Some calligraphic maps are quite practical— a simple road map might show people how to get to your house, or a historical map might be used as an illustration for a historical atlas. (Indeed, before the computer became the principal design tool, many calligraphers made good money making simple historical maps for books.) Today, most calligraphers who undertake map projects are interested in a more personal, narrative approach.

So what are the possibilities? Having taught workshops on mapmaking for many years, I've seen many interesting projects:

Historical Maps
- The growth of the Roman Empire
- Europe, 1914

Practical Maps
- Driving directions to a country house

Personal Histories
- A trip to Europe
- One year spent traveling the United States in a camper
- The cities I have lived in
- Places where our extended family lives

Whimsical Maps
- The backyard as seen by my cat
- The rooms of my house and what each one means to me

Imaginary Maps
- The challenges of life represented by different landscapes

EVERYONE HAS A VISUAL VOCABULARY

One of the most pleasing things about mapmaking is that it does not require an ability to draw, at least in the sense of illustration or rendering lifelike representations of objects. Instead, the visual interest is created by the simplest means. The basic shapes that create the composition on the page are provided by the landforms that you are describing in your map; just render them with precision. Line, color, and lettering combine to make a satisfying whole.

Students who have taken my mapmaking workshops have made beautiful maps with nothing more than a rollerball pen, a colored pencil, good paper, and ordinary handwriting. If you bring a bit more calligraphic skill to the task, the different sizes and weights of writing immediately make your map sparkle. Those who have experience as illustrators and can bring more sophisticated drawing skills to the task can further enliven their maps. But the fact is, everyone has the graphic means at their disposal to make a pleasing map.

Maps from Memory

One of the most interesting approaches to mapmaking is to actually draw your map entirely from memory. When we draw such maps, the places that are important to us usually grow larger, while the places of less significance become smaller. This is geographically inaccurate, of course—a satellite view will look very different than the landscape you draw. But people and satellites differ when it comes to appreciating the world. In a map drawn from memory, the exact distances between things are far less important than the psychological and historical importance of each place. Think about the nature of the thing you are trying to represent.

Despite the claims of nation-states, political boundaries are changeable things, artificial barriers; butterflies and bees flit back and forth across them with impunity. A broken line reflects the permeable nature of a boundary better than a solid one. Sometimes, you may want to represent several kinds of political boundaries in one map and different kinds of

150

150. Examples of different ways to indicate an interrupted feature. The top two images denote bridges; the bottom image denotes a tunnel.

151

151. A pointed dip pen.

152

152. Two chisel-edged brushes and a fine pointed brush.

lines may be brought into play. The edges of counties might be represented by simple dotted lines, quite lightweight, while the edges of a state or province might call for a heavier treatment, perhaps using a colored band on either side of a dotted line of the same weight. A national boundary might be heavier still, with a strong dashed line edged with a wider band of color. The changing gradations and color treatments of each line represent the increasing seriousness of the boundaries being represented in a clear way.

Water usually presents human beings with an impassible barrier: When you arrive at the shoreline, you either have to take off your clothes and swim or find yourself a boat if you want to traverse the body of water. As such, a solid line (often blue) best represents the border between land and sea.

To symbolize areas of water, you might want to evoke the pattern of waves, creating a stylized representation of the roiling seas. Areas of forest might be denoted by a stylized pattern based on foliage or trees.

Think about how things would look from a bird's-eye perspective, and use that as a guide for your drawing. If a road crosses a river with a bridge, then the road is an uninterrupted feature; the river is underneath the road. So when you draw the road, the boundary lines of the road should not change as they pass across the river. The boundary lines of the river, by contrast, should stop on either side of the road. On the other hand, if the road enters a tunnel and passes beneath the river, then it's the road that is interrupted.

THE TECHNIQUES OF MAPMAKING

Special Tools

In addition to the standard equipment needed for calligraphy, map projects usually require a few extra tools.

Pointed dip pens are good for making fine lines. Instead of ending with a chisel-cut edge, they have a sharp point and make a line of unvarying width.

Chisel-edged brushes are handy for making wide lines using color. You may also want to have some very fine-point brushes for painting details.

Some calligraphers like to use *permanent-ink pointed felt-tip pens* to make fine lines. Different pens of varying thicknesses can be used to make heavier or lighter lines. Keep in mind that these may not be archival[*] or they may bleed through the backside of the sheet of paper.

Both the writing and the drawn elements of your map may be rendered in color. You have three choices to bring color into your work: gouache, watercolor, or colored pencils.

Gouache may be used to add colored elements. When we write with gouache, as described in chapter 6, we usually add a *small* amount of water to attain the heavy-cream consistency that allows the writing to be opaque. By contrast, when using gouache to paint in elements such as boundary lines, we may want to further dilute the paint so it becomes translucent.

Watercolors, although not recommended for writing, are very suitable for painted details on maps.

Colored pencils are also very useful for the drawn elements of your map and are a good alternative to gouache or watercolor. They are not usually used for any written portions of the map.

You will also need a large piece of *tracing paper* to work out the composition.

Line and Field

Besides the calligraphy, the basic graphic elements of a map are lines

[*] Archival *refers to materials that are permanent and will not decay over time. Some markers will make marks that fade or change when exposed to light.*

and fields. Your lines should be fairly delicate and generally lightweight so as not to overpower the lettering. The fields should also use soft colors, rather than brash and bold colors.

Let's look at lines first. Lines define edges. You need a repertoire of lines of varying weights, colors, and styles to represent the different kinds of boundaries in your map. Experiment with different tools to create various types of lines: Lines of differing weights may be created using pointed dip pens and narrow-edged pens, and may be dotted or dashed. You may also want to experiment with smooth and rough lines. A rough line can be made by jiggling your pen slightly as you make the mark, or even by going over the same line several times using a jiggling motion. If you add color to the mix, lines of similar weight take on quite a different appearance.

Fields are areas of color or texture. It is tempting to make these quite dark, using bold, saturated colors. Don't. Instead, large areas that need to be set apart from one another should be filled with delicate colors, such as pastel shades or light tints of color. They will still be surprisingly bold.

A field may simply be painted a solid color, but this is the least desirable alternative, for two reasons. First, it is hard to paint an even tone of color over a large area, especially if its boundaries are complicated and irregular. Second, it is hard to write on top of color; the ink or gouache in the pen tends to be blobby and lack crispness, as the pigment already on the page literally sucks the fluid out of the pen. (As discussed in chapter 6, if you do wish to write on an area that has been painted, it's helpful to rub a thin dusting of gum sandarac onto the surface after the paint has fully dried.)

A better alternative is to use fine cross-hatching to fill an area with tone. This can be done in colored pencil.

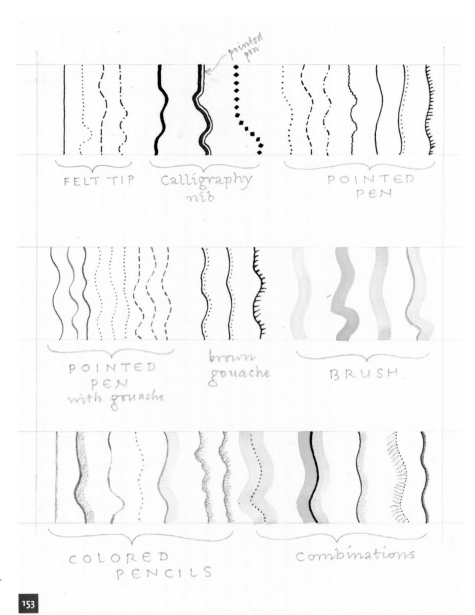

153.

Keep in mind that small differences in color, or in the spacing of the cross-hatch lines, can create quite different tones.

Another method is to devise a system of small abstract marks that are scattered across a field. This can be particularly effective when rendering areas of vegetation, such as forests, swamps, and grasslands.

Here's a visual trick you could use to define an area: If you surround a field with a wide band of color, the entire field takes on the coloring of its edges. This is an optical illusion;

153. Examples of graphic ornaments using various methods and tools.

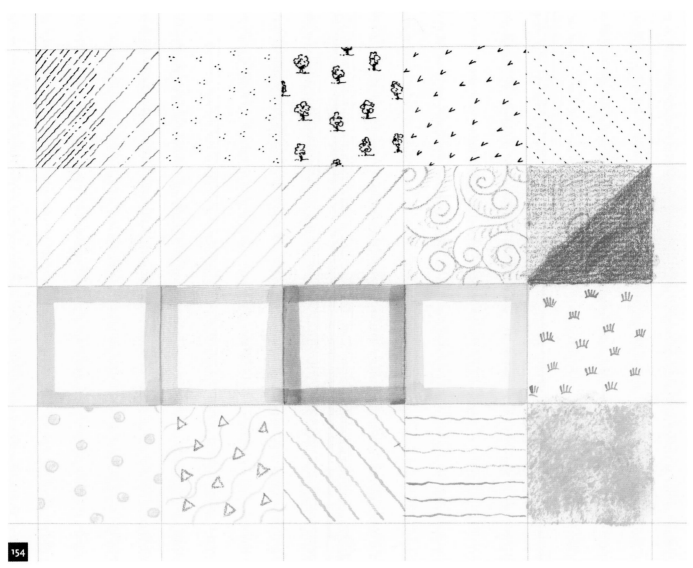

154. Examples of different treatments for fields.

the human eye sees the interior of a color-bounded shape as a tint of the surrounding color.

Some Conventions Regarding Water

Water is often represented in maps by the color blue. An area of water may simply be painted in as a solid blue field, or it may be defined by a fine blue line bounded with a wide band of light blue. You could also create an abstract pattern based on the shape of waves.

Another way to represent water, very common in old maps, is to make ripple lines radiating from the shore. These lines follow the contours of the shore precisely. They usually are

spaced farther apart as one moves away from the land. The outermost lines may even begin to break up.

An Exercise in Lines and Fields

Here is one way to explore the potential of lines and fields: Imagine a perfectly square county, like those in the American West. A river runs from north to south, while a major road runs from east to west. In the center is the county seat, a small city. In one corner is a state park.

Draw the county three times without changing the shapes. In each version, try out a different treatment of line and field to represent each of the map's elements. The possibilities are endless.

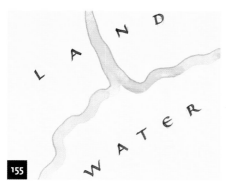

155. A detail of a map I made using a single band of blue to indicate boundary of water.

156. An antique map using ripple lines to indicate bodies of water.

157. One iteration of the county exercise. In this case, it was limited to black and white. Try out different lines and fields and see what combinations you can make. Notice that the labeling here, although generic, establishes a hierarchy of different sizes and styles to represent different categories.

What you end up with is a series of little abstract compositions that explore the potential of line and field. Once you have made three versions of the map, you can add lettering, as I have in Figs. 158-160. Even a small change, such as altering the color of one of the elements, makes for a very different "feel" to the map.

Lettering

The first question to ask when lettering is "What's the hierarchy?" In other words, what should be written large and what should be written small on the map? What has to stand out and what needs to visually recede into the background?

A classic pattern for labeling can be found in figure 158.

As you begin to plan your map, think about what needs to be labeled. Each type of map feature deserves its own particular style of lettering. Label cities one way, rivers another, large expanses of land another, and so on.

Labels for prominent, extended features like rivers and roads work best when placed in alignment with the objects they mark. A large region or territory may be labeled with a broad arc of capitals spaced far apart. Place these so that the spacing is fairly even, and so the letters never collide with anything else on the map. It usually takes several tries to get this right. A city name may simply be written in a straight line next to the object it describes.

Writing on an Arc

There are two ways of writing on an arc. In the first method you simply draw a double arc freehand in pencil. The smaller arc is drawn first, then the outer arc. Make sure the lines remain an equal distance apart; imagine them as segments of two different-size circles that share a center point. Then lightly pencil in the positions of the letters on the arc. I usually simply mark a line that will pass through the center of each letter, as shown in figure 159, but you may also pencil in the letter itself, if you find that helpful. To find the correct position, imagine a line going through the center of each letter and passing through the center point of the two circles.

Another way to achieve a similar effect is to write your letters on a set of straight lines as you are used to doing. Then draw a single arc, cut out the letters, and arrange them on the arc. Move them back and forth until they are evenly spaced.

Whichever method you use, you will find that these widely spaced arcs of letters can be tricky; you don't want them to crash into anything else on the map. With a little tinkering, you can almost always find a convenient set of blank spaces that will accommodate an arc of lettering.

158. A classic pattern for labeling the elements of a map.

159. An example of writing on an arc using the double arc system.

160. An example of writing on an arc using the cut-and-paste method.

162. When drawing a map to be used for directions, a long stretch of road can be interrupted with an accompanying note.

SOLVING PROBLEMS

Insets

There are times when a single map won't do. Perhaps you are mapping a large area, but need to use more detail for the center of a town. In that case, you can draw an inset, which is a map within a map. This is frequently done for maps of the United Sates, where Alaska and Hawaii are so far from the rest of the country that the simplest solution is to put them in two insets tucked into the lower left-hand corner of the larger map of the contiguous United States.

Interruptions

Occasionally, you will find that one feature is so long that it needs to be abbreviated in some way. This is often the case with maps showing driving directions. Much detail is needed to show the highway exit and roads near one's house, but a long stretch of road can be interrupted, with an accompanying note, as seen in figure 162.

The Compass Rose

A compass rose is a fancy name for a very simple device: a four-pronged symbol that indicates the directions of north, south, east, and west. In its most elementary form, it is a simple cross with an N at the top. In its most elaborate manifestations, it can be a full-blown circle with radiating points. Conventionally, only the point indicating north needs to be labeled, but you can label south, east, and west as well. You can also

163. Two ways to indicate a compass rose.

have intermediate points indicating further divisions: NE, SE, SW, and NW. A richly ornamented compass rose is a strongly decorative element in a calligraphic map.

THINGS TO AVOID

Don't try to be medieval—there is no need to go all "ye olde" when making a calligraphic map. Avoid the temptation to fill the sea with little drawings of galleons, unless you are drawing a diagram of the Spanish Armada. The graphic elements of line, field, and lettering are enough to make a map interesting, informative, and decorative. If you want to add illustrations, base them on the reality of the place you're depicting and the story you're telling.

North does not always have to be on the top of a map. Orienting your map with north at the top can be very useful, but that is nothing more than a convention. It is not a rule, so use your common sense. It would be jarring, for instance, to make a map of Europe upside down, because we are so used to seeing European landforms from a certain perspective. But other maps needn't slavishly follow this convention. It's best to look at the landscape you are mapping and see how the shapes could fit neatly into a rectangular format. If that means tilting the landforms on your map so that north points away from the top of the page, that's not a problem. A simple compass rose somewhere in the design will quickly orient your viewer.

161. Two solutions for the same project—a map of the Massachusetts coast with Cape Cod at the bottom. The northern alignment is the most familiar, but with north at the top it squashes the landmass against the left side of the rectangle. A slight shift balances the composition, but presents a less familiar view.

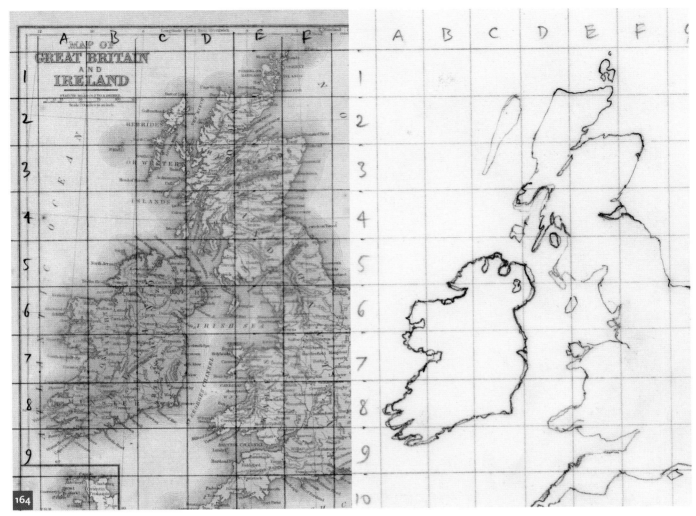

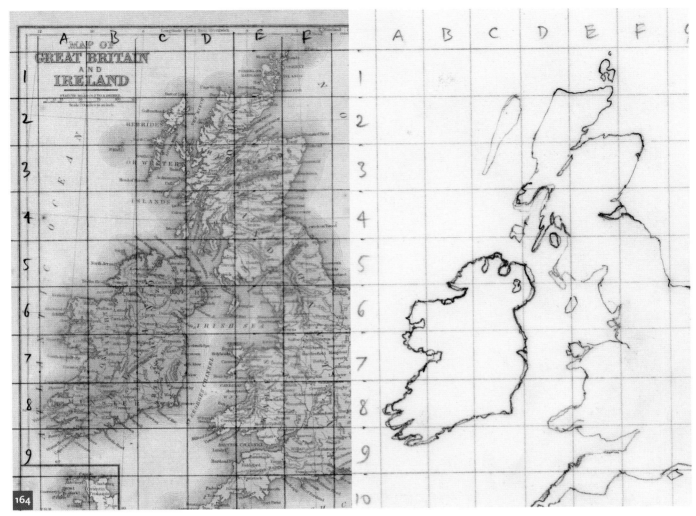

164

A key, or legend, is a little chart showing all the symbols used on the map, with accompanying explanations. You do not always need a key, but on elaborate maps, these can be quite helpful. Road maps usually include a key with all the different symbols for services and attractions; because of the number of different symbols, a key is absolutely essential on these maps. Calligraphic maps, however, are usually simple enough not to require this kind of explanation. The symbols and graphic means you use should be obvious enough that they may be interpreted without further comment. This is not to say that your map *shouldn't* have a key, but if you do, keep it minimal. People will probably have no trouble reading your map without one.

MAKING A MAP

Begin with Research

The first step of any map project is to do some research. You have decided on the place you would like to map, and you know what kind of story it is you want to tell about that particular landscape.

If you are making a geographically accurate map, then you should find some printed maps from which to work. It's good to obtain several maps of your chosen place and compare them—are there differences in the way the landscape is shown? Beware of maps downloaded from the Internet; although you can find good maps online, there are a lot of poorly drawn, inaccurate maps to be found there as well. So if you do download a reference map, make sure it is a

164. The map on the right is a reduced version of the one on the left. The grid of the new map is exactly half the scale of the grid laid over the old map. The new drawing is not complete; the first stage is to draw in the bigger shapes, then you come back and refine them. It is surprising how tricky this can be, but it's gratifying when you begin to see your sketch taking on the character of the map you are scaling down.

165. From left to right: The traced outline of West Virginia; the drawing prepared for transfer; the drawing transferred to a new sheet of paper.

high-quality, high-resolution image. I find that it's best to work from an actual paper map published by a reputable organization. A good source map will be invaluable as you construct your own interpretation of the landscape.

If your map is designed to show historical sites or other points of interest, collect as much information about them as you can. All this background reading will help you make your own map.

If, on the other hand, your map is of a more personal nature—say, for example, a travel map showing places you have been, or a map drawn from memory—then it's advisable to use your research time writing down the things you find significant about the areas you're mapping. Make some notes, write some text, and generally try to get the things about that landscape that are significant to you down on paper. As you begin to write down your ideas, you may find that you remember new things about a personally significant place.

The amount of research you need to do depends entirely on the kind of map you intend to make. Make the process enjoyable, and don't skimp on this stage. It's good preparation for the task you are about to undertake.

Once you've done your basic research, make a note of the things that are most important to you; these

should be the most prominent elements of your finished map.

Geographical Accuracy: Using an Existing Map as a Template

A printed map is a useful reference if you want the sizes and shapes of the elements on your map to be geographically accurate. Printed maps show exact distances and the actual physical arrangement of land and water features. However, unless you are very lucky, the printed map will probably be of a different scale than the map you wish to make. There are two ways to deal with this dilemma. One is to take the printed map to a photocopier and enlarge or reduce the relevant portions. If you are doing this at a copy shop, it's best to make several versions at different sizes. Then, when you get home, you have a range of scales from which to choose. Take a sheet of tracing paper and carefully trace all the elements you wish to include in your map.*

The second method for changing the scale of a printed map is the grid system. This is an ancient technique still used by artists all over the world to reduce or enlarge a drawing. Cover the printed map with a piece of tracing paper and, using a ruler, draw a grid of squares over the image. Take another sheet of tracing paper and draw a similar set of grid lines, but this time make them either smaller

* *To be safe, you should trace a map that is safely out of copyright.*

or larger than the original grid—a smaller grid will result in a reduced-size map; a larger one will produce an enlarged map. Use the grid as a guideline to draw the basic shapes of the printed map on your second sheet of tracing paper.

The grid method requires you to be a good observer; look carefully at how the lines from the printed map relate to the squares of the grid. With some practice, you will get better at rendering them on the different-sized grids.

Whichever method you use, you will end up with a sheet of tracing paper with the basic shapes accurately rendered in pencil at the scale you wish to make your map.

CREATING A COMPOSITION: WORK WITH THE BONES FIRST

Now it's time to make the first rough draft of your map. Take a sheet of good paper. It's best to use a sheet of the same paper you actually intend to use for your finished map, so you get used to working on that surface.

Geographically Accurate Maps

If you are working from a geographically accurate model, trace your design onto a sheet of tracing paper. Now you will need to transfer it to your sheet of good paper. Turn the tracing paper over, and, using a soft pencil,

166. A map of a journey through cities of the American South, beginning and ending at New York City. All other geographical details are removed. The northern alignment is retained here, since the shape is attractive and leaves plenty of space for text and illustrations of the journey.

rub the back of the sheet until every line you wish to transfer is covered with a strong, dark area of graphite. Then turn the tracing paper over again, and lay it in position on your good paper. Your traced drawing should be faceup; the soft-pencil shading is touching the surface of your good sheet of paper. Tape the tracing paper in place so it doesn't shift position. Now take a hard pencil and firmly trace over the lines of your drawing. Do not press so hard that you damage the surface of the undersheet; just use enough pressure

167. A map of a neighborhood with frequently visited stores. The city's grid is not aligned north and south; neither is the map. The natural rectangular shape of the area being mapped suggested its own solution.

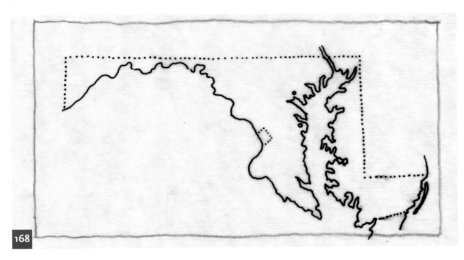

168. A map of Maryland fits neatly in a rectangle, allowing ample room for annotations, compass roses, and other design elements.

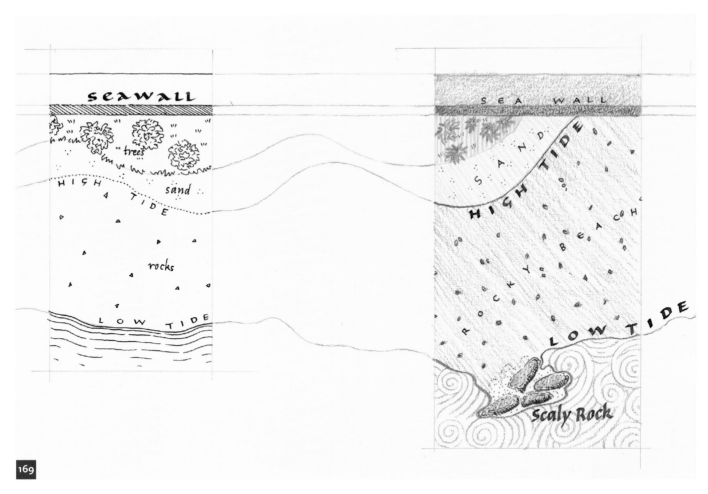

169. This figure shows how a map can change in the steps between the initial sketch and the final completed project.

to transfer the drawing. By tracing over your lines, you are pressing the soft-pencil shading onto the new sheet. When you are done tracing, peel away the tape from one side of the drawing and lift it gently; you will see the faint lines of your tracing. At this stage, if you see that you have missed any parts, you can lay the sheet down again and add them. Check the transfer drawing again. When you see that you have successfully transferred your drawing, peel off all the tape and remove your tracing paper. The soft pencil will have left some smudges on your good sheet of paper. Erase these gently with a soft eraser.

Free-form Maps

Maps drawn from memory or other more free-form projects do not require the tracing and transferring stages described above. Instead, you

can start right away by sketching out the largest shapes you want to include in your map. What is the basic form of the place you're rendering? Is it long, wide, tall, irregular? Get it down on paper.

From Bones to a Working Composition

Whether you are working from a traced drawing or making a more free-form design, at this stage you will have the basic shapes down on a sheet of good paper. These are the "bones" of your composition. Now look at what you have drawn: How can you draw a neat rectangle around it so that it occupies the space comfortably? Remember—you don't have to be slavish about keeping north at the top. The basic shapes of your map should be arranged to use the paper efficiently. If that means rotating the

drawing slightly in one direction or the other, do so.

Many maps contain irregular shapes, so you may well end up with an asymmetrical composition and some large white spaces. You can use these as places to put other elements, such as a title, a compass rose, a key, or a paragraph of text describing the subject of the map. But don't feel you have to fill all the white spaces; a composition with white space can be very pleasing.

DECIDE ON THE DETAILS: FLESH OUT THE BONES

With the bones of your composition worked out, now you should decide on the details: What lines, fields, and lettering will you use to render and label all the elements of your map? Experiment with different solutions.

There are plenty of ways to do this. Some people like to make a series of sketches on a separate piece of paper, trying out numerous combinations of lines for boundaries, fields to fill areas, and different sizes and styles of writing.

One of the best ways to do this is to use your rough draft to try out various possibilities. You have in front of you a full-size rectangular pencil sketch of the bones of your composition on a sheet of good paper. Choose a few sections of the map to try out some solutions.

I usually choose several parts of the map that are "typical." In other words, I look for sections that will include most of the elements I need to work out. I mark off these areas with a pencil-drawn square, about 3 inches wide. Then I bring each square to completion: I ink in the boundary lines, experiment with different colors and field signifiers, and use my calligraphy pens to label the parts within each square.

Since I have marked off different parts of the map, I can see how differ-ent solutions work. In one of my sample squares, I might try a light blue to represent water. In another, I would see how radiating ripple lines would look. In one square, I would write the labels in color, while in another I might try black ink. Remember that this is a rough draft—"Do it 'til you ruin it." In other words, don't be afraid to make mistakes. Try out different things to see how they work. There's nothing precious about a rough draft.

Once you've tried out a variety of solutions, step back and have a look. Decide which lines, fields, and letter-ing styles harmonize and work best to make a well-designed map. Continue experimenting until you have a clear sense of how you want to depict all components of your map.

Complete Your Map

Once you have decided how to render all the elements, you are ready to make your final map.

Take a new sheet of good paper and draw the rectangle that will enclose your map. Then, using the transfer technique described above, transfer the bones to this sheet. If you are working from a geographically accurate rendering, it's best to use the same tracing you used to make your rough draft (tracings of tracings be-come progressively more inaccurate). If you are making a free-form map and drew the bones directly on your rough draft, trace the basic contours now, and transfer that drawing to your final sheet.

Now the task is simple! Fill in all the sections with color and lettering, and you have a finished map.

Calligraphy and Cut Paper

 orking with cut paper is a method that grows naturally out of pen-made calligraphy. Any of the edged-pen scripts that appear in earlier chapters may be adapted for use in cut paper. You may also improvise by drawing your letterforms. The pleasure of cut-paper designs is that they play a trick on the eye: The letters appear to be freely and spontaneously made of fluid, dynamic strokes, yet we know that the work is actually a sheet of paper carved with a knife.

Cut paper plays with voids and solids. Parts of the paper are cut away, and parts remain. The trick is to make a design that will hold together, despite having large parts removed with the blade. To achieve this, you have to work out your design on tracing paper first, before cutting it out of a clean sheet of good paper.

As you work out your design, you must ensure that all the solid parts connect in some way, so that the piece of paper doesn't fall apart. I refer to these connecting elements as *joins*. Working out the joins is a challenge; they should not seem like awkward additions to the piece, but like natural parts of the composition.

Ideally, every solid element is joined to another at three or more places. This is not always possible in practice, but it's something to aim for. A solid joined at two places is perfectly adequate, but a single join is usually too weak. Look carefully at the examples in figure 170 to see how many joins have been created.

TOOLS

To work with cut paper, you will need tracing paper, masking tape, two 2B pencils, an X-acto knife with no. 11 blades, and some stout paper, such as Canson Mi-Teintes.

Using an X-acto Knife

Cutting designs in paper requires the use of a very sharp blade. It is important to bear in mind certain rules when using a scalpel or pointed blade. Just like a sharp kitchen knife, a blade is a dangerous tool; always be aware of where the tip of the blade is. Do not walk around the room carrying a blade, and stay focused on what you're doing while using it. I advise you to buy an X-acto knife with a cap; when it's not in use, you can simply slide

170. An alphabet created using various methods and designs for cut paper.

the cap over the blade. This will ensure that the blade does not get damaged, as well as protecting you from accidentally reaching for the knife and cutting yourself. Also, if you drop the knife, never reach out to try to grab it before it falls—just get out of the way.

When you discard dull blades, never just throw them in the trash. The blades can easily pierce a garbage bag and injure someone. If they fall out of a trash bag, they are a hazard to pets or anyone who walks by. Many packs of blades come in a small plastic box that has two parts. On one side of the box are the sharp blades; on the other side is a closed container with a thin slit for discarded blades. After using them, slide your used blades into the slit. If your blades do not come with a disposal box, save your blades in a paper or plastic cup, and when the cup is full, cover it and throw the whole cup out. Or, when discarding single blades, you can wrap the sharp end in a piece of masking tape.

The front end of the X-acto knife handle is a lot like the end of a hand drill. It is designed to receive the blade in a thin slit at one end. A band around the knife shaft can be turned to open the slit or close it. Unscrew the band and insert the blade. Make sure it fits snugly, and then tighten the band. Once the band has been tightened, the blade should not jiggle.

Hold the knife as you would a pen. The flat edge of the blade should always be perpendicular to the surface you are cutting. Do not press the blade sideways or tilt it as you cut. Pressing on the side of the blade can make the fine tip break off.

You should always use a new blade when you begin a paper-cutting project—these blades dull quickly. If you begin to feel that the blade is no longer cutting smoothly, replace the blade. A small piece can be cut out using a single blade; more ambitious pieces will require several blade replacements.

THE TECHNIQUE

There are two ways, or what I call *modes*, of designing cut-paper pieces: *stencil mode* and *silhouette mode*. When you become adept at the techniques, you can mix the two, but in

171. Two different ways to wish someone happy birthday using cut paper.

the beginning it's best to tackle each one separately. The cutting technique is the same for both modes.

In stencil mode, the letters are cut out. The background is a solid sheet of paper. The letters are voids; the background is solid. The stencil mode is more intuitively obvious to beginners than the silhouette mode. Stencil-made letters are frequently seen on construction sites and elsewhere. Cardboard stencils are available in most hardware stores. As a result, most people can quickly pick up the principles for designing letters in stencil mode. I recommend that your first attempts at cut paper be designed in this mode.

In silhouette mode, the letters are solid paper, and the background is cut away. The letters are solid; the background is a void. This mode is a little harder to visualize for beginners and it raises more complex design questions.

Before I describe these two modes in detail, let me describe the basic steps for cutting letters in paper. I suggest that you read through this section and the next section before you try the technique yourself.

The design and cutting are done in three steps, which will be described in more detail later on. First, you create your sketch on tracing paper. Second, you attach your sketch to a sheet of good paper and make a preliminary set of cuts through both the design and the good paper. Third, you remove the sketch and make the detailed cuts.

Cutting through two sheets of paper is a bit harder than cutting through a single sheet. The idea is to work out your design on the thin tracing paper rather than on the pristine colored paper from which you will cut the final product, so the final cut paper has no pencil marks or smudges on it.

The one downside to this technique is that you destroy your sketch during the process. However, you

172. The knife should be held perfectly upright, with the flat sides of the blade at a 90° angle to the cutting mat. Generally, you should cut toward your body. For cuts made horizontally to your body, turn your whole hand, as shown in the second picture.

173. Never put lateral pressure on the blade—the tip can easily snap off.

174. If you hold the blade so that it undercuts one side, you will risk putting sideways pressure on the blade. Your cut will also not be sharp; here a poorly executed cut raises a small flange of paper along the cut.

A Cutting Tip

Start from the inside of the design and work outwards. You will find that the pressure of the knife passing through the paper pulls it slightly; to avoid tearing or damaging the paper, cut inside shapes first, and outsides next. You may want to use your free hand to hold the paper in position near the cutting edge.

can always make a photocopy of your sketch before moving on to step 2. This is particularly helpful if you want to revisit the same design again or if you want to make multiple cut-paper pieces using the same design.

Step 1: Make a Design

This section presents some general principles that apply to the design stage of both modes. I will describe the individual design principles for stencils and silhouettes in more detail in upcoming sections. The old carpenter's adage, "Measure twice and cut once," is a good motto for working in cut paper. Once you make a cut, there's no going back, so the first stage of any cut-paper project is a careful drawing in pencil on tracing paper.

Many beginners have a hard time picturing the solids (the paper that you want to keep) and the voids (the parts of the paper that are cut away and discarded) at first. Don't be discouraged. With a little practice, and a little trial and error, it eventually becomes second nature. All of us who have explored this technique have had disasters where some part of the design falls off because we've missed making a join. We think we have a perfect drawing, so we begin cutting, and as we cut, we suddenly realize that one part of the design is not attached to anything. Learn from these mistakes.

Take a sheet of tracing paper and, using a pencil, write the words you want to cut out. You can either draw the letters in outline or you can use double pencils to write the words in one of the scripts you have learned. Look carefully at your drawing to see where you can make joins. It's often helpful to write the words or letters on one sheet of tracing paper and then lay another sheet on top to make a tighter sketch in order to refine and adjust your design. When I have written the words with double pencils, I usually refine my design using a single pencil,

tracing over the double pencil draft and modifying the shapes as needed.

The samples in steps 1 to 4 in the "How to" Section are in stencil mode; the letters will be cut out of the solid background.

Once you are satisfied with your design, you're ready to use it as a template for cutting your letters.

Step 2: Make the First Cut

In this step, you will be cutting through your sketch. As previously mentioned, your design will be destroyed in the process. If you wish, you can make a photocopy of your design to save it before you start cutting. See the "How To" section on pages 156 and 157 to learn more methods for creating a cut paper piece of calligraphy.

DESIGNING LETTERS IN STENCIL MODE

In the previous section, I only briefly touched on the design step of the basic cut-paper technique. In this section and the following one, I explain in more detail how to create a design in each of the modes. Stencil mode, as the name implies, functions just as commercial stencil letters do. You see this kind of lettering in spray-painted public notices.

Calligraphic letters cut out in stencil mode could, in fact, be used as stencils to paint with. But we will focus on making the stencil itself the work of art.

The guiding principle is this: Because the letters themselves are to be cut out—the letters are the voids removed from the page—we have to make sure they never touch one another. Stencil letters stand apart. Each one is surrounded by solid paper. In addition, some letters require special treatment, as I explain in the "How To" section on page 158.

Making Cards

One of the best uses for stencil-mode cut paper is to use them to make cards.

Many of the samples I have shown above are made in exactly that format.

Cards are sewn together in the same manner as manuscript books. When you design a card, interleave folios in contrasting colors, so the paper showing through the stencil makes a vibrant contrast to the paper of the stencil itself.

When you make a card, remember that the folded hinge at the spine needs to be taken into account. As you open the card, it will put some pressure on the leaf you are turning. When you lay out your stencil design, make sure there is at least 1 inch of solid paper between the cut-out voids and the spine.

Mounting and Framing

Stencils may also be displayed in a frame. Design your stencil so that it is cut from a rectangular sheet of paper. Cut out a second sheet to use as a backing sheet. This will be placed behind the stencil-cut paper and provide a contrast to make the letters stand out. It's best to choose a color that is distinctly different from the color of the stencil. Cut it to the same overall dimensions as your stencil. Place the backing sheet behind your stencil and frame the two together.

A more interesting approach is to put a spacer between the two layers. This holds the stencil away from

175. Despite its lack of elegance, this painted sign functions well. The letters retain their legibility, even though they have been cut out and all their parts do not connect.

176. A hundred-year-old German stencil cut in thin metal. Look at the way the letterforms are adjusted so that the integrity of the supporting metal is not disturbed. These stencil-mode letters are divided into segments so that huge voids are kept to a minimum. Notice how the large central monogram has little dots at the thickest part of each wide stroke. These are both decorative and create joins across the strokes—a beautiful and functional decision.

For the first sketch, simply write out your words to see what shapes you will work with. You can use the edged-pen scripts you have learned, or you may improvise and draw letters of your own devising.

A second sheet of tracing paper is used for the second, tighter sketch. The first drawing was laid underneath this sheet to provide an underdrawing. In the second sketch, I begin working out how the letters will be altered to adapt them for cutting. In this instance, I have "exploded" the letters and added joins within the large strokes. (These methods are described in detail in the next section, focusing on stencil mode.)

In some parts of the design, the joins are very narrow. In order to make sure that I don't overcut by accident, I mark little "stop" lines, as shown here in a detail of the **N**. (The stop lines are the four diagonal lines drawn where the diamond join meets the sides of the diagonal of the **N**.)

The second sketch, further developed. Taking a soft pencil, which gives me darker lines, I have redrawn and further refined the letterforms. I have erased all irrelevant lines: I only want to leave the lines I will actually cut. Small *x*'s mark the sections to be cut away.

Once you have worked out your design, attach it to a sheet of stout colored paper, using masking tape. It should be attached on all four sides, and should be perfectly flat, without bumps or wrinkles.

Lay your work on a self-healing cutting mat. The mat should be large enough to accommodate the entire piece; if your piece is larger than the mat, you might crease the paper or catch one of the cut edges and tear it. For most pieces, a 12 x 18 inch mat should be sufficient.

Now you begin the first series of cuts. You want to cut the long, major cuts at this stage, but *do not* cut all the way to the places where the lines in your drawing meet, or the joins. Because you are cutting through two sheets of paper, it's hard to see exactly where the tip of your blade is. If you cut out each entire shape all the way to the meeting points, you may find you have slightly overcut. In the case of narrow joins, this can be disastrous. None of the pieces should fall out at this stage.

Once you have made all your preliminary cuts, peel up the tape on one side of the design and lift the sketch (leave one side attached). Look at the cuts on the sheet of good paper. Have you made all of them? It's sometimes hard to see without lifting the sketch.It is always easier to cut toward yourself than to cut lines horizontal to or away from your body. Turn the work as needed, so that you are comfortable as you make your cuts. With small work, I find it helpful to turn the mat with the work on it, rather than turning the piece itself.

If you have missed any of the preliminary cuts, lay the paper down again, tape it in place, and cut the remaining lines. (This is why you peel the sketch up from only one side; the side that remains attached will ensure that the sketch lies in the same position as before.) When all the first cuts have been made, peel away the tape and lift the sketch away. You can discard the sketch at this stage.

What you now have in front of you is a clean sheet of paper in which all the basic components of your design have been cut. But because you have not cut all the way to the meeting points of the lines in your drawing, the whole piece of paper remains intact.

In this stage of the process, the voids are removed and the piece emerges from the original sheet of good paper. Remember that the voids I am referring to here are the parts of the paper being removed. I also refer to them as "waste paper" or "waste pieces."

In the first stage of cutting, you made many long, drawn-out cuts. At this stage, the gestures of your knife are much smaller. By placing your knife at the point where the lines of your drawing meet, a simple push downward is usually all that is needed to sever the voids from your design.

As you cut the corners, the voids will begin to fall out. You may find that you have to make these delicate cuts several times because some of the paper remains attached. Never pull on a piece of paper to remove it; this will leave a little nubbin of torn paper. Instead, cut the paper at that place again, very carefully. Some of the voids will simply fall out of their own accord. If they don't, gently slide your knife under one edge and lift them out or stab them gently in the center and lift them away. At this time, you can refine any awkward shapes and tidy up any edges that are raw or uneven. Be careful not to overcut. Only very small adjustments should be made at this stage.

Once all the corners have been cut away and you have lifted out all the waste, your piece is done. In the figure above, the piece shown here has been folded and a

sheet of contrasting paper has been sewn inside, using the techniques we saw in chapter 8 on manuscript books.

The letters **I** and **C**, are simple letters; you can easily cut them out of a sheet of paper. The piece of paper remains solid and whole.

What happens, however, when you try to cut out an **A**, **O**, or **R**? In the center of each of these there is an enclosed space that doesn't connect to the background around the letter and thus falls out.

What we have to do for these letters is create some points where the inner parts of the letters join to the rest of the sheet. The simplest way to do this is to add a series of straight joins, as commercial stencil-makers do. Now the solids all connect. From a design point of view, however, this is pretty flat-footed. The joins obviously solved a technical problem for the artist, but they do interrupt the smooth shapes of the letters.

Or you can "explode" the letters, breaking them into their component parts, as seen here.

A better solution is to make the added joins into decorative elements. They still have the prosaic function of holding the piece together, but now they do it with some elegance, making the letters more interesting and attractive. Notice how the joins in the figure above became decorative features of the letters. There are hundreds of possibilities—use your imagination in developing the joins. The letters **C** and **I** make an appearance here; although they can be cut out in single shapes, they are structurally stronger when they, too, are interrupted with joins. Large voids are divided into smaller units, which makes the cut paper sturdier. In the **C** and **I**, the joins have been angled—even this small change makes them more interesting than they would be with straight joins.

the backing sheet, allowing a play of shadows to be seen through the stencil letters. A spacer can be cut from cardboard or foamboard. The simplest method of making a spacer is to cut the board to the same overall dimensions as the stencil and its backing sheet. Then neatly cut out a rectangle from the middle. Sandwich the spacer between the stencil and its backing sheet, as shown below.

The purpose of the spacer is simply to create a distance between the stencil and the backing sheet. You should not see the spacer at all once the piece is in its frame. Make sure, therefore, to cut the central rectangle wide enough so you can't see it through the cutout letters.

The spacer doesn't have to be very thick; even a thin spacer made of a single sheet of cardboard will raise the stencil from the surface of the backing sheet and create a shadow. It can be quite pleasing, however, to use quite a thick sheet of foamboard to give your piece a feeling of real depth.

DESIGNING LETTERS IN SILHOUETTE MODE

The stencil mode is fairly intuitive, since we are familiar with stencils from the world outside of calligraphy. Now we turn to a more challenging method of creating cut letters—the silhouette mode.

The basic task is the same—cutting out a design from a single sheet of paper so that all the parts are connected in some way. Now, however, we reverse the processes we followed to make stencil letters. To cut silhouettes, the letters remain solid, while the background is a void. All the letters must touch each other or be connected by some nonletter element.

The simplest way to begin is to design a single letter that appears in a window, as seen in figure 178.

There are many ways to make a letter in a window. The sampler shown at the beginning of this chapter in figure 170 suggests a number of possibilities.

Because the silhouette mode is a bit more complex than stencil mode, there are some important design tips you should follow, which I discuss below.

Expressing the Corners
Part of the secret of any work of cut paper is making sure that the essential form of the letter is not obscured when attached to another letter. One of the best ways to make sure it doesn't get lost is a technique I call "expressing the corners."

Mounting a Silhouette Mode Cutting
Some silhouette mode cuttings can simply be suspended from a fine filament or string and hang freely in the air. Or, if you have a closed display case, you can place a silhouette on top of a sheet of glass or a mirror, which shows off the shadow cast by the letters.

The safest way to display your silhouette cutting, however, is to mount it on another sheet of paper. You could just glue it, but then the three-dimensional quality of the cutout would be lost. I prefer to sew it onto a backing sheet. This gives the cutting a slight dimensionality, while keeping it safely in place so it won't get damaged. The mounted silhouette can then be framed, or you can sew it into a little book.

You can use many kinds of thread. I prefer to use off-white linen bookbinders' thread. You may also use embroidery thread, which comes in numerous colors, so you can choose a striking color that will call attention to the sewing or you could try to match the color of the silhouette itself and make the sewing much less noticeable. Very thin thread, such as the kind

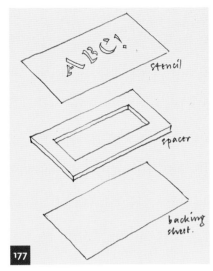

177. How to create a stencil spacer.

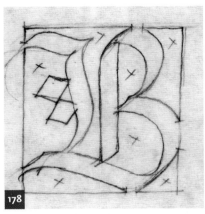

178. A design for the letter **B** using silhouette mode.

179. A card created using the silhouette design above.

Look at the solid letter **I** above. It is a plain letter—notice how it doesn't really look like an **I** at all. The cutout looks like two rectangular voids.

If we cut away the ends slightly, angling the top and bottom of the letter, suddenly we begin to see it as a distinct form.

Or, if we angle the window, the corners of the **I** will emerge. In either case, when we can see the distinct corners of the letterform, it helps us visualize the letter as a shape distinct from its background.

found in a sewing kit to sew on buttons, could also be used, in which case the sewing would almost disappear from view. I don't recommend this, simply because I find it hard to handle. The thinness of very fine thread makes it hard to make clean knots and I find it tears the paper too easily when you pull the ends tight.

To attach your silhouette to backing paper, take your silhouette and position it on a sheet of contrasting paper. Now take a pencil and choose several places where you want to attach the silhouette to the backing. The cutting should be attached at a minimum of four places, spread out evenly over the piece. Larger silhouettes may require more tie-offs.

The sewing shouldn't call undue attention to itself. It's best to choose places where the line of thread will be short. In other words, position your sewing at some of the finer joins in the design. See the "How To" section on page 163 for more detailed instructions on sewing your cut paper design to a backing sheet.

ADDITIONAL TECHNIQUES

Painting Cut-Paper Pieces

In the beginning, it's probably best to simply work with colored papers, but once you have mastered the technique, you may want to try coloring your cut-paper pieces by painting them. This is appropriate for pieces that you intend to frame under glass. It is not recommended for pieces that will be handled, such as cards. Painting your cutouts requires a thick, stout paper, such as Rives BFK. The thicker paper will be able to take paint without curling. Of course, thicker paper is harder to cut—another reason to wait until you feel comfortable with the technique before you attempt to paint your pieces.

After you have cut out your design, place it faceup on a sheet of waste paper. Now mix gouache on a palette to make the color. You can mix the paint beforehand if you want a perfectly even tone or you can mix two or more colors as you go. I like to choose two closely related shades, such as a dark blue and a dark green.

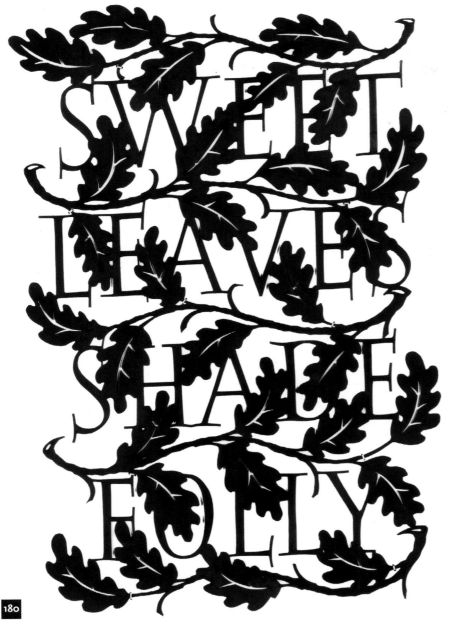

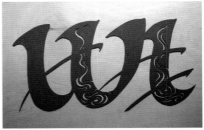

181. Other strategies might be suggested by studying the figures above. These are not complete works, but sketches for making silhouettes.

180 . In silhouette letters we can make joins by creating a rhythm that flows between the letters. If, as in the figure above, the intervening forms are distinctly different from the letters in shape and scale, it becomes much easier to make the letters stand out clearly.

As I paint, I draw from both colors so that the tone shifts slightly from the blue to the green and back again. I dip the brush into each color and gently mix them together on the palette. Each time I dip my brush, the balance between the two colors shifts slightly.

The paint should be quite thick—add little or no water to the paint from the tube. With a wide, flat brush, paint the front of the silhouette, being sure to paint the edges, so none of the paper is left uncovered. The back of the silhouette does not need to be painted, as it will be attached to the backing sheet. Some of the paint will slip under the edges, so the back will-not be pristine and white. Don't fret over this—the back won't show.

As you paint, use slow, careful strokes. Be careful not to catch your brush on the finer edges and accidentally bend them.

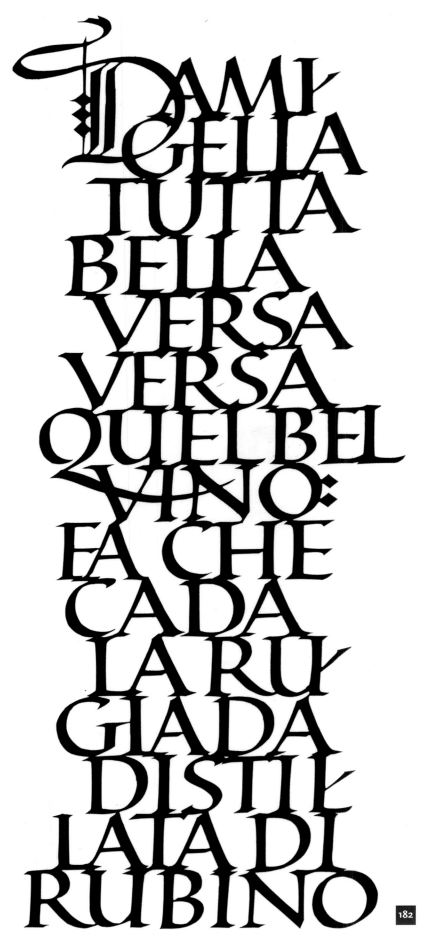

DAMI
GELLA
TUTTA
BELLA
VERSA
VERSA
QUEL BEL
VINO:
FA CHE
CADA
LA RU
GIADA
DISTIL
LATA DI
RUBINO

Once the entire silhouette has been painted, check the edges one more time. It's a good idea to walk around and look at the silhouette from every angle to make sure no spots have been missed.

Carefully lift the silhouette off the waste sheet and place it faceup on a clean sheet of paper. Let it dry. You can mount this on a sheet of plain white paper or you can paint a sheet of backing paper with a contrasting shade.

Backing Sheets Prepared with Pastels

When mounting stencils or silhouettes on a backing sheet, you may wish to color the backing sheet with chalk pastels. (Do not use oil pastels, as they will leave an oily residue that will stain and soil your silhouette.) To prepare your backing sheet in this way, take a sheet of stout, white paper, such as Rives BFK. The backing paper should have enough tooth—texture—to receive the pastel. Choose a stick of chalk pastel in a color that contrasts with your painted silhouette. Using two closely related shades of the same color gives the final product extra richness. With your knife, gently scrape the pastel while holding it over the backing sheet; this leaves a fine trail of chalk dust across the surface. Now rub the chalk into the paper using a soft rag. Paper towels work just as well, although you may find that they fray from the friction of the particles of chalk dust. This won't affect the outcome; just replace the paper towel when it gets too tattered. As you rub, make circular motions across the surface: You are aiming for a fairly even tone across the entire surface, with only slight variations. If some parts are too light, scrape more chalk dust onto those parts and rub again. At the end, gently brush away any residue.

182. Massed letters are also an effective way of designing silhouette forms.

Mark the position where the thread will straddle a join. With your silhouette in place, use a pencil to mark the positions of each pair of holes. When you have marked these positions, set your silhouette aside.

Now take a needle and puncture the holes you marked on the background sheet. Each pair of holes will be threaded and knotted separately.

Pick up your silhouette and put it back in position. Thread your needle and push it from the back through one of your holes. Loop the thread around the silhouette, and push the needle back through the corresponding hole on the other side of the join.

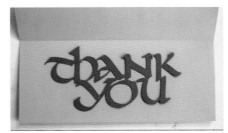

Carefully turn the silhouette and its backing sheet over and tie off the thread with a neatly made knot. With a pair of scissors, cut off the excess thread. Go to the next pair of holes and repeat the process until you have tied a knot at each set of holes.

When you first begin to sew, you will notice that the silhouette is a little hard to handle. Until it is firmly sewed to the backing, it will move around. Although you need to be careful handling it so it doesn't crease, you can let it move a bit; as you sew more pairs of holes, it will stay put better. As long as your holes have been carefully marked and punctured, the silhouette will fall naturally into place as you attach each point.

By rubbing the pastels into your backing paper and removing the residue, the pastel should stay put, without needing any further treatment. You will have rubbed away any loose particles that could detach themselves from the sheet. Once the cut paper design has been mounted on top of the backing paper, and the whole ensemble has been placed in a frame, the work should be fine. If you wish, however, you may spray the backing sheet with fixative, which will ensure that the pastel doesn't transfer to your stencil or leave any residual dust in the frame.

A backing sheet prepared with chalk pastels will have a richness of tone that you don't get from colored papers. The slight variations in tone give the backing sheet an organic, handmade feel. Mount your piece as described in the sections on designing stencils and silhouettes.

Cut paper will transform your calligraphy and lettering into a three-dimensional object. The letters have dimension, cast shadows, and exist in space. It's a wonderful technique to create an object that has a sculptural quality.

The moon,
rising over
49th Street,
touches the
buildings
on either
side.

CAL·
DER·
HEAD

Ephemera

11

Almost all the projects that have been discussed so far involve making an original work of calligraphic art that exists in only one copy and is designed to last for some time. All the effort you put into a broadside or a manuscript book results in a single work executed on beautiful paper, ready to be framed and hung a wall or bound as a book. Calligraphers are often asked, however, to apply their skill to projects that have a limited life span or that are made for a specific event. The most obvious examples of this kind of ephemeral calligraphy are the work of lettering for advertising and promotion and the work of envelope addressing.

At a banquet, most of the carefully inscribed place cards end up in the trash at the end of the night, but they are no less important because they do not last. A few people may even save them as mementos of the event. But more importantly, the fact that the tables were ornamented with handmade place cards helped set a tone of elegance for the evening and showed honor and respect for the hosts and their guests.

Work-for-hire calligraphers need to master the art of the ephemeral as part of their repertoire of skills. In this chapter, I have gathered together a number of calligraphic projects that have that passing quality.

WORKING FOR REPRODUCTION

If you want to make any kind of living with our calligraphy, you need to master the prosaic task of working for reproduction. If you hang out your shingle as a calligrapher for hire, you will find that advertising agencies, publishers, and private clients will begin to approach you to make lettering for printed jobs.

Working for reproduction can be a great pleasure. When you do a single broadside that is meant to be framed, there is always that nerve-racking moment, once the rough is completed, when we have to take a clean sheet of paper and write the actual piece. Making one copy of something on a beautiful sheet of paper is a kind of performance, and it jangles the nerves.

By contrast, when you're working for reproduction, you do your lettering on paper, but you assemble it in pasteup form. If you don't like a line of the writing, you can pull it up and replace it with a better one.

183. A weathergram made by the author and hung in a tree in a friend's backyard.

Working for reproduction allows you to retouch your lettering until you are satisfied with it.

Furthermore, because you write the text and assemble it in pasteup, you can retain a certain spontaneity in your work. You can write the text a few times and choose the best one—you don't have to write it all over again on a blank sheet of fine paper. Once you've written the best word or phrase you can manage, you glue it down to the backing sheet.

In addition, work for reproduction is usually written larger than the size at which it will be reproduced. By shrinking the lettering, you crisp up the edges of your writing. Reduction hides all sorts of flaws. For all these reasons—retouchability, spontaneity, and reduction—working on a piece that will be printed can actually be easier than making an original, singular piece.

The Calligrapher-Client Relationship

If you are already a graphic designer, then you have probably already found ways to incorporate calligraphy into printed projects. Most calligraphers, however, are not graphic designers. They are approached by a designer or art director and are asked to do a bit of lettering to fit into a project under the designer's supervision. You may be asked to write out a single word that will be placed within a larger piece, or you may be asked to provide a more comprehensive composition.

Whether it is a one-word project or a more complex job, like a menu or a printed certificate, the same design principles that we explored in chapter 7, on making broadsides, still apply. You want to make the best letters you can, and arrange them well.

A good client will give you specific instructions about what she would like you to do. Generally, you will be asked to produce a piece of black-and-white camera-ready art. What this means is that she expects a clean pasteup of the lettering in black ink on white paper, with all the elements in position.

In order to explain how this is achieved, I will take you step-by-step through a specific project—lettering for a postcard. This is a fairly typical job for a working calligrapher.

Creating Camera-Ready Art

The client should give you a specific brief on what the project entails. This should include all the text that you are being asked to write, plus clear guidance about the size at which the work will be reproduced and whether your lettering will be part of a more complex design. Many clients will provide a detailed sketch or mock-up of the job, so you have clear sense of what you are being asked to do.

The project discussed here is a postcard for a yacht club regatta. The lettering is to be the main element of the design and will be superimposed over a photograph. I am asked to include a black-and-white drawing of the yacht club's burgee, its distinctive house flag. The words to be used are Flood Rock Yacht Club and Annual Regatta. The arrangement and drawing of these words is up to me, but Annual Regatta is the most important element. After a conversation with the client, I have a general sense of how the lettering and illustrational elements might be arranged.

The postcard is a standard 4 x 6 inch format. We call this the trim size—in other words, the cards will be trimmed to exactly that size. When given a trim size, remember that this functions just like the margins of a broadside; you have to leave space between your lettering and the trim.

Ruling Up the Board

So how to begin? I will be working to produce a finished pasteup to present to my client. This is much like the

Christopher Calderhead, calligrapher & author, & editor of Letter Arts Review, will deliver a talk entitled Around the Word in Eighty Ways. For the past two years, he and his colleague Holly Cohen-Roochvarg have been working on an encyclopedic book about living calligraphic traditions from around the world. Join us as he describes the meeting of brush cultures & pen cultures, & the ways in which societies & language traditions have shaped the scribal arts in all their diversity. ℬℬℬ Wednesday, the 17th of September, 2008, at 12:15 p.m. at the National Arts Club, 15 Gramercy Square South, New York (at 20th St). Keepsakes welcome. Reservations are required. Please see the enclosed form.

184

I was asked to design an invitation for a lecture I gave to a Typophiles event in New York City. The deadline was tight, so I wrote the whole text in one go and did not retouch it. It was written a bit larger than the intended size of the printed invitation. I scanned the art, reduced it, and created two pieces of reproducible art: a black plate and a red plate.

184. From top to bottom: The initial text for the Typophiles invitation; the black plate for the invitation; the red plate for the invitation; the actual invitation printed by the Arm Letterpress.

calligrapher & author, & editor of Letter Arts Review, will deliver a talk entitled For the past two years, he and his colleague Holly Cohen-Roochvarg have been working on an encyclopedic book about living calligraphic traditions from around the world. Join us as he describes the meeting of brush cultures & pen cultures, & the ways in which societies & language traditions have shaped the scribal arts in all their diversity. ℬℬℬ 2008, at 12:15 p.m. at the National Arts Club, 15 Gramercy Square South, New York (at 20th St). Keepsakes welcome. Reservations are required. Please see the enclosed form.

Black plate

Christopher Calderhead,

Word in Eighty Ways. Around the

17th of September, Wednesday, the

Red plate

Christopher Calderhead, calligrapher & author, & editor of Letter Arts Review, will deliver a talk entitled Around the Word in Eighty Ways. For the past two years, he and his colleague Holly Cohen-Roochvarg have been working on an encyclopedic book about living calligraphic traditions from around the world. Join us as he describes the meeting of brush cultures & pen cultures, & the ways in which societies & language traditions have shaped the scribal arts in all their diversity. ℬℬℬ Wednesday, the 17th of September, 2008, at 12:15 p.m. at the National Arts Club, 15 Gramercy Square South, New York (at 20th St). Keepsakes welcome. Reservations are required. Please see the enclosed form.

185. I have enlarged the blue rectangle by drawing the red diagonal line. I then extended the bottom and left sides of the original rectangle (my new lines are shown in red). Then I drew the right side. Where this line intersected the diagonal, I drew the top of the new, larger rectangle.

pasteups discussed in the chapter on broadsides. The difference is that this pasteup will be my finished art; it is not just a sketch.

Since calligraphers making work for reproduction usually work in a larger scale and then reduce their lettering for the final product, I need to start by scaling up the 4 x 6-inch rectangle. Working at 150 percent is a fairly standard procedure. I can do the math in my head: At 150 percent, this would produce a rectangle of 6 x 9 inches.

But what if the size of the piece is a more complex ratio—say, 4.125 x 6.25 inches? The simplest way to scale up any rectangle is this: Using your triangle and T-square, draw a rectangle the size at which the piece is to be reproduced. Now draw diagonal lines between two corners of the rectangle. Any rectangle you now draw that shares that diagonal is proportional to the original rectangle.

You may, of course, scale up a rectangle with a photocopier, but knowing how to enlarge by hand is quick and efficient and saves you a trip to the copy shop.

Returning to our task: I have enlarged the 4 x 6 card by 150 percent. Now I need to rule up my backing sheet, also known as a board. Traditionally, pasteups for reproduction are made using bristol board as a backing sheet. Bristol is sturdy and allows things to be pasted down, cut again using only the board as a backing, moved, and replaced. Bristol can withstand a lot of abuse, so it's the best choice for complicated jobs. In this case, the design is simple enough that I can simply use a stout sheet of paper. Remember that the backing board or sheet of paper should be plain white, just as all the paper you write on and paste down will be plain white. Throughout this discussion, I will refer to the backing sheet as the "board."

After taping my board to my table or drafting board so it won't move, I draw my enlarged rectangle on the board with my T-square and ruler, using a 2H pencil. I then place crop marks in the corners using a fine marker. These marks align with the trim lines and are positioned outside the trim area to indicate to the printer where the trim lines are. (See figure 188 to see what the finished pasteup looks like.)

Design

Now I spend time working out my design, just as I would with a broadside. I rule up paper, try out different sizes and styles of script, and lay them onto my board. Once I begin to have some idea how large and in what scripts I want to write the words, I rule up a number of sheets and write the text numerous times.

Because I know I will cut the lines apart and paste down the best bits of writing, I feel free to continue experimenting until I have all the words called for in the design. I was not satisfied with the **A** in Annual, so I wrote quite a few **A**'s, knowing I could cut and paste them in place as needed.

I let my ink dry thoroughly before going to the next step.

Some people like to make clean photocopies to use for their pasteups. This has the advantage of preserving your originals should anything go awry. However, I generally work directly with my pen-made writing since most jobs are fairly simple and I have the self-confidence that I won't ruin the lettering as I paste it up. If in doubt, work with photocopies.

Pasting Up

Now it is time to glue the pieces to the board. In chapter 7, on broadsides, you were given the option of making a rough draft by taping the elements to the backing sheet. Here, however, you must use glue so that the lettering

is firmly attached to the board and lies perfectly flat.

My preferred glue is spray mount glue because, though it holds the elements onto the board, the adhesion isn't overly strong; I can lift off a piece of writing even after I have glued it down and move or replace it.

Leave your ruled pencil lines on your writing. Do not erase them yet. They will be helpful in lining up the lines of writing using your T-square.

Place your drafts of writing face down on a sheet of waste paper, such as old newspaper, and spray the back with spray mount. Let it dry for a few seconds; then place the lettering faceup on a self-healing cutting mat.

With your X-acto blade, slice out the parts you would like to paste onto the board. I prefer to use a T-square to cut my lines of writing to make sure that my cut lines are parallel to the baselines. This makes it easier to place multiple lines on the page and to judge whether they are straight or not.

As you glue each line to your board, use your T-square to make sure it's perfectly straight. The ruling lines you have left will make this easier. Align the baselines to the edge of the T-square. When you are confident of your placement, gently rub each glued sheet down so it adheres well.

Figure 188 shows my finished pasteup. The primary lines of writing have been sliced parallel to the baselines of the writing, so they are easy to align properly. I have, of course, double-checked them with my T-square before rubbing them down. Notice that the **A** and **R** in Annual Regatta are cut with irregular shapes; I have replaced these letters, and I cut them with an irregular edge so I could wedge them in tightly to the other letters. The burgee was drawn in pencil before being inked with a fine-pointed brush.

Once everything is in place, cover the pasteup with a sheet of tracing paper to protect it, and smooth everything down using a triangle to apply

187. Leave your ruled pencil lines on your writing to help you line up the different text components.

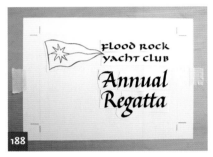

188. My finished pasteup for the regatta invitation.

189. After covering the pasteup with a sheet of tracing paper to protect it, use a triangle to smooth everything down.

190. Tracing paper taped to the edges of the backing board protect the final pasteup from damage and creates a nice package to hand to the client.

some pressure. The triangle is held so that one edge is in contact with the surface. I gently rub the edge across the surface, ensuring that all the pasted-down elements are flat and glued firmly to the board.

Once the elements have been smoothed down, remove the protective tracing paper and gently erase any pencil lines with a soft eraser.

In order to present the finished pasteup to my client, I attach a sheet of tracing paper at the top of the board and trim off the edges in alignment with the edges of the board. This sheet may simply be taped down with a piece of masking tape at the top of the board. The tracing paper protects the pasteup from any damage. It also makes a neat, tidy package for me to hand to my client.

It may surprise you that such an odd pasted-together assemblage is considered finished art, but it is. When the pasteup is placed on a scanner set with the proper parameters, it will read as a simple pattern of black and white. The cut marks will almost entirely disappear. Any that remain are easily removed. Your job is done.

Retouching Your Pasteup

Remember that one of the benefits of working for reproduction is the ability to retouch your work. On page 171, I look more closely at some of the details of my pasteup and I explain how I did the retouches by hand. The pasteup I produced using these methods is camera-ready; it can be scanned, and, with only the most minimal retouching, my art is ready for the designer to use.

However, the reality is that all of us are becoming more computer-adept. Instead of doing a full pasteup, I could just as easily have scanned each piece of lettering into the computer and, using Photoshop or another graphic editing program, composed the whole piece electronically. In

practice, I do both. Sometimes it is easier to make a pasteup; sometimes it is easier to use the scanner. If you have good computer skills, use them. The hand-retouching I described can be done quickly and efficiently with the tools in Photoshop, and there's no reason not to use that tool if you have the ability.

If you are less computer-savvy, then it's perfectly fine to work by hand. (Graphic designers like to think calligraphers are Luddites, anyway— it charms them that we do things by hand. It's part of our mystique.)

In coming years, we will increasingly be asked to supply our work in the form of digital files. If you have produced a camera-ready pasteup and need to scan it, there are two rules to bear in mind: First, the standard resolution for scanning lettering is 600 dpi. That means the computer reads the art at a high resolution: 600 dots, or pixels, per inch. That high resolution gives your letters the necessary sharpness. Second, there are several modes for scanning images. Most calligraphers prefer to scan their black-and-white art in bitmap mode (also called bmp or simply black and white). It is not advisable to scan black-and-white art in either grayscale or color, as those modes are less crisp.

The Final Result

The project I've described in this section was lettering for a postcard. My part—the lettering—is done. But what happens next? My art is scanned as I described above, producing the image seen in figure 191.

Figure 192 is what the final card looks like. My art has been rendered in black and white. Colors have been added to the burgee, and the art and illustration have been superimposed on a photograph.

It's often surprising—and usually gratifying—to see what a designer has done with our work. A good cal-

Some retouching can be done with the X-acto knife. I was concerned that the first **n** in Annual began with a slightly blobby entrance stroke. Using my knife, I carefully sliced away a tiny part of the stroke, leaving a nice, crisp edge.

The **R** in Regatta was a replacement for an earlier **R**. Notice how I have sliced the end of the **R**'s tail so that it perfectly joins the **e** that follows.

In the burgee, I have sliced the corners inside the star shape to give myself crisp edges.

Another way to retouch is to use paint. In the image above, I used white gouache to fix a blobby area inside the arch of the **n**. I diluted the gouache only slightly, using water; it needs to be quite thick, as it has to completely cover any areas of black that I want to remove. I use a fine-pointed brush to retouch in this way. In place of gouache, some calligraphers prefer to retouch with a commercial paint called Plaka, available in art supply stores. It can be used straight from the jar in which it came.

Some of the thin strokes in my design needed just tiny touch-ups. Because my work has been executed at an enlarged scale and will be reduced, I need to beef up some of the very fine thins, lest they break up or disappear when reproduced at a smaller scale. I also need to fix some awkward marks at the ends of a few strokes. In the image above, I used a fine-pointed marker to do this. You may also touch up black areas with a pointed brush and ink.

191. Scanning my art produces this image.

192. The final version of the invitation.

193.

193. Rory Kotin is a New York-based calligrapher who does a great deal of social calligraphy work. Some examples of her oeuvre are shown here. Always improvising, she has worked in many different media. Many of works are the standard envelopes and place cards, but for certain clients she is able to create interesting party favors and menus.

194.

194. Rory's guidesheet, worn from years of use.

195.

195. This weathergram is very simple: a strip of paper 2 inches wide, folded at the top and suspended from a string. To hang one, loop the string through the hole at the top of the paper strip. At the other end tie the string in a simple knot.

ligrapher-client relationship is a collaboration, with each of us playing our part to make something that we, as individual participants, could not have done on our own.

SOCIAL CALLIGRAPHY

The business of wedding invitations, envelope addressing, and the making of other works of social calligraphy is an exceptionally specialized niche activity. Those who excel at it are highly professional and know how to both meet deadlines and educate their clients. The average bride doesn't get married too often—at least we hope not! Most social calligraphers are clear about the ground rules. The guest list must be typed and proofread, because the calligrapher will write exactly what's on it. Sufficient time has to be given for the envelopes to be addressed. Rush orders require extra payment, or may be refused. If a social calligrapher isn't tough and explicit about his expectations, his business will become unmanageable.

From a calligraphic point of view, the basic skills required for work like this are similar to those we've discussed in the previous chapters. You need to know how to rule lines, know how to vary the size and style of your scripts, know how to be sensitive to different kinds of papers, and learn how to write consistently and evenly.

Beginners, of course, should not accept paying jobs doing social calligraphy. Until one has built up a level of skill, it's bad for the profession to have amateurs in the market touting their skills. It takes several years to acquire a mastery of calligraphic writing.

Because so much of the work is repetitive and done at a small scale, a social calligrapher's desk is usually specifically set up for envelopes and place cards.

The guidesheet shown in figure 194, worn from use, has a set of standard ruled lines that match social calligrapher Rory Kotin's repertoire of scripts. It also has a series of extra lines at regular intervals, marked in distances emanating from the center to show her where to begin and end each line of writing. This guidesheet makes it so Rory doesn't have to rule new lines for every job. She has a standard repertoire of five or six hands, which gives her clients a wide range of choices, but which also keeps her from having to invent a new script for each job. As a result, she knows exactly how to center a guest's name on an invitation without having to do rough drafts. She is so familiar with her standard scripts that she can look at a word written in a typescript and judge immediately how long it will be when written in any of her styles. At the end of a year's toil, the ruling sheet needs to be replaced.

WEATHERGRAMS

This project is quite fun. The weathergram was devised by the famous American calligrapher Lloyd Reynolds (1902–1978). Reynolds was an English professor at Reed College in Oregon who established an international reputation for his calligraphy classes. His broad knowledge and vibrant curiosity led him to explore calligraphy in a much wider context than simply as a craft practice. He was inspired by Japanese works to create a form of written poem that could be hung in trees in a natural setting.

The weathergram is meant to be impermanent. It is made of humble materials—Reynolds suggested using paper grocery bags. Two inches wide, they have a flap at the top to create a sturdy structure and a hole punched in the center at the top, through which a piece of twine is laced. An example of a finished weathergram can be found in figure 183 on page 164.

Reynolds encouraged people to write their own texts for the weathergrams. He considered short, haiku-esque poems, usually drawn from observations of nature, best. Once the text is written on the weathergram, the maker should go out into the woods and hang it from a suitable tree. The poem is left there until nature takes its course, the paper dissolves in the rain, and it falls to the forest floor to become part of the soil.

It is important that the materials used for a weathergram are not precious and are biodegradable. The brown paper and natural-fiber twine will last for a season, perhaps, and then the thought disappears, except in the memory of those who have come upon it on a walk in the woods.

WRITING ON THE BODY

Here's a project that may seem unusual—you don't see living skin as a medium very often in calligraphy books. A number of calligraphers, however, have experimented with writing on bodies, and their work has found its way into film and printed pieces. Peter Greenaway's film *The Pillow Book* (1996) includes many remarkable—and tantalizingly erotic—scenes of actors writing on each other's bodies with a Japanese brush. And some of the work of the Italian calligrapher Monica Dengo involves writing on the nude figure.

There is no single way to go about writing on a living body. I have used liquid eyeliner with a 1/4-inch-wide makeup brush that functioned very much like a chisel-edged pen. In the project shown here, calligrapher Anna Pinto writes on a model for a photographic project designed for a book cover.

After taking the model's measurements, Anna designed the Italic lettering with markers on a long sheet of tracing paper. On the day of the shoot, she began by cleaning the model's back with alcohol. The letters were carefully written out with two eyeliner pencils, using the exact technique shown for the Foundational Hand in chapter 2.

The final lettering was executed with nontoxic, water-soluble, felt-tip markers. The markers themselves were pointed, so the double-pencil calligraphy was outlined and filled in. Double-pencil calligraphy operates like an edged pen, and naturally produces the thicks and thins of the writing; a pointed pen, which simply produces an unmodulated, uniformly thick line, cannot create that kind of stroke. As a result, it was used to draw outlines and fill them in.

The lettering was touched up with alcohol and a cotton swab. The alcohol easily removed mistakes and the edges could be sharpened as well.

From a design point of view, writing on the human body presents the challenges of working with contour and movement. No part of the human body is perfectly flat, and some experimentation is required in order to arrive at a design that works in three dimensions. In this case, Anna discovered that positioning the letters horizontally across the back created strange distortions in the letterforms; as the body moved, her Italic lost its elegant, parallel strokes. The design solution here, using the vertical spine as the writing space, maintained the script's integrity, even when the body was torqued or in motion.

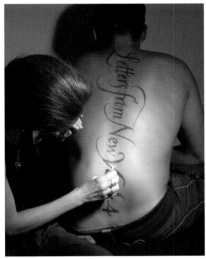

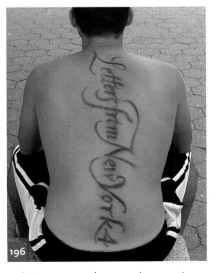

196. From top to bottom: A nontoxic marker is used to make the final lettering; alcohol with a cotton swab is used to remove mistakes and sharpen the edges; the finished product.

PROJECTS

This small portfolio of projects illustrates some of the simpler uses of calligraphy. These kinds of basic projects move you beyond simply practicing lines of writing, to beginning to create a finished project. The genius of calligraphy is that it can be used for intimate work for yourself, your friends, and your family, as well as for important public commissions and works of fine art. You might use calligraphy to make small birthday cards or to label boxes in the attic. Or you might write out a prayer to be hung in a church, or the Gettysburg address in honor of Lincoln's birthday.

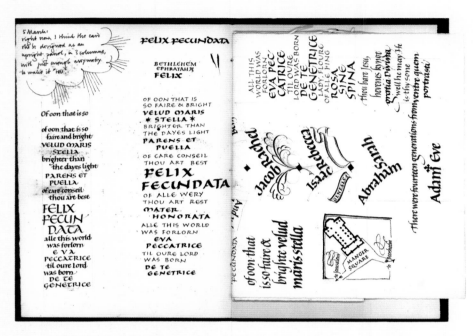

Journals and Sketchbooks

An informal journal records the goings-on of the day. Sketchbooks serve two functions: They are ways of enlarging your study of letterforms, and are also ways to keep odd bits of leftover paper, pieces of nice writing, and the little projects that may never have been finished. This image shows warm-up sheets for professional projects sewn together to make a little compendium.

Calendars

For several years I made my own date books—an example can be seen above—until time and business got the better of me. It can be useful, when talking to calligraphy clients, to pull out a handmade diary and jot down an appointment.

Labels

Many things can be labeled—jars, storage boxes, etc. These notebooks are easily spotted on my bookshelves; the calligraphy makes them stand out from the printed books.

The SHEARS is the first of the mechanical powers, & to be used on the knees. For if ADAM had right, he would power of the used this instrument not have fallen For the Shears is direct as life. For FRICTION is inevitable the universe is FULL of God's because works. For Newton more of But I am nevertheless is error than of truth of the WORD of GOD

Sitting at the Brick Cafe on a lazy Saturday afternoon, & Lexy shows me how a corkscrew works. You screw in the pig tail tine, then lever out the cork in two steps, first with the part labeled {1}, then, from a higher angle, with {2}.

Works for Reproduction

One of the beautiful things about working for reproduction is that you can write your text out as many times as you wish, knowing that you will be able to choose the best version. You can also touch up your work.

When you paste-up your best writing to make finished art, you can adjust problems with spacing and fix mistakes.

In the piece on the left, created as an illustration for a magazine, I picked up a scroll-work experiment from my sketchbook and

applied it to a new project. The image on the right was drawn using a fountain pen and water, which allows the ink to bleed and adds shading. The text was written directly onto the paper, without ruling up.

O my God! We've just learned that you are a girl! Yippeee!!!

We heard your heart-beat today at the doctor. You sound so excited!

Here comes the mad dash to get ready for your arrival.

Practicing in a Pinch

A friend of mine is an avid student of calligraphy. Soon after he'd begun his studies he started his job as a screenwriter on the set of a television drama. Suddenly, there was no time to practice. He had to catch whatever quiet moments there were on the set and do his calligraphy there. Knowing that

he couldn't bring his easel, pots of ink, and pens to the set, he devised a simple project for himself. His wife was pregnant with their second child, so he decided he would make a little book for his unborn daughter. He ruled up a master sheet and photocopied it onto ordinary copy paper. Then each time he had a moment, he'd write one page using

a felt-tip pen. He composed the words himself. At the end of several months, he had a whole book of short thoughts expressing his dreams and hopes for his daughter. The last page has a print of her footprints, taken at the hospital when she was born.

The Maker's Eye

Once you have begun to work with the scripts in this book, you develop a new way of looking at the work of other calligraphers; your perception is informed by experience. Instead of seeing a pretty pattern of letters and colors, you can now imagine yourself writing the text you are examining. You can picture the pen moving from stroke to stroke, letter to letter. In chapters 2 and 3, the instructions for writing the Foundational Hand and the Roman Capitals were very precise. In chapter 4, the instructions for the Italic were a little looser; you were asked to work out more on your own. Now that we come to looking at an original manuscript, you need to become more critical, and look for yourself. The techniques you have started to master apply to any calligraphy made with an edged pen. Studying a manuscript can be useful simply to learn more about the way the edged pen can be used, or you might choose to try to write your own version of the script we examine here.

The manuscript shown in this chapter is a handsome piece of writing by an expert scribe. It is *not* a masterpiece—it has its flaws and inconsistencies. But it does, nonetheless, have a great deal to teach us. As you progress in your study of calligraphy, you will want to examine other examples of calligraphy, both from the manuscript tradition of the Middle Ages and from contemporary scribes. It's best to look at work "in the flesh," so to speak, at museums, libraries, or exhibitions, but you can also review good reproductions in books.

AN AFTERNOON SPENT LOOKING AT A MANUSCRIPT

A few years ago, a friend who was clearing out her studio gave me three sheets from the late medieval manuscript discussed here. I know nothing about when or where it was written—all I have are the sheets in front of me. I am not a scholarly paleographer—someone who studies ancient writings—but, as a practitioner, I have learned to look carefully and have picked up some knowledge of the manuscript tradition. The observations that follow are the fruits of an afternoon's work; here I describe my own process of examining and analyzing a manuscript. I should note that all the illustrations are at the actual size of the original manuscript, unless otherwise noted.

197. A close-up of a page from the medieval musical manuscript discussed in this chapter.

What Kind of Document Is This?

The first question to ask about any piece of calligraphy is this: What is it? The purpose of the piece—its function—will determine a great deal about its size, style, and level of polish. A framed testimonial will be of a different scale than a little handheld prayer book; a love poem given to one's wife will be a small, precious, intimate object, while a quotation written to hang in the entrance hall of a house will be large and call attention to itself. The function of the piece determines how it will be made.

This document is a musical manuscript, with five lines of text per page accompanied by five-line staffs for the musical notation. I've been taught that these large music books are called antiphonaries, or collections of antiphons, which are chanted texts used in the services of liturgical churches. I went online and typed in some of the texts from the manuscript. They came up as verses and responses in honor of Saint Lawrence, a Roman martyr of the third century CE. Large antiphonaries like this one were placed on upright lecterns in churches, where a group of singers could gather and read the music from a single book.

Since the book was meant to be read by more than one person at a time, the page size needed to be large. The pages here are $19 \times 25^{1}/_{2}$ inches. The book was written on vellum (calfskin that has been prepared for writing; it is a type of parchment). This durable material is perfect for a book that will be used for many decades, if not centuries. Each leaf is made of the skin of a single animal and is bound using glue on folded vellum hinges. The skin is wrinkled and varies in tone from milky white to light yellow. It crackles when you turn the pages and many of the lower corners are soiled from handling.

First Impressions

The text is written in Latin and uses many abbreviations. Although I can't read all the text, I can make out most of the letters. Some of the abbreviations are a mystery to me, so I concentrate on the letters I can recognize. I notice that some of the words are broken at the end of lines, or spaced out to match the musical notation above. The more I look, the more words I can read. I notice that when a word is broken to accommodate the music, the scribe inserts a long red bar.

The script is Rotunda Gothic, which was popular in Spain and Italy in the late Middle Ages and throughout the Renaissance. I could check some of my reference books to try to date it more exactly, but my aim is to study the script, not the history, so I decide to let the provenance of the manuscript remain an open question.

The pen angle is extremely variable, ranging from about 20° to 45° or 50°, but the terminals of upright straight strokes (like the **u** shown in the "How To" section on page 180) are squared off. I'll have to look closely to figure out how the squared-off strokes were made.

The scribe is confident and in absolute control of the pen. The fine lines are as crisp as can be. There is an overall consistency of letterform, but the scribe feels free to adjust this for different letter combinations.

Analyzing the Script in More Detail

In what order, were the different sections of the page written? Closer observation tells the tale. The text was written first, then the red musical staffs, then the notes. The staffs are broken when they might collide with the text—an indication that they were added after the words were written. The ink of the notes bled when

198. An uncropped version of the medieval musical instrument page shown on page 176.

it hit the staffs, indicating they were added last.

The musical staves are quite crude compared to the crisp writing and neatly formed notes. Did an apprentice add them, instead of the scribe?

The erasures indicate that this was a working manuscript—people used this book. When they needed to make changes, they did so. The erasures may indicate changes in text or music over time or mistakes made by the scribe. The scribe was probably working at a high speed. His writing indicates

as much: Although the writer was experienced and skillful, his upright strokes are often not quite parallel. His letters sometimes lean backwards. This doesn't reflect a lack of ability, but that the scribe was churning out pages on deadline.

Ruling Up

What of the ruling up? On the first page I look at, I can't see any ruling. But the writing is too even to have been done freehand. Then I notice thin gray lines ruled on one side of one leaf. Looking more closely, I see that

The most obvious abbreviation is the small arched dash over some of the vowels, which leans downward to the right as seen here. This replaces the letters **m** or **n**. Hence, *laurētiun* for "laurentium."

I notice that **fi** and **ti** are usually joined by the horizontal crossbar, as seen in these figures. In **pro fi—de** the second letter is a variant of **r**, which is only used after the bowl of a letter like **p** or **o**. I see that the scribe enjoys joining letters when he can, as he does in **fi—de**.

The **t** usually has a thin line coming off the top left of the upright stroke, which seems to be purely decorative in function, a little flourish, as seen here in *tibi*. The **i**, rather than having a dot, has a similar fine line coming off the right of the upright stroke.

Looking at the figures above, you'll notice that the fine strokes that come off the bottom of letters like **u** are made with the corner of the nib, creating a little finishing stroke that gives crispness and detail to otherwise very chunky writing. The **s**, seen in the figure on the left, is funky, curvaceous, and wide.

The manuscript is full of ligatures, or strokes that tie the letters to one another. The words *pedes* and *debe* use overlapping strokes. In fact, the more I look at the manuscript, the more I see how fluid and flexible the writing is. Though the script is governed by a clear geometric logic, is quite free: Look at the shapes in the word *pedes* in the figure on the left—every stroke is lively. There is nothing cold or mechanical at work here.

This figure, the word *[ba]ptizare*, shows a rather wild **z** and a typical **a**. If I were to use this manuscript as a basis for my own writing, I would probably have to devise my own **z**. This one is hard to recognize; it is very archaic and foreign to our eyes. However, if you look hard enough, you can see the early origins of our contemporary lowercase cursive **z**.

Some words take a while to work out. The word *festina*, seen in the figure on the left, uses the old-fashioned, tall form of the **s**, which ties neatly to the top of the **t**. And the word beatus, of which we see just the first three letters in the figure on the right, is written by overlapping the **b** and the **e**.

In a few places, age and abrasion have revealed the sequence of penstrokes; the ink is partly rubbed away, so I can tell where the scribe lifted his pen and changed his pen angles. I begin to see how the letters were constructed: There are quite a few pen lifts and changes in pen angle throughout the script. I pick up a pen and try copying some of the letters stroke-by-stroke. These partly rubbed-away letters are perfect models since I can see each separate stroke.

The approximately 20° pen angle used for the vertical strokes is consistently shallower than the angle of the other strokes. The diamond-shaped beginning and ending strokes are at more of a 45° angle. If you look at the **u** in *sequeris*, above, you can see how the strokes overlap and how the pen angles change. The diamond-shaped stroke at the top is made at about a 45° angle; then the pen is lifted and put down again at a 20° angle to make the downstroke; it is lifted again and replaced at a very steep 55° angle for the bottom diamond-shaped stroke. The diagram on the bottom shows some of the typical pen angles the scribe used to write the letters. The top of the **r** shows how a square end is made.

The square ends at the top of the upright strokes are generally filled in with a separate stroke. The pen is turned to a steep 90° angle. You can see this in the top of **l** in *le* and more clearly in the top of **u** in *ui*. The square ends at the bottom are not filled in—the scribe has twisted the pen as he has made the stroke; it starts at 20° and ends at a flat, 0° angle. He makes this look easy.

To determine the weight of the writing, we need to make a pen scale. By measuring the end of one letter (the **t** in the figure above in this case), we can figure out how wide the scribe's pen was. Drawing in a baseline, x-height, and ascender line, we measure it with our pen-width. The writing here has been made with an x-height slightly smaller than 4 pen-widths; the ascenders are just 1 pen-width higher than the x-height. Bearing these measurements in mind, we can rule up lines and try writing the script.

Note that the first **v** is a decorated capital. The small dot over the red **v** is an abbre- viation mark; this **v** stands for *verse*.

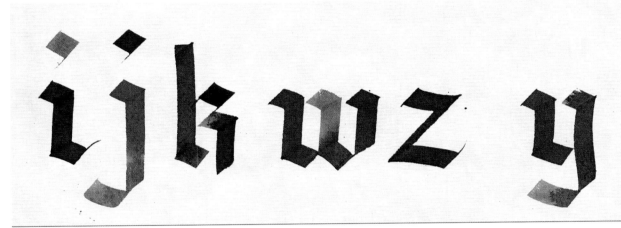

Looking through the pages of the manu- script, I try to locate all the letters of the alphabet. I can find every letter except **j**, **k**, **w**, and **y**. I can create these letters based on the letters for which I do have exam- ples. The **j** and **y** are based on the **g**; the **k** on the **h**; and the **w** on the **u**. I also decide that the **i** and **j** need to be dotted if I'm going to use the script for my own work.

Notice that the ruling shown here is carefully done, but it doesn't stop neatly at the margins. A person working quickly to rule sheet after sheet ran a tool along a straight- edge to the end of the page.

The thin upright strokes, which connect certain notes to the text below, seem to have been made using a straightedge. In some places, they cut into the vellum sharply, which makes me wonder if a metal tool was used.

For a set of only three manuscript sheets, there are a surprising number of erasures. On one page, three notes have been scraped off. The new notes that replace them were added by a less expert hand.

On another page, a full word has been erased, leaving a gap in the line. When I look up the text on the Internet, the word appears to have been erased in error.

The capital letters in the manuscript come in two different forms. The pen-made caps, like the one here, show a degree of playfulness that is almost ill-advised—the free-form quality of the capital doesn't seem to accord with the more formal quality of the minuscules. This figure shows a

capital **B**. The serrated edges were added quickly; they are free, uneven, and rushed. Ornamental dabs of thin red color have been added in a strikingly casual manner.

On the three leaves I have in front of me, there is one fancy painted capital—a Lombardic **B** drawn with a thin pen in red and blue line, seen here. The main body of the letter has been filled in with color using a brush. The colors are counterchanged, to borrow a term from heraldry—on the left side, the thin lines are blue and the painting inside the letter is red. On the right, the pattern is reversed: The lines are red and the letter is painted in blue. It's a nice example of graphic richness achieved through simplicity of means. With only two colors and just two tools (a brush and a pointed pen), the scribe creates a complex design, balancing contrasting tones and textures.

And, finally, a mystery. Someone—perhaps the scribe—has made a tiny notation with a fine pointed pen in a fluid cursive script, much abbreviated. It is so small that no one would notice it when chanting from the manuscript. I show it here, much enlarged.

lines have been ruled in silverpoint—a drawing technique that utilizes a silver pencil on a specially prepared ground—or some other pencil-like tool on one side of each sheet. The scribe relied on the show-through of the vellum (which is slightly translucent) to see the ruled lines on the reverse side.

MYSTERY

My afternoon spent looking at this undated manuscript by an unknown scribe is done. It's apt that it ends with a mystery. By looking carefully, I've gleaned enough information to try writing my own version of this script. Much can be learned from the scribes of the past, but their work will always present challenges and unanswered questions. Having pored over this 500-year-old piece of writing, I feel a kinship with the scribe. I see how he worked; I can feel how he moved his pen across the page. I see where he was rushed and where he made blotted, imperfect strokes. But he remains an enigma, an anonymous master. I wonder if someone centuries from now will look at a piece of my writing, and ponder who I was and how I worked.

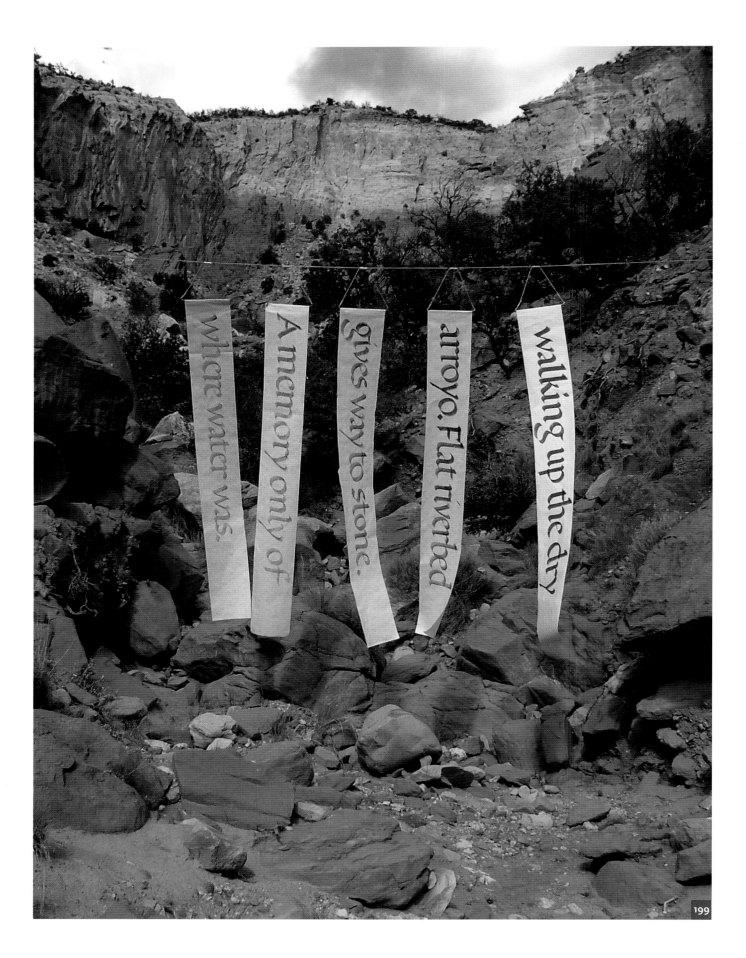

Afterword

Calligraphy is both an ancient art and a contemporary practice. It has deep roots in the past, but it continues to evolve. The scripts and projects in this book are meant to serve as a foundation, not as an end in themselves. Once you have mastered the basic scripts in the book, there are any number of directions in which you can go next.

ARROYO

I was once asked to teach at a conference at Ghost Ranch, New Mexico. The landscape—so foreign to me—was stunning. After a walk up the arroyo (a dry riverbed in a rocky valley) nearby, I went back to class and made the piece seen in the figures on this page. A group of us took it up the arroyo and unfurled it. The text is my own. Reflecting on this piece, I realize that it is a personal version of one of Lloyd Reynolds's weathergrams.

The arroyo piece lasted just half an hour—when we were done, it was rolled up and taken home. But even if it is displayed again, it will be incomplete without the setting and without the group of people for whom I made it.

For many calligraphers, the craft skills that form the basis of our training are a jumping-off point to do work that is expressive and highly individual. We are grateful for the solid foundation that's been laid, but we are also looking to develop our skills in new directions and push forward. Welcome to the journey.

200. The arroyo piece blowing in the wind.

199. Arroyo, Ghost Ranch, New Mexico, 2006. The writing was done with a felt-tip marker dipped in ink on plain strips of layout paper. The length of each strip is approximately 8 feet. Text composed by the artist.

Acknowledgments

Writing a book is an often solitary enterprise, but no book is ever written by one person in total isolation. This book is no exception. I had help from many friends and fellow calligraphers.

Thank you to Anna Pinto, who, in addition to providing samples of finished work, has always been a reliable touchstone when I have a quandary to solve. Her suggestions added much to the shape of this book.

I am grateful to several people for giving me material to reproduce. Jerry Kelly kindly allowed me to photograph the sample of Edward Johnston's writing in the introductory chapter. Rory Kotin and Carol Pallesen were generous in letting me use their work. Joseph Knight made several computer-generated illustrations while working as an intern in my studio. Bradford Winters allowed me to show his writing samples in the chapter on the Italic Hand.

Some of the works I used in the book were personal gifts to me from other calligraphers. Alan Blackman gave me the metal stencil reproduced in chapter 11 on cut paper. Lili Wronker, whose generosity knows no bounds, and who has done more than almost anyone I know to promote the art of calligraphy, gave me the manuscript that I dissect in chapter 12.

I am grateful for the Brick Café in Astoria, New York, where much of the text was outlined and written, and where I made a surprising number of the pencil illustrations, holed up in a corner of the bar. Special thanks go to Mitu, Natasha, and Marcelo who graciously agreed to be hand models for some of the photographs, and to hold up large works of calligraphy for me to photograph.

Sasha Tropp, who line-edited the book, called me out on all my calligraphers' jargon and made sure the book was accessible to the widest possible audience. Her work has made the text much clearer and eminently reader-friendly. Thanks are due to her and to Barbara Berger, my editor, who has shepherded the project through Sterling Publishing.

And finally, thank you to Holly Cohen, my frequent collaborator and friend, who allowed me to use her studio as a place to take photographs and was the hand model for chapter 6 on working with color. Holly also commented on the text and was a helpful nudge who told me to stop fooling around and sit down and get writing. I don't know how I would have gotten through the project without her unstinting support and encouragement.

Glossary

Angle of lean: The degree at which the upright strokes of a script depart from 90° to the baseline.

Arch: The rounded tops of minuscule letters such as n or m.

Archival materials: Art supplies such as paints, inks, and paper that are chemically stable and will not decay over time.

Ascender: In a minuscule letter, a long stroke that extends above the x-height.

Ascender line: A ruled pencil line that indicates how tall the ascenders should be.

Backing sheet: A large piece of paper on which drafts of lettered texts are arranged in order to make a rough.

Baseline: A ruled pencil line on which the letters sit. The baseline is the most important of the ruled guidelines.

Bowl: An enclosed part of a letter, such as the rounded portions of P, R, or d.

Branch, branching stroke: A stroke that gradually emerges from a previously made stroke.

Broadside: A work of calligraphy on one side of a single sheet of paper, designed to be hung in a frame.

Cap height: The height of the capital letters, as measured from the baseline.

Cap-height line: A ruled pencil line that indicates how tall the capital letters should be.

Carolingian Minuscule: A script popularized in the ninth century, with a short x-height and prominent ascenders and descenders. A precursor to Italic.

Chisel-edged brush: A brush with bristles that end in a flat, straight-cut end. The chisel-edged brush makes marks similar to those produced by an edged pen.

Compass: A tool with two arms joined at one end used for drawing circles and arcs. One arm ends in a pointed metal tip, while the other holds a length of graphite or some other writing implement.

Descender: In a minuscule letter, a long stroke that extends below the baseline.

Descender line: A ruled pencil line that indicates the length of the descenders.

Dip pen: A pen that must be manually loaded with ink or gouache, as opposed to a pen with an internal supply of ink, such as a fountain pen.

Dividers: A tool used for measuring. Composed of two metal arms with sharp points joined at one end.

Downstroke: An essentially straight upright stroke.

Edged pen: A pen with a square-cut nib.

Entrance stroke: The terminal of a stroke that shows the motion of the pen as it makes contact with the writing surface; the beginning of a calligraphic mark.

Exemplar: A sample of a particular script that serves as a model for study. Exemplars generally include all the letters of the script, along with instructions for writing the hand.

Exit stroke: The terminal of a stroke that shows the motion of the pen leaving the writing surface; the end of a calligraphic mark.

Flat-pen angle: A pen angle less than 30°.

Flicked stroke: A stroke that ends with a small, quick gesture of the pen, resulting in a delicate termination to the stroke.

Fore edge: In bookbinding, the right-hand edge of the text block. The fore edge is the side on which the book opens.

Folio: In bookbinding, a sheet of paper folded in half and trimmed.

Font: A typeface set by a machine. Never used to describe a calligraphic hand or script.

Foundational Hand: A script devised by Edward Johnston for introducing students to calligraphy. Inspired by a specific manuscript—the Ramsey Psalter—it has an o based on an underlying circle and broad, round forms.

Fugitive: Liable to fade; not permanent.

Gothic: A family of medieval scripts characterized by diamond-shaped terminals. The forms developed in Northern Europe show a compact, dense character of closely spaced, parallel, upright strokes.

Hand: A specific style of calligraphic writing, such as Italic or Carolingian.

Head: In bookbinding, the top end of a text block.

Inkpot: A small vessel containing ink into which the pen is dipped.

Italic Hand: A calligraphic script first developed in the Italian Renaissance that is characterized by an oval-shaped o and branching strokes. Often has a distinct angle of lean.

Join: (1) In calligraphy, a place where two strokes meet. Usually used to refer to a place where the component strokes need to be modified or adjusted in order to create a neat junction. (2) In cut paper, an area of solid paper that connects two parts of a composition.

Knock up: In bookbinding, to gently tap the text block against a flat surface so that the tops of the folios fall into alignment at the head.

Leaf: In bookbinding, one-half of a folio. The sides of each leaf are referred to as pages.

Majuscule: A capital letter. Also sometimes described as upper case.

Margin: An area of empty space surrounding the elements of a composition.

Minuscule: A small letter. Also sometimes described as lower case.

Modulated line: A line with a variable width. The edged pen produces a modulated line, with varying thicks and thins.

Monoline: A line having a consistent width. Skeleton capitals are monoline letters.

Nib: The writing end of a pen. Metal nibs are machine-made pen tips that fit into a holder.

Nib-width: The width of a square-cut end of a nib. Used as a system of measurement.

Octavo: In bookbinding, a page size derived from folding a sheet three times.

Page: In bookbinding, one side of a leaf.

Pasteup: Lettering attached to a board or backing sheet. A pasteup may be a fully finished work prepared for reproduction, or a less formal rough draft for a handmade work.

Pen: A writing implement with a firm tip. From the Latin penna, meaning "feather." In preindustrial times, pens were cut from the feathers of large birds. A modern dip pen is composed of a holder into which a metal nib is inserted.

Pen angle: The angle of the flat writing end of the nib relative to the baseline.

Pen ladder: A set of small rectangles set corner-to-corner, made with a pen held at a 90° angle to baseline. Used to define the proportions of the heights of the letters as a fixed number of nib-widths.

Pen manipulation: The action of changing the pen angle while writing a stroke.

Penholder or holder: Part of a pen. The wooden or plastic rod into which a metal nib is inserted.

Pointed pen: A pen whose tip comes to an acute point.

Quarto: In bookbinding, a page size derived from folding a sheet twice.

Quire: In bookbinding, a collection of interleaved, folded sheets. The basic unit forming the text block of a bound book.

Reservoir: A small metal attachment to a metal nib that holds a quantity of ink to feed the writing end of the pen.

Roman Capital: A majuscule letter based on the forms used in ancient Roman inscriptions.

Rough, rough draft: A carefully worked out sketch for a finished work of calligraphy.

Ruling up: Making a set of parallel lines with a pencil and T-square to use as guidelines for writing.

Script: See Hand.

Scriptorium: The traditional name for a workshop employing a team of calligraphers.

Section: In bookbinding, a collection of folios that are placed one inside the other. The basic building block of a bound book.

Self-healing cutting mat: A flat panel of rubbery or plastic material that serves as a support on which to cut paper with an X-acto knife or some other blade. As the name implies, the surface remains free of damage, even after many cuts have been made.

Serif: A mark added to the end of a stroke. Can be made in one motion with the main stroke, or added as a distinct stroke.

Spine: In bookbinding, the side of the book on which the sections are sewed and/or glued together.

Square: (1) In bookbinding, the small extension of the cover that protrudes beyond the text block. (2) Parallel or at 90° to an object or figure.

Steep pen angle: A pen angle greater than 30°.

Stroke: A calligraphic gesture made with a pen. Often describes a discrete mark made in a single action. Sometimes, as with entrance and exit strokes, used to describe a distinct part of a longer calligraphic mark.

Stroke order: The recommended sequence for writing the component strokes of a letter.

T-square: A T-shaped metal or wooden tool consisting of a straightedge attached to a handle. Used at a drafting board to rule parallel lines.

Tail: In bookbinding, the bottom end of the text block.

Text block: In bookbinding, the section(s) that make up the interior of the book. The text block is sewn or glued into a cover.

Tooth: In paper, the quality of slight roughness that gently resists the pen. This texture is considered desirable, as an overly smooth paper can be too slick, making control of the pen difficult. Not used to describe papers with obvious bumps or ridges (such as rough watercolor papers).

Triangle: A three-sided, flat plastic tool used to rule upright and diagonal lines. Triangles always have one 90° angle; the two most common configurations are 30°–60°–90° and 45°–45°–90°.

Uncial Hand: A script popular from the fifth to the eighth centuries. Characterized by an **O** based on a circle. An all-majuscule alphabet, it includes some letterforms that are similar to our minuscules.

Waterpot: A container for water used to rinse pens and brushes while working.

Weight: In calligraphy and lettering, weight describes the ratio of black and white within the letters of a script. Heavyweight letters are dense and dark; lightweight letters are more delicate and have more pronounced white space within the letters themselves.

X-height: In minuscule letters, the height of the shortest letters (such as **x** or **o**), as measured from the baseline.

X-height line: A ruled pencil line that indicates how tall the shortest minuscules (such as **x** or **o**) should be.

Metric Equivalency Chart

Inches	mm	cm
1/8	3	0.3
1/4	6	0.6
3/8	10	1.0
1/2	13	1.3
5/8	16	1.6
3/4	19	1.9
7/8	22	2.2
1	25	2.5
1 1/4	32	3.2
1 1/2	38	3.8
1 3/4	44	4.4
2	51	5.1
2 1/2	64	6.4
3	76	7.6
3 1/2	89	8.9
4	102	10.2
4 1/2	114	11.4
5	127	12.7
6	152	15.2
7	178	17.8
8	203	20.3

inches	cm
9	22.9
10	25.4
11	27.9
12	30.5
13	33.0
14	35.6
15	38.1
16	40.6
17	43.2
18	45.7
19	48.3
20	50.8
21	53.3
22	55.9
23	58.4
24	61.0
25	63.5
26	66.0
27	68.6
28	71.1
29	73.7

inches	cm
30	76.2
31	78.7
32	81.3
33	83.8
34	86.4
35	88.9
36	91.4
37	94.0
38	96.5
39	99.1
40	101.6
41	104.1
42	106.7
43	109.2
44	111.8
45	114.3
46	116.8
47	119.4
48	121.9
49	124.5
50	127.0

Index

Note: Page numbers in **bold** indicate glossary references.

Adhesives, 27, 104

A letters. *See* Arches; Diagonal letters; Roman Capitals; Straight strokes; specific hands

Alphabet(s)
about: overview and letter components, 4–6
letters. *See* Ascenders; Curves and round strokes; Descenders; Diagonal letters; Roman Capitals; Straight strokes; *specific hands*

Analyzing manuscript, 177–187
approach to, 177
background of manuscript, 177
determining what it is, 178
first impressions, 178
in more detail, 178–185
mystery discovered, 185
page from medieval musical manuscript, 176
ruling up, 184
step-by-step analysis, 180–185

Angle(s)
checker, to evaluate stroke angles, 25
flat-pen, **190**
of lean, **189**
pen, 22–23, 24, 30, **191**
protractor for measuring, 23
steep pen, **191**

Arches, 34–36, 72–73, **189**

Arches Text paper, 17, 121

Archival materials, 26, 140, **189**

Arroyo (Ghost Ranch, NM), 187

Artists' books, 116

Ascenders, 38–39. *See also* specific hands
about, 4–5, **189**
height of, 35, 36
with round strokes, 38–39

Backing sheets, 105, 160, 162–164, **189**

Baseline, about, 4–5, **189**

Binding agent (glair), 91–93

Bindings
about: overview of, 117
choosing cover paper, 131
folding flaps, 133
holes/slits for, 131–133, 134

measuring cover sheet, 131
measuring text block, 131
multiple-section books, 133–135
presentation, 117–119, 130–133
sewing, 132–133
single-section books, 130–133

Bleeding pen, 19

B letters. *See* Ascenders; Curves and round strokes; Roman Capitals; Straight strokes; specific hands

Body, writing on, 173

Bold letters, 47

Book of Hours, 8, 113–115, 122

Book overview, 10–11

Books. *See* Manuscript books

Bowls. *See* Curves and round strokes

Branch, branching stroke, 72–75, **189**

Broadsides, 97–109
about: overview of, 97, **189**
copyrighted text permissions, 108
design considerations, 100–104
examples, 96, 98, 99–100, 101, 103, 104, 105–107, 109
framing suggestion, 104–108
layout and design, 102, 105–107
making, guidelines, 105–107
margins, 98, 99–100, 101, 107, 108
positioning elements of, 102–104
rough drafts and pasteups, 103–104
scale, 102, 103
script selection, 102
size and weight variations, 103
tape vs. adhesive for, 104
using gouache and, 93
writing quotations, 97–100

Brushes
chisel-edged, 52, 140, **189**
cleaning pens with, 17
colored gouache and, 89–90, 91, 92
painting paper with, 161
for Roman Capitals, 52
toothbrushes, 17

Calendars, 174

Calligraphy
book overview and, 10–11
historical overview, 6–8
learning from scribes of past, 2, 7–8. *See also* Analyzing manuscript; Manuscript books
like leaves of tree, 11
pleasures of imperfection, 8–10
as writing and drawing, 2–4

Camera-ready art, 166

Camp, Ann, 2, 53

Cap height, **189**

Cap-height line, 4, **189**

Capitals. *See* Majuscules (upper case letters); Roman Capitals; specific hands

Carolingian Hand
about, 82
Carolingian Minuscule and, 82, **189**
examples, 82–83
pangram using, 82

Chair, for studio, 15

Circles. *See* Curves and round strokes

Cleaning pens
washing nibs, 17, 18
wiping with rag/paper towel, 17

C letters. *See* Curves and round strokes; Roman Capitals; specific hands

Color, 87–95. *See also* Gouache
fugitive, 19, **190**
longevity of inks, 25–26
mixing, 89–91
painting cut-paper pieces, 169–162
principle of working with, 87
variations of light and dark, 92–93

Colored pencils, 140, 141

Commas, 45

Compass
defined, **189**
as divider, 17. *See also* Dividers
for skeleton letters, 55–56

Compass rose, 143–144

Copyrighted text permissions, 108

Corners, expressing, 159, 160

Counter-culture calligraphy, 11

Cursive
Carolingian Hand and, 82
Gothic, 7, 8
Italic Hand and, 69–70, 74, 75
term origin, 3, 69–70

Curves and round strokes
arches, 34–36, 72–73
bowl of letters, 36, 38, 40, 59, 63, 64, **189**
circle exercises, 22
Foundational Hand ascenders/descenders with round strokes, 38–39
Foundational Hand round letters, 37
Foundational Hand straight lines combined with curves, 39
Roman Capitals, 63–64
spacing of letters, 44
writing on an arc, 143

Cut paper, 151–163
about: overview of, 151
backing sheets with pastels, 163–164
cards from, 157
designing letters in silhouette mode, 159–160
designing letters in stencil mode, 154–156, 158
examples, 150, 152, 157, 161–163
expressing corners, 159, 160
first cut, 154
making design, 154

mounting silhouette mode cuttings, 163
painting pieces of, 160–162
step-by-step guidelines, 156–157
techniques, 152–153
tools for, 151–152
Cutting mat, self-healing, 17
Cutting tools, 16, 17

D

Descender lines, 4–5, **189**
Descenders. *See also* specific hands
about, 4, 5, **189**
with round strokes, 38–39
Designing projects. *See* Broadsides; Cut
paper; Manuscript books, making;
Mapmaking; Working for reproduction
Diagonal letters
Foundational Hand, 41–42
Roman Capitals, 65–66
Dividers, 17, 24–25, 26, 27, **189**
D letters. *See* Ascenders; Curves and round
strokes; Roman Capitals; Straight strokes;
specific hands
Downstroke, defined, **189**
Drawing boards, 13

E

Easels, 13–14
E letters. *See* Curves and round strokes;
Roman Capitals; Straight strokes; specific
hands
Entrance stroke, defined, **189**
Ephemera, 165–173
social calligraphy, 171–172
weathergrams, 172, 173, 185
working for reproduction, 165–171
writing on human body, 173
Erasers, 17
Exclamation marks, 45
Exemplars
about, 10, 29, **189**
Carolingian Minuscule example, 82
using, 70
Exit stroke, defined, **190**
Expressing corners, 159, 160
Ex Voto, 116

F

Felt-tip pens, 19
Five-line system, 4–5
Flat-pan angle, **190**
F letters. *See* Curves and round strokes;
Roman Capitals; Straight strokes; specific
hands
Flicked stroke, defined, **190**

Folios. *See also* Manuscript books, making
defined, 117, **190**
folding, 119, 120, 126
illustrated, 117
knocking up, 130–131, **190**
from large sheets of paper, 119–120
leaves and, 117, **190**
sewing into sections, 119. *See also*
Bindings; Sewing books
Fonts, 3, 6, **190**
Fore edge, 130, 131, 133, **190**
Foundational Hand, 29–49. *See also*
Foundational Hand, how to
about: overview of, 29, **190**
awkward letter combinations
(e.g. **r** and **f**), 45
capital alphabet with minuscule elements
of, 67
Edward Johnston and, 29
examples, 28, 30–31, 33–49
Italic Hand rhythm vs., 70
minuscules, 30, 31
origin and function of, 29
punctuation marks, 45
Ramsey Salter and, 29, 30
serifs, 35, 48
writing, general guidelines, 30–33
Foundational Hand, how to
ascenders and descenders with round
strokes, 38–39
diagonal letters, 41–42
odd men out (k-s-g), 40–41
punctuation and numbers, 45–46
round letters, 37
spacing, 43–44
straight lines combined with curves, 39
straight strokes and arches, 34–36
variations (size, weight, etc.), 47–48
Fountain pens, 19
Four-line system, 4, 5
Framing suggestion, 104–108. *See also*
Broadsides
Frankfurt paper, 17, 121
Fugitive colors, 19, **190**

G

The Game, 2
German word game, 3
Ghost Ranch, NM, 187
Gill, Eric, 8, 53
Glair, 93–95
binding gouache to paper, 94
making, 94
working with, 94–95
Glass, protecting work, 104
G letters. *See* Curves and round strokes;
Odd men out (k-s-g); Roman Capitals;
specific hands
Glossary, **189–192**
Gothic Hand
about: overview of, 82–84, **190**
Cursive (Bâtarde script), 7

defined, **190**
examples, 7, 78, 84–85
historical perspective, 7–8
majuscule alphabet, 84
minuscule alphabet, 84
Rotunda, 178
Gouache
binding agent (glair) for, 93–95
choosing colors, 87–88
color options, 88
examples created with, 92
formulated for pen, 88
loading pen with, 89–90
for mapmaking, 140
mixing colors, 91–92
mountain-and-lake preparation
technique, 89
palette options, 88–89
preparing, 89
preparing surface for, 95
storing, 88
technique, 87–92
trick to working with, 87
writing with, 90–91
Grids
manuscript books, 113–114, 116, 118, 123,
128, 129
map, 145, 146, 147
Guardsheet, 15, 21
Gum sandarac, 95, 139

H

Handmade books. *See* Manuscript books
Handmade papers, 121
Hands, defined, 6, **190**. *See also specific hands*
Head, of text blocks, 130, 131, **190**
History
of calligraphy, 6–8
of Gothic Hand, 7–8
of Italic Hand, 6, 7–8
of manuscript books, 111–113
of pens, 6
of Roman Capitals, 51–52
of Uncial Hand, 7
H letters. *See* Roman Capitals; Straight
strokes; specific hands
Human body, writing on, 173

I

I letters. *See* Arches; Roman Capitals;
Straight strokes; specific hands
Imperfection, pleasures of, 8–10
Inferno (Danté), 86, 87
Ingres papers, 17, 123
Ink
archival, 26, 140, **189**
bleeding pen, 19
controlling amount in pen, 19
dipping pen into, 19
fugitive, 25–26

lasting over time, 25–26
nonwaterproof black, 17
recommended, 17
walnut, 80, 81, 82, 93
Inkpots, 17, 19, **190**
Italic Hand, 69–77
about: overview of, 69–70, **190**
branching strokes, 72–73, 75, **189**
"cursive" origin and, 69–70
defined, **190**
examples, 6, 7, 68, 70, 71–77, 86
Foundational Hand rhythm vs., 70
historical perspective, 6, 7–8
origin and history, 69–70
pen angle, 23, 24
"picket fence" rhythm of, 70, 73
rhythm of, 70, 73
stroke order and direction, 72–75
writing on body, 175

J

J letters. *See* Curves and round strokes;
Roman Capitals; Straight strokes; specific
hands
Johnston, Edward
Foundational Hand and, 29
framing of work, 108
grave of, photograph, 2
historic scripts and, 80
influence on author, 2
legacy, 1–2
perspective on calligraphy, 2
perspective on style, 6
renewing craft practices, 112
text example, 2
writing process and, 2, 10, 98
Join, defined, **190**
Journals, 174

K

Ketubah, 113
K letters. *See* Diagonal letters; Odd men out
(k-s-g); Roman Capitals; specific hands
Knives, 17, 130, 151–152
Knocking up, 130–131, **190**
Kotin, Rory, 172

L

Labels, 174
Ladder. *See* Pen ladder
Leaf (leaves), 117, **190**
Learning from scribes of past, 2, 7–8. *See also*
Analyzing manuscript; Manuscript books
Left-handers, 14, 15, 16, 90

Letters. *See* Alphabet(s); Ascenders; Curves
and round strokes; Descenders; Diagonal
letters; Roman Capitals; Straight strokes;
specific hands
Lighting, 14–15
Lines. *See also* Ruling up
ascender. *See* Ascenders
combining minuscules and majuscules, 4
descender, 4–5, **189**
five-line system, 4–5
four-line system, 4, 5
two-line system, 4
writing between, 8, 9
x-height, 4, 5
L letters. *See* Arches; Roman Capitals;
Straight strokes; specific hands
Longevity of work, 25–26
Lower case letters. *See* Minuscules (lower
case letters); specific hands

M

Majuscules (upper case letters). *See also*
Roman Capitals; *specific hands*
cap-height line, 4
combining minuscules and, 4
defined, 4, **190**
Italic Hand, 75–77
lines written on, 4
origin of, 4
"upper case" origin, 4
Manuscript, analyzing. *See* Analyzing
manuscript
Manuscript books, 111–135
about: overview of, 113–115
artists' books compared to, 116
Book of Hours example, 113–115, 122
distinction from other book types,
112–116
examples, 110, 112, 113, 115, 125, 127,
129, 134–135
grids, 113–114, 116, 118, 123, 128, 129
historical perspective, 111–113
making. *See* Manuscript books, making
margins, 114–115, 121–122, 123, 125, 129
printed books compared to, 115–116
scrolls and, 111–112
single-section, 117, 130–133
Manuscript books, making. *See also* Bindings;
Folios
about: overview of, 116
column layout techniques, 121–123,
124–130
folding paper, 119, 120, 126
grain direction of paper, 119
illustrations, 129
line spacing, 123
organic approach, 124–130
page sizes, 120
paper considerations, 118–121, 131
planning phase, 118
practicing, 123–124
recommended papers for, 120–121
ruling up, 123
sample books, 125, 128

steps for, 118
structure of book and, 116–120
texture and weight of paper, 118
Tschichold diagram for text layout, 121–
123, 124, 125
using traditional format, 121–123
working with large sheets of paper,
119–120
Mapmaking, 137–149. *See also* Maps
about: overview of, 137–138
appeal and simplicity of, 138
avoiding problems, 144
bird's-eye perspective for, 139–140
bones to working composition, 147–148
compass roses, 143–144
completing map, 149
composition, 147–149
experimenting with solutions/drafts,
148–149
fleshing out bones, 148–149
geographical accuracy, 146–147
grids, 145, 146, 147
insets, 143
interruptions, 143
keys/legends, 143
land/foliage symbols, 139
lettering, 142–143
lines and fields, 140–142
problem-solving tips, 143–144
research, 144–146
techniques, 140–144
template from existing map, 146
tools for, 140
visual vocabulary and, 138–140
water symbols, 139, 141
writing on an arc, 143
Maps
examples, 137, 138, 139, 143, 145
free-form, 147
historical, 137, 138
imaginary, 138
from memory, 139–140, 147
personal history, 138
practical, 138
types of, 137–138
whimsical, 138
Margins
broadside, 98, 99–100, 101, 107, 108
defined, **190**
manuscript books, 114–115, 121–122, 123,
125, 129
Masking tape, 17
Mats, 104–108
Mene Mene (Calderhead), 96, 97, 108–109
Metric equivalency chart, 193
Mezuzot, 111
Minuscules (lower case letters). *See also specific*
hands
combining majuscules and, 4
defined, 4, **190**
lines written on, 4–5
"lower case" origin, 4
origin of, 4
M letters. *See* Arches; Diagonal letters;
Roman Capitals; Straight strokes; specific
hands

Modulated lines, defined, **190**

Monoline letters, 69, 70, **190**

Mounting silhouette mode cuttings, 163

Musical instrument, 8

Musical manuscript. *See* Analyzing manuscript

N

Nibs. *See also* Pens
caring for, 18
defined, **190**
left-oblique, 16
recommended, 16
reservoirs, 16, 18, 19, 90, **191**
right-oblique, 16
sliding into penholders, 16–18
Speedball, 16
square-cut, 16
Tape, 16
types of, 16
washing, 17, 18
William Mitchell Round Hand, 16, 18, 32

Nib-width, 6, 23–24, **190**

Nideggen paper, 17, 121

N letters. *See* Arches; Diagonal letters; Roman Capitals; Straight strokes; specific hands

Nonwaterproof black ink, 17

Notes on terminology, 6

Numbers, Foundational Hand, 46

O

Octavo, 120, **190**

Odd men out (k-s-g), 40–41, 56

O letters. *See* Curves and round strokes; Roman Capitals; specific hands

P

Page, defined, 117, **190**

Paint(ing). *See* Color; Gouache

Pallesen, Carol, 77

Pangrams, 80, 81, 82

Paper
archival, 26, **189**
binding gouache to, 91–93
grain direction, 119
for manuscript books, 118–121, 131
positioning, 15
preparing with gum sandarac, 95
protecting with guardsheet, 15, 21
recommended types, 17, 120–121
tooth of, 11, 104, 162, **192**

Pasteups, 103–104, 165–166, 168, 169–170, **190**

Past scribes, learning from, 2, 7–8. *See also* Analyzing manuscript; Manuscript books

Pencils
art, 17
colored, 140, 141
double, for exercises, 19
for ruling up, 17, 19

Penholders, 16–18, **191**

Pen ladder, 23–25, 26, **191**

Pen manipulation, defined, **191**

Pens. *See also* Nibs
angles of, 22–23, 24, 30, **191**
bleeding, 19
caring for, 18
defined, **191**
dip, 16, 19, 140, **189**
edged, 4, 6–7, **189**
felt-tip, 19
fountain, 19
historical perspective, 6
holding, 15
impacting shape of Roman letters, 6–7
inkpots for, 17
lifting, 22
"likes" and "dislikes," 22
for mapmaking, 140
moving, guidelines, 22
origin of, 6, 16
pointed, 173, 182, **191**
positioning reservoir, 18
pulling vs. pushing, 22
quills, 6
rags for wiping, 17
reservoirs, 16, 18, 19, 90, **191**
shaft of, 16–18
sliding nibs into, 16–18
toothbrush for washing, 17
washing. *See* Cleaning pens
waterpots for, 17
writing with. *See* Writing

Periods, 45

Pinto, Anna, 77, 173

P letters. *See* Curves and round strokes; Descenders; Roman Capitals; Straight strokes; specific hands

Pointed pens, 173, 184, **191**

Posture and positioning, 14, 15

Practicing
making books, 123–124
in a pinch, 175
specific letters. *See* Ascenders; Curves and round strokes; Descenders; Diagonal letters; Roman Capitals; Straight strokes; specific hands

Printed books, 115–116

Projects
calendars, 174
journals and sketchbooks, 174
labels, 174
reproduction works, 175

Protractor, 23

Punctuation marks, 45

Q

Q letters. *See* Curves and round strokes; Descenders; Roman Capitals; specific hands

Quartos, 120, **191**

Quires, 117, **191**

Quotation marks, 45

Quotations, writing, 97–100. *See also* Broadsides

R

Rags, 17

Ramsey Salter, 29, 30. *See also* Foundational Hand

Reproduction works, 175. *See also* Working for reproduction

Reservoirs, 16, 18, 19, 90, **191**

Retouching pasteups, 170, 171

Reynolds, Lloyd, 172, 187

Rives BFK paper, 17, 121

R letters. *See* Arches; Curves and round strokes; Roman Capitals; Straight strokes; specific hands

Roman Capitals, 51–67. *See also* Roman Capitals, how to
about: overview of, 149–150, **191**
basis of, 53
Eric Gill inscription, 53
examples, 50, 51, 52–67
first-century inscription tracings, 52
origin and history, 51–52
serifs, 61, 62, 64, 65, 66, 67
skeleton letters, 53–60
system for making, 53–56

Roman Capitals, how to
diagonal strokes, 65–66
pen-made letters (defined by strokes), 61
round strokes, 63–64
skeleton letters described, 57–60
straight strokes, 62
variations, 67

Rough, rough draft, 103–104, 105, 118, 130, 148–149, **191**

Round letters and strokes. *See* Curves and round strokes

Ruling up. *See also* Lines
aim of, 19
board for client project, 168
defined, 10, **191**
essentials of, 19
pen ladder for, 23–25
ruler/other tools for, 16, 17
step-by-step guidelines, 20–21
Tschichold diagram, 123
varying size of letters and, 47

Rustic Capitals, 7

S

Sandarac, 95, 141

Scribes of past, learning from, 2, 7–8. *See also* Analyzing manuscript; Manuscript books

Scriptorium(ia), 6, **191**

Scripts, defined, 6. *See also specific scripts (hands)*

Scrolls, 111–112. *See also* Manuscript books

Sections, of books, 117–118, **191**. *See also* Manuscript books

Self-healing cutting mat, 17, **191**

Selimiye Mosque, 113

Serifs
 defined, **191**
 Foundational Hand, 35, 48
 Roman Capitals, 61, 62, 64, 65, 66, 67

Sewing books
 about: overview of, 117
 holes/slits for, 131–132, 134
 multiple-section books, 134
 single-section books, 132–133

Size of letters
 broadside design and, 102, 103
 cap-height line and, 4
 condensed and strong, 47
 larger, 47
 ruling up for. *See* Ruling up
 smaller, 47
 varying, 47
 weight variations, 47
 x-height line and, 5, 19, **192**

Skeleton letters. *See* Roman Capitals

Sketchbooks, 174

S letters. *See* Curves and round strokes; Odd men out (k-s-g); Roman Capitals; specific hands

Social calligraphy, 171–172

Spacing
 creating even "color" to line, 43
 establishing rhythm, 44
 Foundational Hand, 43–44

Spine, of book, 130–131, 132, 133–134, **191**

Spray adhesives, 27, 104

Square, defined, **191**

Square exercises, 22

Stencils. *See* Cut paper

Straight strokes
 Foundational Hand arches and, 34–36
 Roman Capitals, 62

Stroke, defined, **191**

Stroke order, defined, **191**

Studio
 chair, 15
 desk set-up, 14
 lighting, 14–15
 tool position, 14, 15
 writing space, 13–15

Style, hand vs., 6

Surface, for writing, 13–14

T

Tails, of books, 125, 130, 131, **191**

Taping works, 104

Terminology notes, 6

Text blocks, 117, 131–132, 133, **191**

Text, word origin, 8

Thickness of strokes, 22

Thomas, Jeremiah, 3

Thoreau quote, 98, 99

T letters. *See* Arches; Roman Capitals; Straight strokes; specific hands

Tonality. *See* Color; Gouache

Tools, 15–16. *See also specific tools*
 for cutting, 16
 for mapmaking, 140
 notes on, 17
 positioning, 14, 15
 for ruling, 16, 17
 for writing, 16, 17, 19

Toothbrush, for washing pen, 17, 18

Tooth, of paper, 11, 104, 162, **192**

Training overview, 1

Triangles, about, 17, **192**

Tschichold diagram, 121–123, 124, 125

Tschichold, Jan, 121–122

T-squares, 17, 20–21, **191**

2H Pencils, 17

Two-line system, 4

U

U letters. *See* Arches; Curves and round strokes; Roman Capitals; Straight strokes; specific hands

Uncial Hand, 79–82
 about, 79–82
 defined, 7, **192**
 examples, 7, 80–81, 82
 historical perspective, 7, 79
 Insular Semi-Uncials, 7, 8, 23, 24
 pangram using, 80, 81
 variations in letter forms, 80

Upper case letters. *See* Majuscules (upper case letters); specific hands

V

V letters. *See* Diagonal letters; Roman Capitals; specific hands

W

Washing pens. *See* Cleaning pens

Waterpots, 17, **192**

Waterproof ink, 17

Weathergrams, 172, 173, 187

Weight, defined, **192**

Weight variations, 47

W letters. *See* Diagonal letters; Roman Capitals; specific hands

Work-for-hire opportunities. *See* Ephemera

Working for reproduction, 165–171
 advantages of, 95, 165–166
 client relationship, 166
 creating camera-ready art, 166
 designing project, 168
 final result, 170–171
 pasting up, 168, 169–170
 retouching pasteups, 170, 171
 ruling up board for, 168

Writing, 19–22. *See also specific hands*
 act of, correct term used for, 6
 broadsides. *See* Broadsides
 calligraphy as drawing and, 2–4
 dipping pen into ink, 19
 fonts and, 6
 guardsheet for, 15, 21
 holding pen, 15
 lighting for, 14–15
 longevity of work, 25–26. *See also* Archival materials
 nibs for. *See* Nibs
 ordinary, calligraphy vs., 3–4
 pen movement, 22
 pleasures of imperfection, 8–10
 posture and positioning, 14, 15
 practicing in a pinch, 175
 pulling vs. pushing pen, 22
 space for, 13–15
 stroke thickness and, 22
 tools for, 16, 17. *See also specific tools*

Writing space, 13–15. *See also* Studio

X

X-acto knives, 17, 130, 151–152

X-height and X-height lines, 4, 5, **192**

X letters. *See* Diagonal letters; Roman Capitals; specific hands

Y

Y letters. *See* Diagonal letters; Roman Capitals; specific hands

Z

Zigzag exercises, 22

Z letters. *See* Diagonal letters; Roman Capitals; specific hands

Picture Credits

All images courtesy of Christopher Calderhead except as follows:

Page 12—©Shutterstock/Mediamix photo

Page 77—Top row: Carol Pallesen; bottom row: Anna Pinto

Page 112—Wikimedia Commons/18_Arhat_Kawamura_Jakushi_Inscription_by_Yinyuan_
color_on_silk_18_hanging_scrolls_Shomyo-ji_Temple_Shiga_Pref.jpg

Page 113—Top: Wikimedia Commons/-Ketubbah._Venice,_Italy,_1750-.jpg; bottom:
©Shutterstock/Sufi

Page 172—Top and middle: Rory Kotin

Page 173—Anna Pinto

Page 175—Bottom row: Bradford Winters